The Merchant of DENNIS

the Menace

Hank Ketcham

The Merchant OF DENNIS the Menace

Abbeville Press ▪ Publishers ▪ New York

Editor: Walton Rawls
Designer: Molly Shields
Copy Chief: Robin James
Production Supervisor: Hope Koturo

Library of Congress Cataloging-in-Publication Data

Ketcham, Hank, 1920–
 The merchant of Dennis the Menace/Hank
Ketcham.
 p. cm.
 Includes index.
 ISBN 0-89659-943-4 (hard) $24.95
 1. Ketcham, Hank, 1920– . 2. Cartoonists—
United States—
 Biography. I. Title.
 NC1429.K52A2 1990 90-702
 741.5'092—dc20 CIP

Contents

Preface

For most of us, the Growing Years—say, the first twenty—were spent in the Buffet Line, sampling everything under the sun, from low hurdles to cello lessons, from aardvark-tracking to zucchini-stuffing, never quite certain which direction to take.

But I was a luckier young man than most and barely in the first grade when I was a witness to the hypnotic movements of the "magic pencil." Slipping instantly into tunnel-vision mode, I knew right away where I was headed. On occasion, of course, I nipped out and sampled other "buffet" offerings, but always returned to my comfortable dream of spending most of my life drawing funny pictures.

I grew up in a wondrous cartoon world inhabited by Barney Google, Harold Teen, Mutt and Jeff, the Toonerville Folks, the Gumps, and many others, and was mesmerized by the funny-looking people who could live in a bottle of ink—amusing char-acters who with a mere squiggle of a pen did as directed. When Mr. Disney brought out his *Three Little Pigs,* I got the deep-down feeling that I must seek my destiny in his exciting new world of fantasy-in-motion—which I abandoned college to enter. With a bit of help from friends, a good deal of per-sistence, and an enormous amount of luck, I have, so far, attained most every goal I sought.

The unbelievable technological leaps of the past three-score years and ten kept me goggle-eyed and on the edge of my shooting stick, and I marvel that I could both concen-trate on what had to be done and find time for the pursuit of happiness. But pursue it I did! Ducking the slings and arrows, side-stepping the plagues, and avoiding ties at intersections, I emerged smiling and rela-tively unscathed.

Although working forty years for a five-year-old has been rewarding and exciting, it

also has been confining. In the art deadline business, the mind might wander but the body is chained to the drawing board (though, to be sure, with velvet bonds); once you make a commitment to a newspaper syndicate, the agenda for the rest of your productive life is set. Like a fat, happy dog on a long leash, you are well taken care of but restrained from straying far afield—without the old cartooning tools. That my sanity has been preserved must be equally credited to an exceptionally loving and supportive wife and the nearness of an absolutely magnificent and humbling golf course—a pair of assets I desperately needed and for which I shall be forever grateful.

Indeed I have enjoyed a busy and successful life, but I still have other thirsts that must be quenched; so, I plan to start managing my time and energy more efficiently—before the sands in my hourglass run too low.

This book might have been a hodgepodge of curious memorabilia and awkward phrases had it not been for the tasteful touches of designer Molly Shields and the wisdom and patience of editor Walton Rawls. These two very skilled and gentle collaborators have seen to it that my best foot was always forward. I would also like to acknowledge the enthusiastic cooperation of Boston University and express my thanks to Dr. Howard Gotlieb, director of Special Collections at Mugar Memorial Library, for supplying much of the "vintage Dennis" material.

The Good Lord continues to smile down upon me, and no matter where I happen to be in this wide, wondrous world, every day is Thanksgiving.

I enjoyed the write; I hope you enjoy the read.

Hank Ketcham

Seattle, 1920-1938

Cartooning Was Early Thrust Upon Me

A seed was planted the Sunday afternoon that one of my dad's friends, an art director of a Seattle advertising agency, paid us a visit. As I watched him scribble some quick sketches of Barney Google, Moon Mullins, and Andy Gump, I couldn't wait to borrow his "magic pencil" and try my own hand at drawing these comic-strip characters. It looked so easy and such a lot of fun. I couldn't have been more than six years old at the time.

Well, the two men sure came up with a good way to get rid of me in a hurry. I moved over to the creaky rolltop desk, found some thin sheets of paper and remained there until dinner, slavishly tracing the visitor's sketches, quite sure the pencil was magic. It was a major discovery, and I was floating on air with excitement. During the weeks to follow, I copied every single comic in both the *Seattle Times* and the *Post Intelligencer* and soon had them all

memorized. Not very creative, but certainly persistent!

As soon as my teacher discovered the doodlings, she took me by the hand and marched me around to the other classes, where she announced: "Henry Ketcham from the second grade will draw some cartoons for you on the blackboard." She even urged me to demonstrate my new-found skills to the big kids in the fourth grade room!

In due course dozens of yellow slickers were festooned with the Ketcham (memorized) originals, and I was commissioned to decorate all the apple boxes that served as bodies for the popular homemade "skate-mobile" (a cross between a skateboard and a scooter).

My first commercial assignment came when I was a ten-year-old. Jim Neidigh, a classmate from one of the neighborhood's well-to-do families (his father had a steady

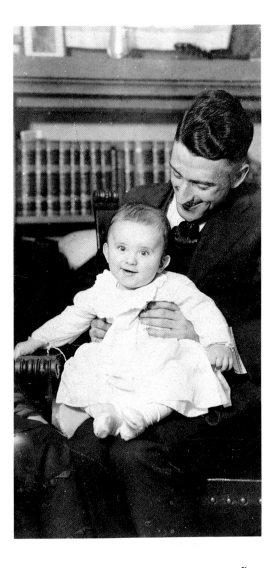

A proud papa Weaver Ketcham shows off his firstborn, several years before the youngster became attracted to the "magic pencil."

job), said he would pay me twenty-five cents cash if I would draw a hundred cartoon heads for him. Here was a golden opportunity to earn enough money with my own two hands to pay for extra lunches! However, it was a frightful experience and took me all of two days. I suffered horrible frustrations, and my homework went entirely neglected. I realized then that every artist needs someone to negotiate his business affairs for him.

As the years ticked by, I signed up for whatever art courses the schools offered, did regular drawings for the school paper, and accepted most any request for a funny drawing. It was a splendid ego massage; I received as much attention from the girls as the muscular athletes and was never out of breath or suffered a pulled ligament. Besides, I was too skinny and basically chicken for body-contact sports and too dense for intellectual jousting. Humor seemed to be the easiest way to "fit" into the community. Happily, during those grim days of the twenties, I developed a knack for seeing the lighter side almost to the point of blindness when it came to the hard facts of life.

Looking back on my artwork gives me the willies. I don't see how I could have made such an impression with junk like that. But it worked, and I kept at it on a semi-regular basis—meaning whenever I found spare time between classes, homework, the track team, golf, Hi-Y, school theatrical productions, Yell Team practice, lawn and garden maintenance, and cleaning my room! I also worked a noon shift flipping hamburgers at the Grizzly Inn, a popular hangout across the street from Queen Anne High.

It is virtually impossible for an imaginative student to devote meaningful time to any single subject during such a critical period of development. Life then is one continuous smorgasbord; a nibble of this, a dab of that, a sample of one thing, and a smidgen of something else. Absolutely days of glory, but busy, frantic, and confusing. Oh, that we could do it all over again!

As a matter of fact, several of my friends are still at it!

Family History

Unraveling the tangled web of family origin is an awesome and frustrating task unless, of course, your predecessors were able to read and write, kept diaries, or, better yet, were thrown in jail or held public office, thus becoming a part of recorded history. I have little knowledge of a European beginning and will only risk picking up one thread, which is dated 1800.

The family Corkhill ran the Custom House near the town of Ramsey on the Isle of Man, a speck of rock in the middle of the Irish Sea. This imposing wooden structure was built on the strand not far from the lighthouse, and at low tide eels were in abundance and easily dug from the sand with pole and sickles. When the herring were running, every man in town would leave home to join the fishing expedition, and the women would run the island businesses.

Apparently this beach-boy lifestyle became a bloody bore for father Corkhill, so in 1822 he took his wife, four children, and Aunt Ella to Liverpool, where they boarded the sailing ship *Massasoit*. Eight weeks and four days later they sailed into Chesapeake Bay. In due course they managed to find space on a lumber wagon that was deadheading west, and, for what must have been another cramped and uncomfortable adventure, they clip-clopped their way across the Allegheny Mountains into Ohio and finally settled in Steubenville.

In no time at all, a local boy, Andrew McDivitt, swept young Eliza Corkhill off her feet. They subsequently raised two boys and two girls and moved to Mt. Pleasant, Iowa, where a Ketcham, William B., finally enters the picture and marries Harriet McDivitt.

Great-grandfather General James B. Weaver, a popular two-time loser.

One of their sons, Albert Ravenswood Ketcham, was to become my grandfather, some years after he had wooed and won the trembling hand of a young lady from Mt. Pleasant, Miss Laura Weaver. Miss Laura's daddy, Brigadier General James Baird Weaver, in a singular claim to political fame, was elected to Congress in 1878 and served three successive terms. He was also an "incorruptible but uninspiring" candidate for President of the United States, running on the Greenback ticket. He lost in 1880 to James A. Garfield and in 1892 to Grover Cleveland. He did, however, account for thirty-five percent of the total vote in the twelve western states and was given twenty-two electoral votes.

Once their four offspring were old enough to travel, the Ketchams moved

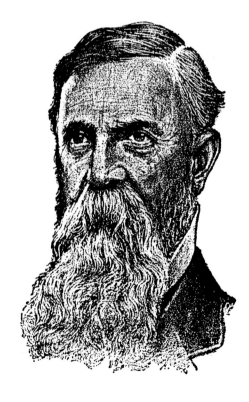

west to Seattle, Washington, where young Weaver, Albert Junior, Ernest, and Laura went through school. Their neighbors in the University District were the Kings—Nellie Helt, a young Ohio native, and her husband, Henry Richard, who hailed from Covington, Georgia. They had recently arrived from Miles City, Montana, with their two off-spring, Chester and Virginia. The fickle fin-ger of fate soon beckoned, and Weaver Vinson Ketcham waltzed down the aisle with Virginia Emma King. Eventually they celebrated the arrivals of Henry, Joan, and Virginia. And we are still here! Though I am a bit out of breath from the above, shall we proceed?

Seattle in the Twenties

My sister Joan is two years younger than I, and we grew up as two normal, well-behaved, insecure, terrified kids. Dad served in the Navy during the first World War and was by nature a stern discipli-narian. I don't know what prompted it, but one evening he brought home a horsewhip —a stiff, tapered thing about three feet long that he solemnly placed in the corner near the front door. My first thought was, "Oh, boy! When is he gonna bring the horse?"

The rules were quite simple: no whip-ping above the knees. Now maybe this is as it should be on horses, but on skinny little underfed kids it's murder. However, it did stimulate the circulation on cold after-noons, and I developed various techniques of fancy footwork that to this day have given me the reputation of being an "agile" dancer.

In all fairness, I must point out that Mother was a sweet, loving softie who sel-dom raised her voice in anger. Dad had realized that his gentle, redheaded Mon-tana lady was not a believer in things like "discipline" or "punishment," so to serve in his absence, he had supplied this symbol of raw violence, hoping it would scare the whey out of the two Ketcham ragamuffins. From all reports, Joan and I were capable of "acting up" and causing enough com-motion to call down the wrath of the gods, but the ugly horsewhip was only half-heart-

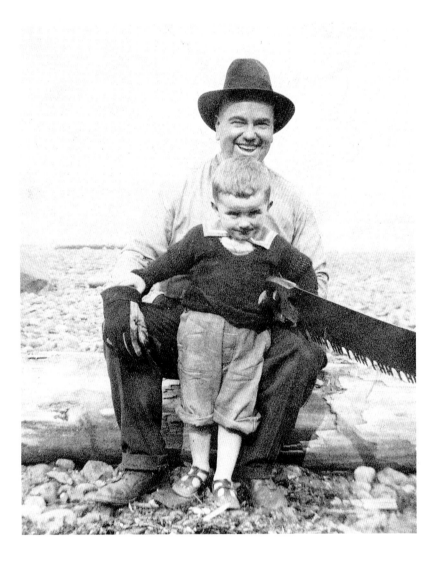

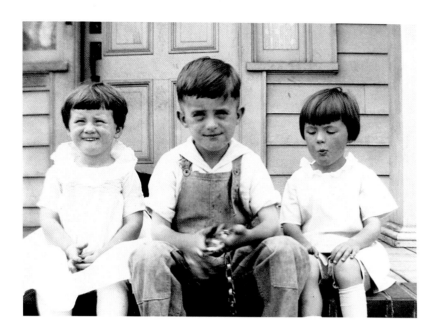

edly switched around our ankles on very few occasions. It caused no more than a slight, tingling sensation—though Joanie insists I screamed bloody murder.

The Ketcham tribe took themselves seriously, and Grandfather Ketcham saw to it that his three sons were raised toeing the mark. All of these menfolk had exceptional humor, but they also carried a steely glint in the eye that translated into "State your business and don't mess around." Aside from stern warnings, the horsewhip, and a good swat on the fanny from time to time, I don't have any memories of "trips to the woodshed." I got along very well with Dad, and we enjoyed each other's company. He was always supportive of my cartoon ambitions, although he constantly was after me to "just draw that vase over there on the shelf the way it really looks." He wanted me to learn the craft correctly, to understand good drawing before I went off the deep end into caricature. He was right, I was an impatient schoolboy. I am grateful now that he lived long enough, as he put it, "to bask in the reflected glory of Henry's success."

Sister Joan, her five-year-old brother, and our next-door neighbor, Jerry Johns, try their best to accommodate the photographer. Judging from the costumes, this picture and the one below must have been snapped on a Sunday.

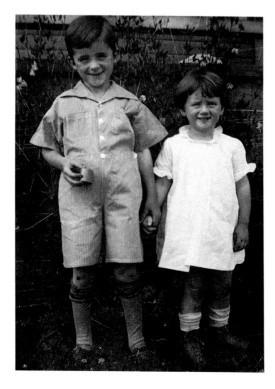

The Seattle First Methodist Episcopal Church was the theological service station for the Ketcham family, and, like clockwork, we arrived by streetcar every Sabbath morning for spiritual refueling. Paying regular homage to the Lord was ingrained in us from the beginning: grace before dinner, prayers at bedtime, and we went to Sunday School religiously (Is there a better way to go?).

Anyhow, it was as much a part of the schedule as taking a bath and brushing the choppers. When I began wearing long trousers, I moved up to Junior Church where I

became an instant fan of Rector Harry Wilson's spirited readings of such non-church stories as *The Hunchback of Notre Dame* and *Moby Dick*. I was also enamored of raising my soprano voice with fifty other whippersnappers to belt out some rousing Methodist hymns. "Rock of Ages" and "Throw Out the Lifeline" immediately come to mind. Later I took my turn teaching simple Bible lessons to the kindergarten set and was even called upon to offer short "sermons" from the pulpit in the big auditorium upstairs.

There were also monthly Friday-evening vespers with potluck suppers, and quite often Mr. Wilson would treat a full house of a hundred or more devout WASPs to a movie, shown on a huge beaded screen. The church had a soundproof booth and one 35mm projector, and while the reels were being changed we'd sing our heads off to "Old MacDonald Had a Farm," "I've Been Workin' on the Railroad," "K-K-K-Katy," and other musical jewels from the Top 50 of 1928.

Of course there was no sound and no color, but a piano player, loaded with creative arpeggios, always accompanied the action, and the evenings were memorable as we feasted on such celluloid classics as *A Connecticut Yankee in King Arthur's Court*, with Will Rogers, and laughed hysterically as the swarm of Model T Fords petrified the horses and the knights in shining armor.

Harold Lloyd comedies were regular fare, but for some reason or another we never did see much of Clara Bow, Jean Harlow, or Gloria Swanson.

Prohibition was in full swing when I was nine years old, and the Sunday School teacher felt prompted to trot out a blue card for each of us children to sign. It was

a Temperance Pledge, of all things. I dutifully tucked it between the pages of my Bible and eventually had it neatly framed and hung in my bar.

Grandmother Ketcham and her sister Maud were Carrie Nation clones, and for all I know founding members of the Women's Christian Temperance Union. Although they refrained from barging into waterfront saloons armed with axes and bent on total destruction, the Weaver sisters made their point loud and clear on the home front, much to the despair of Grandpa Albert K., a whiz at three cushion billiards and an enthusiastic brandy sniffer. They blamed the acrid pollution of his Blue Boar tobacco for the wilted house plants, the discoloration of curtains and wallpaper, and relegated him to the cellar for his pipe-puffing. My grandparents were a little like Maggie and Jiggs, a popular comic strip in the twenties and thirties, but Grandpa was no wimp. If his wife hadn't been such a sensational cook and housekeeper, I feel sure he would have flown the coop early on. I'm glad he didn't. He was a marvelous grandfather with a great sense of humor. We'd sit for hours at checkers, and he taught me how to play caroms, a sort of miniature billiards where your fingers are used to propel small wooden rings around an enclosed board.

Before retiring one evening, Grandpa absentmindedly placed a bottle of beer in the ice box. The next morning sister Joan was doing the dishes when Grandma entered the kitchen for her bowl of hot cereal and milk. In utter horror she spied the suds, dramatically grabbed the bottle by the neck, and, as though christening the USS *Ticonderoga*, shattered the thing to smithereens on the kitchen sink, demanding of everyone within earshot: "Who brought

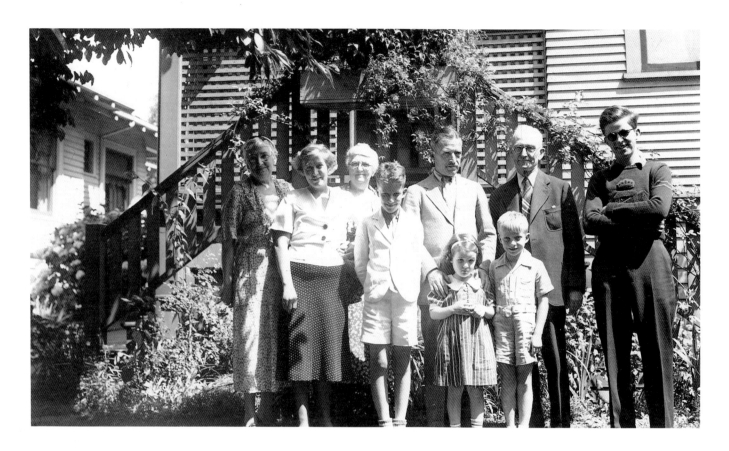

this WHISKEY into my house?" Poor Joan was so disturbed that, within the hour, she had gathered up all the vanilla extract and aftershave lotion in the house and had tossed it all into the garbage can.

Aunt Maud, Grandmother Ketch's older sister, "came to dinner" and graced the guest room for the next five years. She also was devoted to the cult of Abstention, but somehow these two elderly Iowa girls were lured into attending a large afternoon gathering of society matrons where they were served a "delicious fruit punch decorated with exotic flowers floating in a bowl."

Watching them help each other out of the taxi was as good as any Mack Sennett comedy—hats at a jaunty tilt, glasses slightly askew, laughing and giggling their way through the front door, loving the whole wide world for once in their cloistered, Puritanical lives. Nary a soul, of course, would ever remind these prim and proper ladies that they had both been gassed to the eyeballs.

Incongruous handles have been attached to long-suffering grandparents since Year One. These are pet names, the first feeble utterances of infant grandchildren that, once applied, seem to last a lifetime. Grandmother and Grandfather Ketcham were no exception: they were called Manga and Bapa.

Sunday dinner at Manga's was a tasty ritual that afterwards usually found us sitting around the fireplace, listening to family stories of earlier days in Iowa, and singing to the accompaniment of Manga's guitar and Dad's mandolin. In a sincere effort to broaden my musical appreciation, Manga would open the old Victrola and ply me with records of Madam Schumann Heink, Harry Lauder, and Enrico Caruso. This stuff never really grabbed me, but one fine day Bapa gave me a broad wink and showed me where he kept his small collection of recordings by the Mound City Blue Blowers and The Two Black Crows. This I *did* appreciate!

I couldn't believe my ten-year-old eyes when I saw the big Atwater Kent console being delivered. She was a beauty, housed in an attractive wooden cabinet and packed with vacuum tubes, speakers, wires, switches, and knobs, carrying a price tag of $49.95. It was about the only article in the house we ever bought brand new. How on earth my dad ever paid for it never occurred to me; I was too absorbed in the magic of this box that brought glorious sounds into our living room from as far away as Salt Lake City. And when the local station became affiliated with the Red and Blue Network, it opened up an exciting new world and made it easier to endure the cold and wet Seattle winters. Don McNeil's Breakfast Club from Chicago was a morning must, as were the news bulletins reported by H. V. Kaltenborn and the sporting events by Graham MacNamee and Ted Husing. The entire country paused to hear the daily episodes of "Amos 'n' Andy," and every Thursday on CBS my ears were tuned to the Major Bowes Amateur Hour, hoping to hear some poor off-key tenor get the gong.

I can't truthfully complain that we lived under much tension or nervous strain—but I bit my nails, sucked my thumb, and wet my bed until I was nearly fourteen.

Seattle in the Early Thirties

My youngest sister, Virginia, was born on 16 October 1932, and Mother died ten days later from complications of the birth that led to peritonitis. She was a loving, vivacious girl of only thirty-four years. Dad had been unemployed for months, Joan and I were threadbare, and now a housekeeper and a nurse were needed. The strain must have been unbearable.

Joan, of course, was very close to Mother—helping in the kitchen, learning to sew, and spending hours together in mother/daughter talks; I was all over the place riding my bike, playing ball, hanging out with my pals, and finally dragging into the house just before dark.

I was terribly depressed but didn't shed a tear until the day of the funeral when the three of us sat near the coffin, half-listening to the eulogy and last rites. Father appeared shattered, drawn, and hopelessly lost. I guess it was only then I fully understood what had happened and suddenly burst out crying.

My mother had been a fastidious writer. She sold several short stories to magazines and kept a diary from the day she entered high school. As I was only twelve when she died, her collection of daily happenings and thoughts has given me insight, understanding, and appreciation of from whence I came and the nature of the cast of characters involved. I have been fascinated, appalled, saddened, surprised, and uplifted by her periodic entries and feel that I have finally gotten to know my mom.

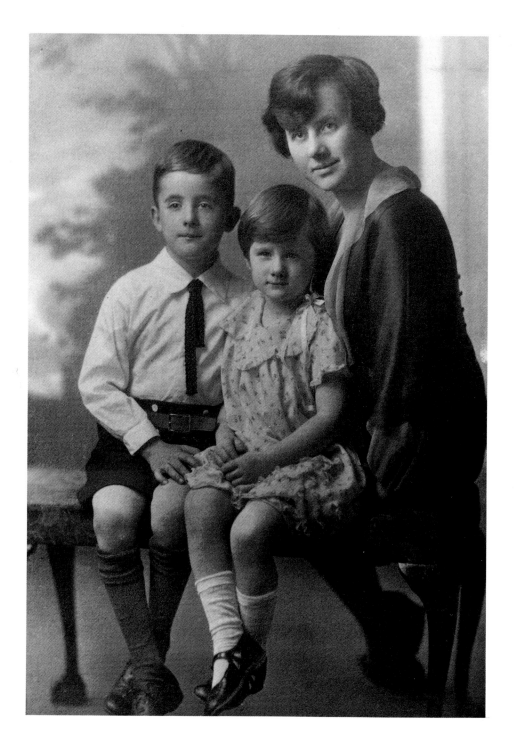

A portrait with Mother, as Henry and Joan watch the birdie with suspicion.

I discovered a hint of the sensitive nature of this young lady in the following bit of poetry she wrote shortly before her marriage:

It's just two years since you told
Me you were in love.
You didn't say exactly who she was,
But I guessed.
And later you confessed.
It's queer how quickly times goes.
It seems like yesterday that
We were in the throes
Of high school work and play.
And now it's college and business
That we talk about.
It's fun to wonder what the
Next two years will bring.
Do you remember all we've done
Together?
We've braved all sorts of weather,
You and I. But our love has only
Had one season—Spring.
It seems to keep on shining
Sweet and true, just like
It did when we found it, new
And beautiful.
Somehow I feel it's always
Going to be that way with us,
No matter what some others say.
Idle gossip and opinion are
Incapable of breaking love
Forged in friendship and true loyalty.
As long as we keep our purpose
Straight and well in sight—
And cling tight
To the causes and the works that count
And never lose the vision of our Lord—
We'll get along alright.

Virginia King
October 4, 1916

Grass grows quickly in the misty Northwest, so Henry and his rotary cutting machine clattered about the neighborhood on weekends servicing regular customers. Cutting: fifty cents. Trimming: two bits extra. Those precipitous Seattle lawns were definitely a challenge. I've had remarkably good luck playing in the streets, but three times I've been run over by lawnmowers.

About this time, a young man born thirty miles down the road was making a big splash with his intimate singing technique, something they called "crooning." Harry Lillis Crosby was then appearing in Mack Sennett films and was a featured vocalist with the Gus Arnheim band at the famous Coconut Grove in Los Angeles. Later, we listened to him daily over the Blue Network in his fifteen-minute "Croon for Cremo" (cigars) program.

One of my Queen Anne Hill pals, Ken Dever, and I became avid collectors of Crosby records, scouring junk shops and dusty attics and pestering friends in search of his early discs. By 1938 we had acquired the complete assortment, handling them like rare porcelain and using only freshly cut cactus needles.

One summer I was a guest at the Dever farm up on the San Juan Islands and brought along a few favorite platters and my portable, hand-crank phonograph. After supper, on star-dusted August evenings, Ken and I would build a bonfire on the beach, light our pipes, stretch out, and dream to the strains of "Black Moonlight," "Soft Lights and Sweet Music," "Learn to Croon," "The Day You Came Along"—while ten yards away, a pod of inquisitive seals popped their whiskered heads out of the icy water and edged closer for a better gander at this unique concert.

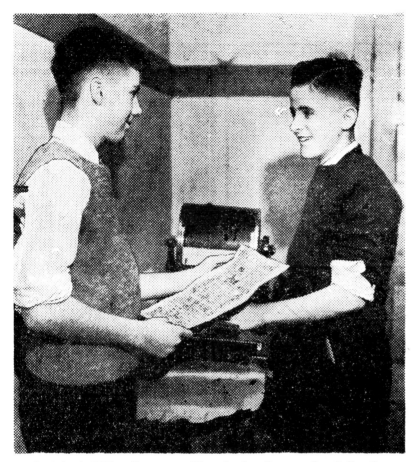

Assistant Editor Lawrence Fry checks the proofs of the Queen Anne Shopper while Editor Henry Ketcham runs another sheet thru the mimeograph. Besides being their own compositors and pressmen, the boys are also reporters, advertising salesmen, artists and publishers. And business is very good, they say.

loaded with Salinas lettuce chugged to a stop in the neon glare of a roadside tavern. I slid out of the cab, stretched my cramped legs, and joined the driver inside the warm shack. As usual, I was short of funds and was hitchhiking back to Seattle for a breather and to report my recent success in landing a job at Disney's. The driver sprung for coffee and doughnuts, and I dropped precious nickels into the psyche-delic-looking jukebox to hear a familiar voice singing:

> I'm no millionaire
> But I'm not the type to care, for
> I've got a pocket full of dreams.

I've seldom felt more uplifted.

Queen Anne Hill, 1930

Most children exhibit great creativity through the age of ten, then they seem to peel off into areas of interest not necessarily creative. Nevertheless, even after ten I continued to amuse myself in examining the family's wondrous stereoptican slides of Venice and Rome, in listening to the music and comedy records squeaking out of Grandma Ketcham's Victrola, and in creating weekend theatrical events and neighborhood boxing matches, apparently in response to an awakening entreprenurial urge.

I would enlist my pals to help publish a neighborhood newspaper/shopping guide and badger local merchants to advertise. At other times we would clog the Ketcham basement for days with improvised benches and elaborate lighting and projection machines, all painstakingly assembled for The Big Show. The basement was always warm and friendly in the winter, cool and refreshing in summer—a place where

This was my first real taste of the free-enterprise system, and if the Xerox copier had been invented sixty years earlier I might have remained in the newspaper business.

The Day They Invented Bing Crosby should be commemorated. He bolstered sagging spirits, lightened weary hearts, brightened eyes, and radiated a philosophy everyone could identify with during the grim thirties. Bing's Thing was inspiring tonic.

One cold, foggy night on the northern California coast, a big diesel semi-truck

wooden steps wrapped around the furnace, the coal bin, a workbench, the washing machine, and where a mile of clothesline strung from overhead beams gave off the unmistakable aroma of freshly hung washing, with just a hint of Clorox suspended in the damp air.

At one "Saturday Night Smoker" the contender failed to turn up for the main event, so in the spirit of the-show-must-go-on, I announced the substitution, turned over my referee job to one of the parents, slipped into a pair of shorts, laced up my gloves, and answered the bell for Round One. My worthy opponent must have beaten Joe Louis's Bash-the-Living-Day-lights-Out-of-Him record by a full minute that night. I was more mortified than hurt and raced up the stairs in a flurry of tears and grunts, remaining there until the restless fight crowd dispersed and I had gathered my wits together. I'm with Poe's Raven—*Jamais encore!*

M - I - C - K - E - Y—
Now let's hear it BIG!—
M - O - U - S - E !

A few years later Jerry Appy, Tom Trumbull, and I built the Victory Theatre, only this time we used Tom's basement. Basically a motion picture palace, we outfitted it with sliding curtains, a balcony, and an enclosed room to house Tom's huge 35mm projector. We regularly struggled home on the streetcar with big cans of Charlie Chaplin, Buster Keaton, and Our Gang comedies from the Film Exchange. With Mrs. Trumbull making batches of caramel popcorn balls, we filled every seat in the house for several weekends. As it is today with neighborhood cinemas, we could never have made it work without the popcorn sales.

In the summer of 1930 I was appointed official cheerleader for the Saturday matinee Mickey Mouse Club! Not only did I have free admission to the Cheerio Theater, but they gave me a white sweater emblazoned with a big picture of Mickey. Little did I dream that nine years later I would become more seriously involved with Walt Disney.

Bill Severyns, son of King County's sheriff, played guitar and harmonica (often at the same time) and joined with me to become the Queen Anne Hillbillies (one of the acts that helped kill vaudeville). While Bill warbled the cowboy ditties, I chimed in on percussion and alleged harmony.

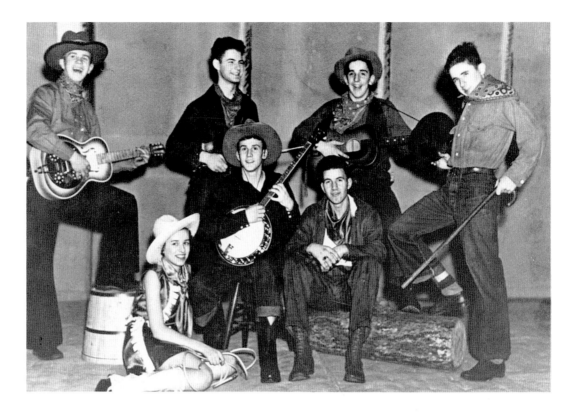

Strangely, I've been able to vamp two and three-part harmony since I was a nine-year-old. Strange is the operative word, all right. You should have heard some of the clunkers I hit. Dad was an active member in the (take a deep breath) Society for the Preservation and Encouragement of Barber Shop Quartet Singing in America—often referred to as S.P.E.B.S.Q.S.A. So once we found a song where we knew all the words, Dad and I were off together in a cloud of cool chords. I was involved with glee clubs, choral societies, or with small combos wherever I happened to be, and I loved it. Still do. Just toot your pitch pipe, and I'll come a running!

Somehow in entertainment-starved Seattle, we struck a nerve and won first prize in an amateur show on radio station KOL, which resulted in a week's engagement at the Olympic Bowl, a spiffy nightclub in what was then the city's largest and finest hotel. We developed some momentum and started to make regular appearances at fund-raising events, school performances, and service clubs. We were even invited by the Seattle Democrats to join them in a motorcade to California and a ride in one of the first cars to cross the new Golden Gate Bridge from the north end!

Not what you could call an auspicious beginning, but the experiences of creating situations that captured an audience set aside my identity for the moment and relieved my awareness of serious problems facing the world, the city, and our home.

Henry the Yell King with his megaphone and his three knights, Cliff Loflin, Sid Goodwin, and Ed Cannell.

These were perilous times, and I was determined to play ostrich, or so it seems in retrospect.

Junior Boy Scout

Each year following the World Series, an All-Star baseball team would be selected to visit Japan for several weeks of exhibition games. They traveled on the Great Northern Railroad to Seattle where they would loosen up and display their talents at the Civic Auditorium Field on the afternoon prior to boarding the steamship.

One day in late October of 1930, I scampered down Queen Anne Hill, scrambled up and over the ten-foot chain-link fence,

darted beneath the bleachers, and casually took a seat directly behind home plate. While I was congratulating myself and still trying to catch my breath, someone tapped me on the shoulder. I froze and slowly inched around to see a smiling, cigar-chomping sports fan holding out a brand-new, genuine Spaulding horsehide baseball. "Here, kid. Wanna make a quarter?"

"Sh-sh-sure!" I stammered with relief and a wide grin.

"Just go down there and get a few autographs of the players for me. Okay? Wait. Don't forget the pen."

Now my heart was really pounding as I bounced down the steep wooden steps toward the dugout. I was on a roll and didn't

feel at all bashful about asking for signatures. In less than twenty minutes I was back in the stands anxious to return the ball. The delighted owner dug into his pocket for the two bits, patted me on the back with a big "Thanks, kid," and sat there ogling the freshly inscribed marks of Lou Gehrig, Jimmie Foxx, Babe Ruth, and a few others I can't recall. I was terribly proud of my performance, and the thought of heading for the hills with the precious souvenir and the expensive fountain pen never crossed my mind.

That certainly would have impressed the troops at the First Methodist Episcopal Church.

I attended the YMCA Friendly Indian Summer Camp for the first time when I was nine years old and remained an active "Y"

A nine-year-old Hank, packed and anxious to get going on his first two-week vacation at the YMCA Friendly Indian Camp.

member through my high school years. I spent a jillion hours riding the creaky Seattle streetcars to and from the downtown headquarters where I regularly worked out in the gym and swimming pool.

When I became twelve, I wanted badly to join the Boy Scouts of America. Troop 65 was an active bunch of kids who seemed always to be taking hikes up Mount Rainier or spending weekends camping at nearby lakes. It sounded like a lot of fresh-air fun, and, besides, they wore such a neat-looking uniform. But, alas, the outfit, not including the knife, cost twelve dollars, and my dad simply couldn't afford it. I was devastated. I am sure he felt as bad as I did, but he had been without a job for more than a year and there were other priorities.

So I returned to the Young Men's Christian Association, which by then apparently was aware of the precarious fiscal condition of the Ketcham family and kindly arranged a "scholarship" so that I could continue my activities. During the summer camping session I earned my keep by peeling potatoes and doing K.P., and one summer I helped publish a daily camp newspaper, profusely illustrated, of course. Throughout the year I continued to turn out special drawings, posters, and announcements both for the "Y" and for various school activities. Looking back at that crude stuff makes me choke in disbelief. How on earth I ever got the reputation of being a funny cartoonist is beyond me.

As the Twig Is Bent

I'm a looser goose now. I tolerate some strange notions. I am no longer so naive or quite so uptight in many respects, but, nonetheless, I have a built-in conservative straight arrow in me that pops to the sur-

face like Old Faithful, especially where children are concerned. There is a behavior I expect, certain codes of dress and etiquette I demand, and areas of language and respect I insist upon.

I am painfully aware that this is extremely old-fashioned and out of step in light of today's permissiveness. Somewhat chagrined, I have to admit that I am beginning to sound like an echo of my father, but there is no room for fads in these basic matters. The fundamentals must never vary if we plan to peacefully share space with others.

The odd shape of my branches is due to the many people who have had a hand in twisting me this way and that while I was just a twig, and I am grateful to most of them for my case of the bends. Lucky I didn't end up looking like a bonsai tree.

Walt Disney was one of my "benders." Through his influence I became enamored of the "little folks," those pen-and-ink characters who stand no more than three or four heads tall—whether a duck, a mouse, or a menace—and with them I feel quite comfortable and to them I remain loyal.

Spellbound

One Saturday afternoon in the summer of 1929, while Mom and Joan were visiting with some lady friends, Dad surprised me by taking me to a movie matinee. Just us men. Among the short subjects was one of the Max Fleischer series "Out of the Inkwell," a combination of live-action and animation featuring an artist at his drawing board and a cartoon clown who lived in the bottle of India ink. I was hypnotized.

These drawings were different from those I saw in the funny papers—they moved! While my classmates planned to become ranchers, doctors, aviators, and lawyers, I had made up my nine-year-old mind to be a cartoonist. I didn't have a clue about where my drawings might be published or what kind of cartoons I would draw; I just knew that somehow, when my schooldays were over, I would end up at a drawing board trying to be funny for money.

Walt Disney's Technicolor blockbuster, *The Three Little Pigs,* was released in 1933, and I was smitten. No doubt about it; at least I knew at a tender age where I was going, and The House of the Mouse was my target. Not to huff and puff but to pounce right into the front door and be greeted with open arms! Hot dog! I could feel it in my bones. This was where my kind of action is. This is where I belonged, and as soon as I got a bit more school under my belt and a little dough in my pocket, I was heading south.

My mother had just passed away, I was a wide-eyed freshman at Queen Anne High School, and my dad was unemployed. In retrospect, I guess this Planning Ahead, this urge to get out of town, was understandable. Those were dark days, and there really wasn't much at home to look forward to.

Apparently academic standards weren't as demanding as they are today, for I often found myself on the Honor Roll. Strange, as I was never considered a "whiz kid"; but, come to think of it, I always did well in geometry, of all things—probably because the shapes and graphics were something I could understand. I was especially active in drama and a regular performer throughout high school, usually in the role of a comedian. This was great experience that helped me immeasurably to develop the theatrical elements in my cartoon panels. To aspiring artists I always recommend in-

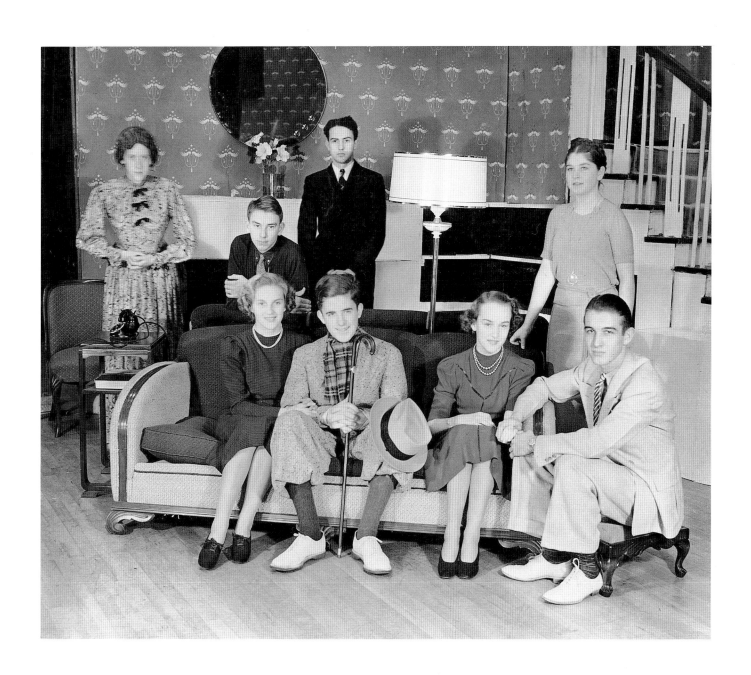

OPENING THE OPEN HOUSE . . . *By Henry "King" Ketcham*

volvement in the theater during school years.

At eleven, I went through a spell where I really wanted to get into cartooning, but there were precious few books available on the subject and there was no one to talk to, except my kid sister, and what did she know? But one day a friend of mine told me about his older brother, he must have been nineteen or twenty, and how he was taking an art course at night school and was up in his room drawing most of his spare time and would I want to meet him.

Well! It didn't take long before I became a close friend of Al Thayer. I spent many after-school hours hanging over his large drafting table watching in awe as he made beautiful renderings in red and brown chalk, a technique used by the old masters when developing preliminary studies. A far cry from cartooning, but the emphasis on draftsmanship was inspiring. Al would give me suggestions and corrections, and I felt pumped up for days on end because of this outlet for my artistic energies. It wasn't so much what I learned at these impromptu rap sessions, the importance of it all was the fact that I had a stimulating dialogue going with a kindred spirit. Without it I fear my interest would have withered.

My linoleum block print decorated the 1933 graduation program of our eighth-grade grammar-school class.

Whatever Happened to My Role Models?

The Grizzly Inn, a hamburger/milkshake/sneak-a-smoke hangout directly across a tree-lined street from Queen Anne High, featured a large brick fireplace at one end of the front room where the ice cream counter action took place. During my freshman year, Seymour Kail, the cartoonist-in-residence, had the decorating franchise,

and he colorfully lettered each brick with a student's name. Once the spaces were filled, you had to wait until after someone's graduation before you could put down your twenty-five cents and commission a brick of your own. What a delightful racket!

When Kail graduated, along came Leonard Shorthall to work the same scam. He soon was followed by another talented cartoonist, Kelly Oeschli, who proceeded to cash in on all the new undergraduates. All of these guys were great artists, and I wanted dearly to follow in their footsteps. I later heard that Kail worked for Disney for a short period and then wound up in South America with Pan Am. Shorthall went on to the university and then disappeared in the direction of New York City and the book illustration business. Oeschli graduated about the time I finally learned how to spell his name, and he went east to join forces with Shorthall. I was sure that I would be seeing their names in lights. They were so outstanding, head and shoulders above anyone in Seattle—but I have not heard one word of them since. Is the world so large that it can just swallow up such talent?

Snow White had been in the planning since 1934, and the press gave it a lot of play since it was to be the world's first full-length animated feature. While the country was in the depths of a miserable depression, the movie industry flourished and offered temporary relief to the millions in despair, and at prices most could afford. Disney was able to attract top artistic talent and surrounded himself with the very best team of designers, writers, musicians, and animators ever assembled. *Snow White* was released during Christmas Week of

CLASS REUNION

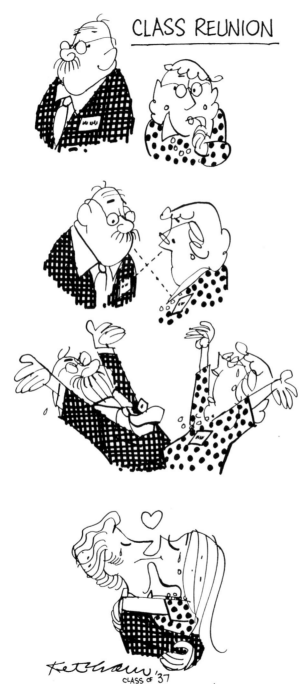

Ketcham '37
CLASS OF '37

This absolutely cannot be appreciated until you attend your own fiftieth class reunion.

1937, at the unheard of production cost of $1,500,000!

While the cream of the world's artists and technicians headed for Los Angeles, the Disney recruiters were also placing ads in the newspapers and magazines to seek out young cartoonists who were interested in joining the industry. This was April 1938, smack in the middle of my first year at the University of Washington. I was an art major and a drama minor, had pledged to Phi Delta Theta, and was just settling into campus life with every intention of graduating with the Class of '41. But apparently Disney's offer was one I couldn't refuse. I jumped at the opportunity and immediately wrote for an application, which—after three weeks' waiting!—I thought was surely lost in the mail. By the time the big envelope with Mickey Mouse on the cover finally arrived, I was reaching the end of my tether.

In addition to my vital statistics, they wanted to see samples of my work and outlined three situations involving Mickey, Goofy, and Donald Duck that I was to develop as rough pencil sketches. As I had been drawing cartoons since the first grade and had gained a reputation in the neighborhood as an "exceptionally gifted cartoonist," I knew the Disney test would be a piece of cake. A mere formality.

Manga and Bapa Ketcham's home was but a fifteen-minute stroll to the university, so they kindly invited me to bunk with them during my pursuit of a higher education. I had a fine room, a great place to study, and ample servings of Manga's delightful cooking. A very fortunate young man was I.

Early one morning (it was always early—nobody slept past 6:30 in that household) as Manga poured a cup of hot chocolate, she addressed me rather seriously.

I wonder where Oliver Hardy was at the time? I could also whip out my pocket comb and do a dandy Adolf Hitler.

"Henry, your grandfather and I are concerned about your education and your future plans. We know how anxious you are to work for Mr. Disney, dear, but don't you think that could wait until after you have finished school?"

This conversation was not entirely unexpected. They were absolutely correct in wanting me to weigh the matter carefully, hoping that wisdom would prevail and that I would remain at the U. of W., as did my father and both of his brothers, Ernest and Albert—at least until World War I interrupted. Their logic was pure, and I felt uncomfortable trying to justify my unbridled enthusiasm for a cartooning career rather than hanging in there at the university for three more years and a bachelor of arts degree.

I was enjoying school, the choices of extracurricular activities, and my exhilarating fraternity affiliation. But much of my schedule had me sitting in large auditoriums and listening to long lectures on subjects like "The History of the Russian Theater" or "A Closer Look at Porcelain Art in China." I finally decided that I didn't want to watch the parade, I wanted to *march* in the parade! Somehow this juvenile philosophy gave me an inner peace and made it less difficult to leave school and to brave the weird world of animated cartoons.

Full of my usual gusto and enthusiasm, I whipped up the required drawings for Disney, dispatched them forthwith, and began my vigil at the letterbox, which seemed interminable. It was near the end of May, the school year was coming to a crashing end, and I seethed with frustration at not hearing one word from the Mouse Factory.

My Uncle Ernie kept his large boat at the yacht club and put me to work afternoons and weekends chipping paint, varnishing

Apparently I had little sympathy for prizefighters.

woodwork, and polishing the brass. This sudden burst of energy was motivated by my need for funds to keep me afloat in Los Angeles until my first studio paycheck was issued. Ernie's stepson, Larry Williams, was driving as far as San Francisco in his '36 Packard Coupe and invited me along to keep him company, which was absolutely perfect—with two exceptions: he planned to leave two days before my final exams, and he was taking along his two-year-old Dalmatian pup.

But, what the heck, my mind was made up. I was as good as gone. I raced over to the yacht club to collect my traveling money. Uncle Ernie sifted through his loose change, and for all of my grunting and sweating he handed me twelve dollars, muttered something like "Good luck, kid," and gave me a pat on the back. I never had discussed the "terms" of my employment, stupidly leaving it entirely in his hands.

Served me right, I guess, but I was bitterly disappointed to be hornswoggled by my very own uncle. He more than made it up years later, but I never ceased reminding him of his miserly manner.

Larry and his spotted hound picked me up at Manga's minutes after the mailman had finally delivered the Mickey Mouse envelope. In it was a form letter of regret that my application had not been accepted.

As we sped across the Aurora Bridge and headed south, I was not a very jolly passenger. Considering how long it took them to reply, they obviously had a tough time making up their minds. When I meet them in person, they'll realize their mistake. Good thing I decided to leave the university and devote my entire time and talents to the Disney organization. They aren't aware of it at the moment, but they *need* me, by God!

"Step on the gas, Larry!"

Hollywood, 1938-1942

The Mouse Factory

As soon as I arrived in Los Angeles, I telephoned my Dad's older brother, Albert Ravenswood Ketcham, Jr., who was gainfully employed as a producer at CBS radio in Hollywood. Dear Manga had written her son the week before to inform him of my arrival, asking him to take me in for a few days until I secured my job at Walt Disney Studios. (I didn't have the heart to tell her about the letter.)

Uncle Al and Aunt Peg lived in a neat three-bedroom cottage in Westwood and couldn't have been more hospitable. Their two young sons, Al III and Dick, were fun to be around, and they all seemed to enjoy showing off their orange-blossomed, palm-treed territory to Cousin Henry. Even Clancy, their Irish Setter, adopted me after a short woof and a perfunctory sniff. This was the closest to a real family I had been since Mother died. It was a delicious feeling of comfort, security, and bubbling good humor, and I secretly hoped that time would stand still for a while and let me soak it all in.

But first things first; my priority was to let the folks at Disney's know that I was now in town and anxious to discuss what position I was best suited for. The California Ketchams were pleased that I had definite plans for employment and expressed hope that I could at least stay on for a few days' visit. After all, the last time we were together was in Seattle nearly two years ago and Dick was just a baby.

Early the next morning Uncle Al dropped me off in Hollywood, and I took a bus out to Disney's Hyperion Boulevard studio and marched straight into the Personnel Office, which was housed in a dinky wooden shack across the street from the main cluster of buildings. I asked to see the employment director, but was told that he was not taking interviews. I explained that I had just come down from Seattle, expressly to study the art of animation at the feet of the

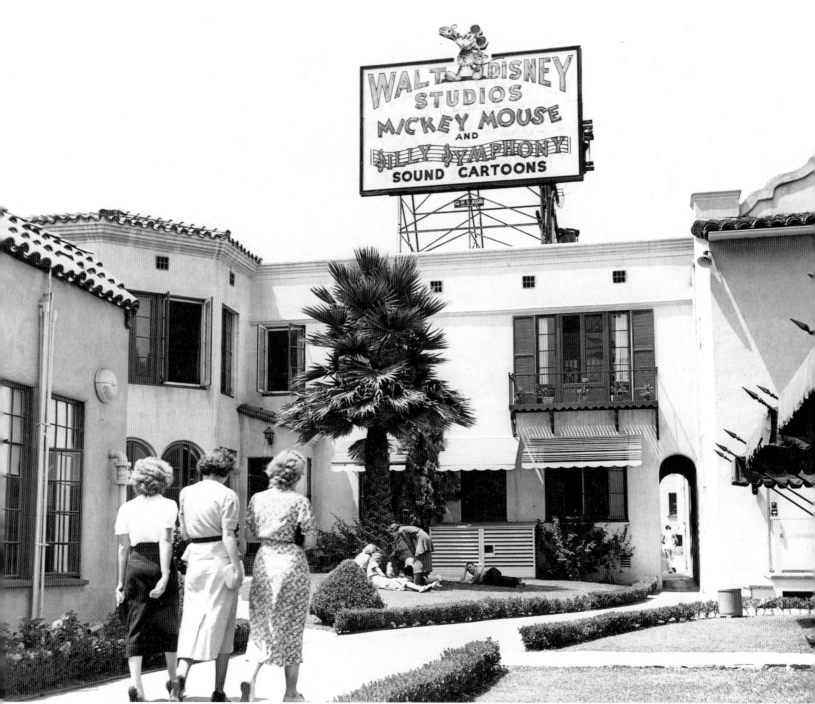

34

world's greatest talent, the almighty Walt, and could I then at least have an appointment for a more appropriate time? This young lady was a tough cookie, and the bottom line was "No way, Jose." I slumped back to CBS and sang the blues to Uncle Al. He was an upbeat guy, a very positive person, and he liked to label his friends with funny names. He called me "Henley."

"Henley, old boy, cheer up," he chirped. "This is merely the first of a bunch of rejection slips you'll have in your life, so don't let it get you down, kid."

Help Wanted sections were practically nonexistent in 1938. But we pored through the newspapers every evening and made plans for the following day when Uncle Al would drive me to the bus stop near CBS and I would chug into L.A. to scout for a job —*any* old job. Days turned into weeks. I

HIP HIP HOORAY! COUSIN HENRY FOUND A JOB TODAY AND HE'S GOING TO MOVE AWAY....

tried to look at the bright side, but I could never find it. There was very little wind left in my sails. Were the years I spent as a cheerleader all for naught? It was downright discouraging and tiring, and the $30 I turned over to Aunt Peg to help defray food expenses barely paid for the mountain of mashed potatoes I devoured in the first two weeks of my visitation.

"Why don't you get into air conditioning, Henley? There are schools everywhere. That's where the future lies," suggested Uncle Al as we drove into the brilliant sunset after another exhausting day of strikeouts. By this time I was certainly excess baggage at the Ketcham household and couldn't blame Uncle Al for trying to get me thinking along more practical lines.

Mercifully, the following week I stumbled onto an offer at Art Service, Inc., a small group of artists and designers whose clients were advertising agencies in downtown Los Angeles. They needed someone to organize the stockroom, make deliveries, and sweep out the joint. I was stunned, almost giddy, and instantly accepted the twelve dollar per week assignment.

Even more joyous were Uncle Al and Aunt Peg, who instantly spread out the Classified Section and in nothing flat had circled a room & board establishment on Magnolia Boulevard.

There was an unusual amount of good cheer and celebration that evening, but I felt a bit queasy knowing that I was about to enter the real world with nobody to hang onto. It was almost the same sensation I had on my first day at school.

The Road to Hollywood

Seventh & Olive Street was a far cry from my dreams of Mickey Mouse and Donald

Duck, but I was encouraged by my sudden independence and thankful even to be involved on the periphery of creative art.

My weekly salary, a welcome twelve dollars, left precious little to squander. However, room and board was only going to set me back six bucks, which included a lunch bag and a bicycle loaner, so I still had funds for cigarettes, cokes, and maybe a movie. I don't remember how I handled the laundry, phone calls, shaving cream, or toothpaste. I probably just remained dirty and lonesome.

My education now centered on the city streets, the particular smells and sounds and the parade of odd-looking people dashing around or hanging out. Clem, a highly strung fellow from Minneapolis who shared my room and bath, was recently separated from his wife, and on weekends he would invite me along for company as he cruised by her apartment to see if she was entertaining a boyfriend. I would stay in the car and chew my nails while Clem sneaked through the bushes for a closer peek, always toting a loaded pistol—a situation I found most unnerving.

After Clem had settled down and stashed the Saturday Night Special in the glove compartment, we usually drove around MacArthur Park and stopped to pick up a jug of nineteen-cent sauterne, a couple of six-cent hot dogs slathered with free mustard and relish, then stretched out in the Chevy Coupe and munched and sipped the evening away. Very little culture acquired there.

Once I left the support system of Aunt Peg and Uncle Al and began to make my own waves, develop tentative friendships with total strangers, and come to my own conclusions at every crossroad, I was stricken with a bad case of the lonesomes,

my self-confidence wobbled, and I longed desperately for familiar faces and stronger shoulders to lean on.

At the first opportunity to take a few days off (it must have been around the Christmas holidays), I packed a small suitcase, polished my thumb, and headed north on Highway 101, sporting my high school letter sweater, saddle shoes, crew cut, and a big smile. Seattle was a mere 1,300 miles away.

In those gloriously simple times, almost everyone was friendly and helpful, and I experienced very little worry or hardship during my nonstop trek to the tall timberland. The truckdrivers were pure gold, wanting nothing more for their kindness than your company, someone to keep them from getting too drowsy during the long, boring stretches over mountain passes.

During the Depression, hitchhiking was, for many, the only way to get from here to there. It was cheap, healthy, safe, and you usually met some great characters along the way. Alas, that has all since changed, and I would never recommend this form of transport to anyone. Today, when you hoist a thumb, someone gives you the finger.

As I was getting ready to leave the northwest once more, I remembered hearing earlier that a Queen Anne grad, Vernon Witt, was in Hollywood working for the Walt Lantz Animation Studio at Universal. I don't know why this sudden brainstorm hadn't struck earlier, but I quickly got him on the phone and laid on the Seattle native stuff pretty thick—one Grizzly to another.

He sounded pleased to hear from a former neighbor, and when I blurted out my hope of getting a start in animation, he asked me to drop by the Inbetween Department the next day for an interview—and to bring along samples of my work! Samples? The only samples of my work were pasted in a scrapbook at Grandma's. What to do? Well, whatever it would be, I had to hustle down to an art store for supplies. In twenty-four hours I would be showing my stuff to Mr. Witt.

Clem was scanning the Want Ads when I returned to the room with illustration board and a sack containing a pencil and eraser, a croquill pen, and a bottle of India ink. Then it struck me—a newspaper, of course! I tore out a couple of feature articles and worked far into the night. By nine o'clock the next morning I had phoned in "sick" and was rattling through Cahuenga Pass on the big red streetcar, wearing my only suit, and proudly clutching two freshly minted samples of my work on which the ink was barely dry.

The Inbetween Department, where Vern

Witt worked, was situated in a high-ceilinged, windowless room in which the artists sat in the dark at animation desks, bathed only in the light shining from beneath their glass-covered drawing tables.

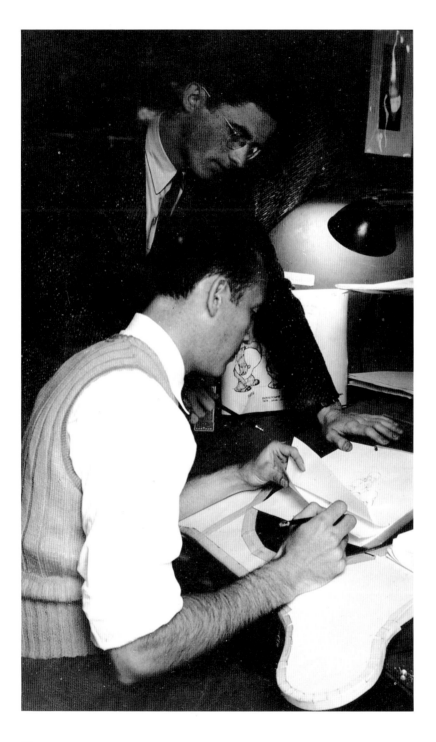

It was dank and eerie and blue with cigarette smoke, but I was fascinated.

Witt made a cursory inspection of the sketches I had sweated over the night before, ignoring the splotches of perspiration, and smiled. "Could you start Monday morning, Hank?"

Ka-boom-ka-boom! There went the old ticker again. "Sure! You bet—sir," I stammered, with nary a thought of giving suitable notice to my current employer, nor to my landlady, or to the immediate need of finding another pad closer to my new job.

Vern put a friendly hand on my shoulder and apologized that Lantz had him on a very tight budget and the job only paid sixteen dollars a week.

A thirty percent raise overnight! Bingo! Hollywood here I come!

Walt Lantz Studios

The "inbetweener" holds the bottom rung job in the animation business. He is responsible for supplying the many added drawings that result in smooth and fluid motion. Let's say the scene is supposed to show a baseball player swinging his bat at a pitched ball and missing it. It has been timed by the director to require about thirty drawings. He positions the character on a layout sheet and hands it over to the animator who develops the key poses, sometimes called "extremes." He would probably produce drawings 1, 6, 10, 14, 15, 16, 20, 25, and 30. His assistant would then supply "breakdowns," the action drawn between each key pose, which might be drawings 3, 8, 12, 18, and 23. The inbetweener takes it from there and completes the scene with the missing numbers.

It sounds more tedious and complicated than it really is. In order to guide a pencil

between the lines of two other drawings, you slip the thumb and two fingers of your left hand between three sheets of paper in sort of a chopstick grip, enabling you to flip the pages to see the action. Inbetweeners always labor in a darkened room, using a light beneath the glass drawing board to better delineate the sometimes delicate pencil lines they must draw between.

In the Black Hole at Lantz there were eight of us paper flippers making all kinds of raucous noises and telling outrageous jokes—anything to fend off boredom. Understandably, the room was off limits to the girls in Ink & Paint. My years spent at the First Methodist Church and at the YMCA hadn't prepared me for these new sights and sounds. I observed in wide-eyed wonderment.

Jolly Tolly Kerchonoff and Wild Jimmy Petch were among the inmates of this dark den of inbetweeners, as were Tom Barnes, Ben Duer, Dick Kinney, Fred Rice, and Spider Brown, a stoop-shouldered string bean who shuffled through life wearing a long, moth-eaten cloth coat that hung almost to the floor. This amiable, bespectacled individualist spent his evenings listening to classical records as he painted in oil by the light of a single bulb hanging from the ceiling of his dingy one-room pad. A George Price *New Yorker* cartoon come to life!

Spider was granted a one-year art scholarship at UCLA on the basis of his pencil study "The Crucifix," which was drawn on a large piece of butcher paper. At Christmas, Walt Lantz gave Spider a new overcoat, which he gratefully wore, ignoring the balmy and often suffocating climate of southern California.

The Hollywood Art Center School on Highland Avenue featured a course in "Cartooning and Pre-Animation" and was looking for instructors for the evening classes. Vern Witt was asked to make some recommendations. I guess the fee was too insignificant for others, so I became the new faculty member even though I had been in animation only four months! But, three bucks a night, twice a week, added some much-needed extra padding to my skinny financial cushion. Although I was able to answer questions and demonstrate basic fundamentals, I thought it a bit cheeky to pass me off as an expert.

Another moonlighting opportunity blossomed about once a month when a Universal feature movie needed some "voice over" additions and the director would call the Lantz studio for a few volunteers. These were situations where the sound of crowds or incidental conversations or the cries of London youngsters hawking newspapers would be added to the track for realism. Two dollars an hour was the reward for simply opening our yaps.

The joys of working on the lot of a major studio were endless. The hustle and bustle of the costumed extras hurrying to the sound stages and the daily invasion of construction crews, painters, electricians, and sound engineers hurriedly putting together new sets kept the decibel and excitement levels at the top of the meter. There were W. C. Fields and Edgar Bergen strolling down the alley between the rows of huge auditoriumlike buildings, and coming out of the commissary was Louis Armstrong and some of his sidemen on their way to the *Pennies from Heaven* stage to shoot another sequence with Bing. Universal had built two attractive dressing room-cottages for their new superstars-to-be, Deanna Durbin and a young lady by the name of Judy Garland, if I remember correctly.

When the spirit moved, it was a treat to

TUITIONS

Payable in advance

DAY CLASSES, two 3-hour periods a week

5 Months	$ 95.00
10 Months	180.00
Registration fee	5.00

EVENING CLASSES, two 2-hour periods a week

5 Months	$ 75.00
10 Months	140.00
Registration fee	3.00

NOTE:—When the above tuitions are paid in advance the school will furnish free drawing materials, use of equipment and free locker.

SATURDAY MORNING Classes, 9 to 12 A. M.

5 Months (20 weeks)$60.00

Students may select any of the subjects taught in these classes under Mr. Lovins, Mr. Duer or Mr. Witt.

*Terms may be arranged at slightly higher rates. The semester is based on 20 weeks or 5 months. No refunds will be made of tuition or registration fees. Absence from class cannot be excused.

HOLIDAYS

No classes will be in session on the following holidays: Thanksgiving Day, Christmas and New Year's Week, Washington's Birthday, Easter Week, Decoration Day, and the Fourth of July.

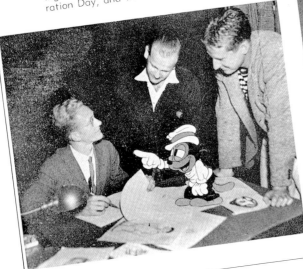

CHARACTER INVENTION

1 The use of the model.

2 Basic formations.

3 Expressions

4 Exaggerated action

5 Timing in relation to action.

6 Violent expressions, takes, etc.

7 Roughing action.

8 Study of simple actions.

9 Special effects

10 Personal tests.

11 The layout.

12 Inking.

13 Painting.

14 Backgrounds

15 Camera.

16 Test.

17 Finished projects.

This study includes the animation of people, animals, birds, reptiles, fish and other living things.

Classes are conducted in small groups to insure individual instruction and rapid progress.

TELEPHONES
HE-4067 Day
HE-4801 Evening
FOR INTERVIEWS

A fuzzy eighteen-year-old on the Universal back lot imagines that he's in Europe. Notice how neat his shirt looks tied down in front with a rubber band.

take a short lunch-hour walk around the back lot with a brown bag and a sketchpad. Only a few hundred yards beyond the studio buildings we would saunter onto a cobblestone courtyard in a French village then turn the corner and, bang, we'd be standing on Main Street in a typical western frontier town. A New York tenement district was a permanent set, as was a midtown Chicago street in the thirties, while a Mississippi River plantation was nestled among the lush willows and cried out for some banjo pickin' and a mess of mint juleps!

And all of this without a credit card or passport. If they could see me now!

Pop Foster and his wife ran the bar, restaurant, and gas station directly across the street from the Universal Main Gate. Foster's was a major hangout for the single strays and a paycheck-cashing center for those who subsisted on Pop's credit. But before I set foot in the door, my fellow in-betweeners dressed me in a large overcoat and a hat that almost covered my ears, trusting that Pop wouldn't mistake me for a minor. It got rather stuffy, but by summer I was an accepted habitue, hyponotized by the wild tales and goggle-eyed at the parade of characters who kept the barstools warm.

A bunch of stunt men once paid a visit after a long, hot day of shooting on the Universal back lot. As the supply of whiskey dwindled, the joint was livened up by outlandish bets made by those fearless idiots who gained their living by taunting disaster.

"Walk on the ceiling? Child's play!" laughed one of the bombed bravados. With one sweep of his arm he cleared the bar of glasses and ash trays, did a nimble handstand and walked its length, leaving his boot prints overhead and his keys and loose change on the floor.

Then came the thunderous belching of motorcycles as the uninhibited clowns began to race in the parking lot, roaring around the gasoline pumps, doing "wheelies" and figure eights, and, to the cheers of the exuberant drinkers, they varoomed right through the door and into the bar. It was enough to drive a man to drink. Pop Foster surveyed the damage with white lips and closed early that night.

Determined to bring some order into my life, I started a daily log of expenditures. Looking at those entries today, I find it hard to believe: "cigs 13 cents, gas $1.00 (13 cents a gal), dinner at Barney's Beanery 85

cents, borrowed 50 cents from Ben, haircut 75 cents...." The raise to $20 a week put me on Easy Street for a while.

Max Fleischer was starting *Gulliver's Travels,* an ambitious, full-length animated feature and, if you were interested in moving to Florida, they were offering inbetweeners $85 to $100 per week. A few were tempted and packed their bags, but I passed, hoping to find an opening soon at Disney.

Mrs. Brown's boardinghouse was well situated on Laurel Avenue, a few yards

The young customer tries to look casual and legitimate at Pop Foster's Bar & Restaurant.

from Sunset Boulevard and Schwab's Drugstore, a hangout of movie celebrities, and a nine-iron shot from the Garden of Allah, a cluster of small, chic hotel-bungalows, the scene of intimate intrigue involving Big Names in the celluloid set. The food was great, the rooms neat as a pin, the occupants full of good humor—and a cute little blonde lived next door. I threw away my bicycle clip and, with the kind assistance of the Bank of America, acquired a 1929 Model A Ford roadster. This $110 beauty was topless and in need of sprucing up, but T-shirts slipped over the seats kept the springs in place, and a new, white steering wheel added all the class I needed. Perhaps not an embarrassment of riches—but certainly high cotton!

Happy Days Are Here Again!

Hollywood, 1938–1941

Mary Brown epitomized the perfect mother image (or grandmother, depending on your age). A natural for a Norman Rockwell cover, she was blessed with apple-red cheeks, twinkling eyes, and her snow white hair was held in place with a blue ribbon. She adored young people and was always rarin' to go. Mary also knew how to discipline and seriously frowned on any breach of good conduct. My favorite housemother. Her husband had been the YMCA director in Peoria, Illinois, and when he died she moved out to California with her three children and established a boardinghouse that attracted some interesting occupants. John was a 250-pound one-legged CPA, Carl was a high-strung transplant from New York working at the Bank of America, Mae was Orson Welles's secretary, and Mrs. West was a blind lady.

Two vacancies in the house were

No blues in the boardinghouse while Hank, Hugh, and Betty make like the Andrews Sisters and Paul caresses mellow tones from his sax.

quickly filled by Paul and Bob Longenecker, brothers who had just arrived from Lititz, heartland of the Pennsylvania Dutch. Bob already had a position with CBS as a junior producer and could afford the luxury of private quarters. So this boy wonder, destined for greater things, soon moved into the high-rent district, married actress Ruth Hussy, and is now living happily ever after, father of three boys and one of Hollywood's more prosperous talent agents.

Paul and I became the best of roommates and kept each other out of serious trouble for more than two years. With "a little help from a friend," he became an usher at CBS, and I was always Johnny-

on-the-spot to assist him in putting up the seats. In the process, I would be on hand to watch Burns & Allen, Al Jolson, Bing Crosby, and many others perform in front of the microphone. One evening I watched Eddie Cantor introduce a young Dinah Shore to his vast national audience. On that same program he also launched the career of a youthful announcer from peachtree country: Bert Parks—of special significance to every Miss America since.

This was the era of the Big Bands, and they all played at least once a year in Los Angeles. Charlie Barnett was booked at the Palomar Ballroom, an ancient establishment just east of Hollywood so, one Sunday evening, Paul and I hopped into my topless marvel and joined the stag line.

During intermission a magician entertained some two thousand dancers gathered around the bandstand. In the middle of his act, someone noticed a slight flickering in the cloth bunting overhead. Then, as flames suddenly took over, we all saw it. The cool magician immediately quieted the crowd and calmly suggested that everyone stroll outside—firemen had been called, and our hats and coats could be claimed later.

The crowd gave an impressive performance, with nary a sign of panic or hysteria —except perhaps for our Man of Magic who was having difficulty gathering up his scarves, rings, pigeons, and bunny rabbits. I grabbed Paul's arm.

"My God! Look at the bandstand!"

There were no flames, but the intense heat generated from above was melting the instruments. Paul was an excellent saxophone/clarinet player, and the sight nearly brought tears to his eyes.

"Let's go!" he yelled, and we scurried to the rescue—only to be confronted by three men swinging clubs at anyone attempting to get near the stage. We watched dumbstruck as the floor became a brass puddle and $25,000 worth of handwritten arrangements on the music racks went up in smoke. By 4:00 A.M. the old Palomar was a smoldering dump of charcoal.

Well, so much for our hats and coats.

The Pasadena Auditorium filled the jitterbug vacuum on weekends when they booked some outstanding musicians. In what seemed like a few short months, the Palladium, a magnificent state-of-the-art dance pavilion, was constructed next to the new CBS Radio Center on Sunset Boulevard and soon became a swinging scene, opening with Glenn Miller, followed by Benny Goodman, and then one fabulous dance band after the other.

Stan Kenton was a regular at Newport Beach, Freddy Martin a fixture at the Coconut Grove, and Culver City featured Duke Ellington and Jimmy Lunceford annually. There was a quiet night-spot at the west end of La Brea where I visited to hear Art Tatum's delightful ramblings over the black and white keys, and at the corner of Hollywood and Vine you could sit at the bar in the bowling alley, order a ten-cent beer, and be hypnotized by the King Cole Trio, just twenty feet away. The Santa Monica Cafe, where you could just drop in for a nightcap, offered the nonstop jazz of Wingy Manone and other itinerant practitioners.

In those glorious days, Southern California smelled good and sounded good.

Mary Brown's eldest son, Fred, was a makeup man for Max Factor and often involved in preparing clients for publicity stills. We all nearly fell apart one evening when Fred imitated a typical studio photographer trying his utmost to "bring out the sexy look" in portraits of various leading actresses. It was a wild display of pelvic propulsion and suggestive rhetoric. But amusing cornography.

Mrs. West, a marvelous woman in her late sixties, seldom joined the wild ones at the big groaning board, but was seated at her small private table in the corner of the room. She was the kind of person whose mere presence added warmth and good humor. Paul and I spent many pleasant hours in her room listening to recordings of dramatic readings and discussing our dreams and plans for the future—a rather high-class bull session that we all seemed to enjoy. I was especially intrigued with Mrs. West's extensive library, as I had never seen anything like it. Every book was in Braille. I ran my fingers across the covers—and silently counted my blessings.

On occasion, many of us would have no weekend plans, so during dinner on Friday we'd discuss potential group activities. Invariably we'd decide to drive to Las Vegas that same evening, across 300 miles of sand and sagebrush in Mary's wheezing Pontiac. But the clear desert air and vast horizon was always envigorating tonic, and our sleepless night seemed worthwhile. Motels with swimming pools charged about $4.00 a person, a horse could be rented for a dollar a day, and the evenings were spent playing nickel slots, two-bit roulette, or blackjack. I haven't been back to Las Vegas since, although I understand they've paved the roads and built some fancy hotels. But it'll never be the same. Mark my word.

This warm souvenir was a gift from my old employer following a recent reunion in North Hollywood.

WE SURE GOT IT MADE WOODY, WITH KETCHAM AND LANTZ

YEAH, DENNIS. WITHOUT US THEY'RE NOTHING

Walter Lantz

I had spent fourteen delightful months with Walt Lantz, learning the wondrous art of animated cartoons and what "makes 'em move"—drawing more Andy Pandas, rabbits, squirrels, and monkeys than I care to remember. Now I felt ready for the Big Time and made an appointment to see the personnel director at Disney.

Whistling with confidence, I arrived at the Vine Street office of Walt Disney Productions. The smiling receptionist motioned me to be seated and took my small portfolio of samples into the next room. I'm more than a year late getting here, I thought, but at least I am better qualified after my recent promotion to "assistant animator" and working with the likes of Gerry Geronimi and Laverne Harding. I lit a cigarette and reached for the *Wall Street Journal.*

I had barely settled into the chair when the girl returned with my drawings.

"I'm sorry," she said, still smiling, "but we have nothing for you at the moment."

Stunned is hardly the word. I was numb and speechless at this brusque turndown. I knew they were shorthanded and looking desperately for help.

She led me to the door. "In fact," she continued, "Mr. Drake suggests that you not waste your time trying to break into the animation business, that you should look around for another kind of job."

Discouraged I was not. I was livid with rage and disbelief. Drake? Probably a close relative of Donald Duck!

I kicked the wheels of my car, gnashed my teeth, and sulked for three weeks. Then, lo and behold, Johnny Bond, Disney's Man About the Studio, the little guy who knew where all the bones were buried, called me to the phone one afternoon in the late fall of 1939. Would I be interested in helping to finish up *Pinocchio?* It was "just a tem-

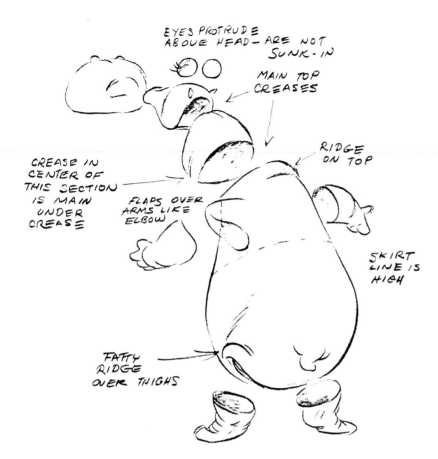

EYES PROTRUDE ABOVE HEAD — ARE NOT SUNK-IN

MAIN TOP CREASES

CREASE IN CENTER OF THIS SECTION IS MAIN UNDER CREASE

FLAPS OVER ARMS LIKE ELBOW

RIDGE ON TOP

SKIRT LINE IS HIGH

FATTY RIDGE OVER THIGHS

Above: *How to assemble a hippopotamus. A surgeon's-eye view of a Fantasia model sheet from Ponchielli's "The Dance of the Hours."*

Weird illusions were common after working on Fantasia for so many months.

our culture, and *Snow White* was setting worldwise attendance records. As demand for Disney's products soared, so did his needs for additional talent and space.

Based on this mind-boggling track record and a meteoric profit projection, the Bank of America came to the rescue and underwrote the construction of a large, modern, efficient production facility out in Burbank, a half-mile away from the Warner Brothers lot. The move from Hyperion was made three months after I arrived, and it turned out to have been a real case of bad timing.

Acceptance of Disney films in those days was so universal that fifty percent of the company's income was derived from the European market. When Hitler marched into Poland, this revenue source dwindled to a trickle. Bank commitments and increasing production costs plunged Disney to the brink of bankruptcy. The friendly B.

porary job," starting at $25 a week! YAHOOOOOOO!

I apologized to my wheels, had my teeth cleaned, and wore a broad smile that lasted through *Pinocchio, Bambi, Wind in the Willows, Fantasia,* and dozens of Donald Duck shorts.

The original old Disney Studio out on Hyperion Boulevard was an informal, haphazard, jerry-built assortment of wooden boxes, but it housed some of the most creative and happy innovators in the entertainment business. Each time a new picture was released, Walt would tack on another wing. "Mickey Mouse" was already part of

OH Boy!
dis is da life;
Huh, Pinokey?!

A Walt Kelly classic portrays animator Ward Kimball as Lampwick and Freddy Moore as the naive Pinocchio. (From the Kimball Collection)

Opposite: *My boss, animator Bernie Wolf, picking on me again.*

of A., however, simply enlarged their contribution and assumed ownership of the Mouse Factory. But their bet was cleverly hedged: this new air-conditioned studio was a six-story, eight-wing affair that could be converted into a hospital overnight.

The Mouse Factory, 1939

They moved me into the animation unit headed by Ward Kimball and Fred Moore, where I alternated as an assistant to Bernie Wolf, doing inbetweens and pencil clean-ups, and similarly helped David Swift (later to become a top storyman and the creator of an early TV smash hit, *Mister Peepers*) and Walt Kelly (the genius from Bridgeport, the creator of the comic-strip classic *Pogo,* the ever-lovin' 'possum of Okefenokee Swamp).

Animation would begin with a batch of rough pencil drawings that were photographed. After an examination of the test film, which was made overnight, correc-

"I DON'T WANNA STRAIN MY SELF"

"LISTEN — I'M IN SWELL SHAPE"!

"YES! I'M QUITE A HAND WITH THE WOMEN!"

tions were inserted and the scene was "cleaned up," meaning that the loose sketching was reduced to single lines, easily traced onto cels by the young ladies in the Ink & Paint Department. (Today, few studios shoot tests or take the trouble to make refinements or corrections on the same scale that was standard then. Time and money are of prime concern. The expensive and tedious chore of inking has all but been eliminated by a Xerox process that transfers tight pencil drawings onto the celluloid. Disney first used this technique successfully in *101 Dalmatians,* where it gave the picture a soft look.)

When *Pinocchio* was finally "in the can," as the expression goes, and all energies were focused on *Fantasia,* there were twelve hundred employees, most of them young, eager, and gung ho. The campus atmosphere was laid-back, relaxed, and everyone seemed to be enjoying a daily picnic, joking, laughing, singing, and drawing caricatures of each other. During frequent breaks, Ward Kimball and Clark Mallory would magically produce a trombone and a clarinet and jump into "Royal Garden Blues," "Lazy River," and other Dixie gems, while Tom Oreb, Bud Swift, Walt Kelly, and I thumped on wastebaskets and film cans. Those were boisterous Burbank matinees—a joyful, foot-stomping memory. A few years later animator Frank Thomas sat in on the Steinway, Harper Goff brought in a tuba, and other artists joined the group, which quickly gained national attention as The Firehouse Five Plus Two.

A Glimpse of His Majesty

We minions toiling in the corporate boondocks had precious few opportunities to even see the boss, let alone chat with him.

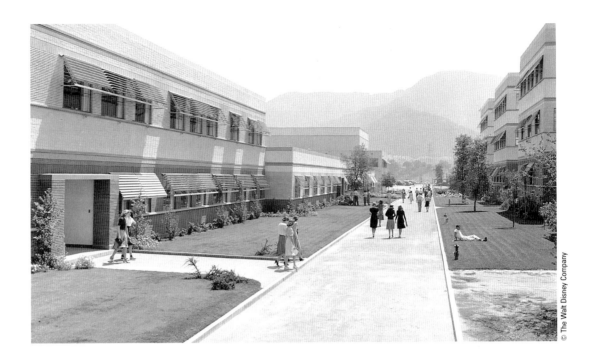

A 1940 view of the new Disney Studio at Burbank and one of the street signs below.

His path, understandably, crossed mostly with those who faced daily creative decisions.

I was briefly introduced to him at the Penthouse Club one noon when I was a guest of animator Don Towsley. Once when Walt and I rode alone in the elevator, I remember that by the time I thought of a clever opening line we had reached the top floor. Occasionally I would see him in the hallways when he had buttonholed a story director or a key animator for an impromptu conference.

Brother Ray Disney, however, maintained a high profile, as all successful insurance salesmen should, and he spent most of his time popping in and out of rooms around the studio, peddling his assortment of programs. But when the company went public, offering five million shares of common stock at $25, Roy, the

business brother, was at our elbow to take the order. I bought one share. A year later, for some unfathomable reason, the company wanted to buy back all of the shares for the same price. The war was heating up in Europe and the outlook didn't appear too rosy, so, what the hell, I dumped my modest investment. I reckon that, had I been allowed to hang onto that single share of Disney common, it would be worth today, after all the change of managements, splits, and accumulated dividends, $5,473,288.97. More or less.

Several years later when I was stationed in our nation's capital, wearing bell-bottom trousers and a funny little white hat, I received a nice personal note from Walt, congratulating me on the work I was doing at the Navy Department and for my cartoons, which were starting to appear in the magazines. He wished me luck and looked forward to the day when all of us would be back at the Burbank studios.

If I have a regret, it is that I did not have the opportunity to become more involved with that moustachioed mother hen, the courageous coach who handpicked his international All-Star Team, the likes of which will never again be seen. Together, they created a benchmark against which all animation is measured today.

The spacious Disney restaurant and cafeteria, at the intersection of Mickey Mouse Avenue and Donald Duck Boulevard, featured standard items such as Stromboli sandwiches, Snow White salads, Goofy meatballs, and a hot plate Jiminy Cricket. (Even then it sounded too cute.) For the Upper Echelon, Walt offered a Penthouse Club, an attractive first-class establishment featuring an intimate bar & grill seating about twenty and a small gym with sauna and showers.

At the old Hyperion studio, Mary Flanigan had served coffee, doughnuts, and moist sandwiches from a cramped cubbyhole on the rickety second floor. When we moved to Burbank, she was awarded the pole position, smack in the middle of the first floor main corridor, with a state-of-the-art coffee shop offering electric mixers, refrigeration, counters, stools, and everything a snacking artist could hope for. We could dial her number at any hour and request room service from a large list of tasty munchers and quenchers. Credit was automatic, and there was *no tipping allowed!*

The Traffic Department consisted of messenger boys, eager young go-fers at your beck and call to make deliveries and pick-ups within the studio. They were also useful for carting milkshakes and other Flanigan delights right to your room. Story talents Vip Partch and Dick Shaw began their career in "traffic."

"Informality" is the word to describe the pace and ambiance, and you could stretch the "lunch hour" to include two Ping-Pong games and several innings of softball before going back to the old drawing board. It was like a small college campus to most of

The always cheerful Mary Flanigan ran a cramped but cozy coffee shop in the old Hyperion mousequarters.

the twelve hundred young employees. Occasionally, some of us would drift off campus, and our lunch hour would stretch to ninety minutes or more. A wonder that much of anything was ever accomplished in those days. But many of us would enthusiastically work nights and on weekends, mesmerized by the lush Stokowski soundtracks of Beethoven, Puccini, and Stravinsky that permeated the hallways. The pay was lousy but we really cared.

Virgil Partch's self-portrait features an opium pipe— into which he stuffed Lucky Strikes.

Footnotes from the Disney Days

Being young and single when most of your friends are married is often awkward, and you find yourself cadging drinks, mooching meals, and hanging around like a fifth wheel—a pain, I am sure, to newlyweds aching for privacy. When Ginge and Dick Kinney spent their honeymoon in a tiny Hollywood hotel, there I was, like a lonesome Fido, curled up on the floor beside their bed.

I once parked for ten days with Helen and Vip Partch, two-year-old Nicky, and Ajax, a giant Great Dane. They lived in a typical North Hollywood crackerbox and were obviously of "the more the merrier" school. I have only hazy recollections of meals, but a vivid memory of a seemingly endless supply of liquids. Southern Comfort was coming into vogue, a taste treat to the gin-jaded palate, and there was always a can of beer to wash it down. Vodka in those days was considered "Commie booze" and was never much in evidence.

The Partches added some fresh new wrinkles to parenting. While Vip worked at the drawing board until late in the evening, Helen followed suit, washing, ironing, and vacuuming long after the neighbors had retired for the evening. Meanwhile, little

Nicky was kept amused in his playpen until they all finally went to bed, which was usually long after midnight. Not a soul stirred until noon. By the time Nick went outdoors to play, the other children were taking their naps; when they were ready to play, it was time for him to rest. The Partch lad remained out of sync until he entered the first grade.

Dick Shaw was another genuine original, and a regular contributor to the *Saturday Evening Post,* where he established his own brand of humor in complicated scenes of enormous catastrophe, like train wrecks, ship sinkings, and horrendous aircraft disasters.

Strangely, Dick and I first met at the YMCA camp on Orcas Island when I was twelve years old. Shaw would carry a tobacco pipe around in his pocket for shock value, and every day he drew a wild comic strip and posted it on the bulletin board outside the dining hall. Everybody read it, and I was so inspired that I followed suit with my own version, but I ran out of ideas after three days. Dick was a pro even then,

and we all looked up to him with awe and respect.

On some weekends, Partch and I would sit around at Shaw's and brainstorm gags for the magazine market. ("Gee," I kept thinking," just imagine being *paid* for drawing cartoons!") For instance, I would offer the "concept" of an idea, then Shaw would come up with a twist, then Partch would top us all with an even better version. Many outstanding gags were (and still are) developed in just this manner. We agreed that the credit would go to whoever made the initial pitch.

Virgil Franklin Partch (everyone called him Vip) was a fountain of hilarious, off-the-wall cartoons, strongly suggesting Picasso's outlandishly distorted graphics. But he was terribly shy, and the masterful thumbnail sketches he made during these sessions would wind up in the wastebasket.

Shaw and I couldn't stand it, so we recovered the bits and pieces, and his dear wife Katie ironed them back into shape. Dick then sent the batch to Gurney Williams, cartoon editor of *Collier's Magazine,* and the rest is history.

With his fantastic success at *Collier's*

"AND THAT, GENTLEMEN, IS HOW TO PULL THE PIN ON A HAND-GRENADE."

Two genuine, first-class characters, Virgil Partch and Richard Shaw.

ing thick blue lips, widely spaced teeth, and eyeglasses resembling the bottoms of Coke bottles. This Alaskan-born funny man was a soft-spoken basso profundo who laughed and snickered easily, smoked profusely (as did most of us then), and moved through life with the urgency of a sea turtle in a tub of molasses.

Down at the beach, when a bunch of us would be batting at a volleyball or a shuttle-cock, body surfing or playing catch, Himself remained comfortably on the sidelines, sip-ping beer and kibitzing. He was well-coor-dinated and had ample strength, it was just that those heavy spectacles would fall off with the slightest twitch. Without the cheaters, he was a candidate for the White Cane Club. If you lined him up for a 100 yard dash, it was doubtful that he would find the finish line.

The amount of time Helen and Vip spent together about equaled the time they spent apart. As it turned out, they were a perfect match and alternately saved each other's bacon. They were good for each other—but not always good *to* each other.

As with James Thurber before him, Vip's eyesight started to deteriorate badly. Al-though he had stopped driving altogether and had about given up trying to watch television, it didn't have much effect on his production at the drawing board. Yes, he did make larger originals and he cut down on extraneous detail, but he was two years ahead of deadline when, shortly after noon on 10 August 1984, their Chevy sedan smashed into the rear end of a stalled trailer rig and they died instantly.

I enjoyed them both immensely.

In October of 1941, the bubble burst. Art Babbit, John Hubley, Sam Cobean, and a

and then at *True,* Vip became the hottest cartoonist in the land. Eventually he tired of the insecurity of the free-lance market and signed with Publishers Syndicate to supply a daily newspaper panel and a Sunday page. They should have had the confidence to give Partch his head and let him run, maybe even calling the feature "VIP," but they didn't. They chickened out and told him to design a character, something they could merchandise, someone to whom the readers could relate. Virgil then came up with *Big George* and grudgingly produced it, with a bunch of pussyfooting editors looking over his shoulder. They surely did not get their money's worth, and the multi-tude of Partch fans felt cheated.

Vip had a solid two-hundred-pound body on a six-foot frame, a roundish face featur-

This is Dick Shaw's version of his friend Partch, a handicapped driver.

handful of dissident artists organized a group of unhappy employees and, with the gleeful assistance of the Teamsters Union, Disney was presented a list of grievances, demands for restitution, and an ultimatum. To no one's surprise, a general strike was called.

Most of the men in my unit were recently married, just starting a family, and scratching to make monthly mortgage payments, barely making ends meet. They had every reason to join the picket line at the gate.

To me, the Teamsters were a bunch of heavy-handed spoilsports interrupting my "life of Riley," but I could easily empathize with my older colleagues, so I became one of the marching sign-carriers. Although I

was young, single, with no heavy commitments, and didn't really need additional income, it was obvious that the Kansas City Mouseketeer had to loosen his purse strings or perish.

I shared living quarters at Manhattan Beach with Virginia and Richard Timothy Kinney (who also answered to the name of Potato Nose). His older brother, Jack, was one of Walt's top directors, so, not surprisingly, Dick stayed with the management. With a sad shake of his head and a snide sidelong glance, he would drop me off a block away from the studio, then proceed slowly through the ring of strikers parading around the entrance. I quietly checked in with the organizers.

© The Walt Disney Company

I declared myself a "Guild man" and joined the picket line. Bernie Wolf comments with the drawing below.

As serious as the issues were, it all struck me as infantile behavior. And the rantings of Teamster official Herb Sorrell, dramatically recounting his days on picket lines at the Ford Motor Company and telling about the clubs and lead pipes goon squads had used to make their point, upset my naive conception of fair play and good taste. Even the "soup kitchen," staffed by wives of the strikers seemed symbolic of the Depression and a step in the opposite direction from where I wanted to go.

After only a few days, I had had enough. I went back to work.

I scrunched myself down between Kinney and Al Bertino, two protective line backers, hoping to be invisible as the Mercury convertible eased through the

The animated sequence of Dennis below illustrates a series of "extremes." Additional drawings would be made (by an "inbetweener") between these key positions to give the illusion of smooth movement.

mass of chanting, wild-eyed revolutionaries. But they spotted me, and I instantly became King of the Finks and the target of other creative terms of outrage and venom. The loudest insults seemed to come from those whom I once considered very good pals. It was a shattering experience for

many; as in any civil war, the house was divided and close friendships evaporated. Years later the stigma remained, and all concerned were still labeled.

The years of innocence had ended, and with that a great deal of fun. We were now card-carrying members of the Screen Car-

toon Guild, Local 852, Brotherhood of Painters, Decorators and Paperhangers of America. A row of timeclocks was installed, the Penthouse Club folded, Mary Flanigan's room service was suspended, the Ping-Pong tables were put into storage, and Walt went into a seven-year snit, determined to bring the Teamsters Union to its knees. Bad vibes were all over the place.

Animation: *Giving Life To.*

As a youngster I sketched cartoons in a crude, primitive way that was still sufficiently amusing enough to draw polite attention and words of praise from my family and school chums. Apparently this was sufficient to assuage my teenage ego and to motivate my continuance of this inexpensive hobby. A buck fifty would buy enough supplies to last a month.

Aside from what was offered in the Seattle public school system, I had no serious art education and blithely stumbled along, drawing by the seat of my pants, as it were, not one bit concerned as to how the head bone was connected to the neck bone and totally oblivious to layout, color, and design. I chalk it all up to the natural laziness that comes with being a kid and having too much fun to care.

Later, after I became secure in my job at Disney, I finally had an "awakening" and became a serious student of the Wondrous World of Animation Magic into which I had plunged. I asked questions, listened attentively, and absorbed everything that was going on about me.

As an assistant animator, I dealt with scenes designed by the director and key drawings designed by my boss, the unit animator, so my function was more mechanical than creative. I would produce penciled "break-downs," drawings that further delineated the chain of action and that were inserted between the "extremes," or key drawings. I am often asked if I found it boring. Not in the least; I was intrigued with every detail.

Each sheet of the peg-holed animation paper was numbered to follow the Time Sheet, which indicated the precise musical beat and phonetic guides of dialogue from the sound track. When I had finished the scene, often no more than twenty or thirty drawings, I would turn it over to an "inbetweener" for completion and delivery to the girls at Ink & Paint.

The study of drapery and articles of clothing that stretch or drag as the body moves was of major importance, as was awareness of the "line of action." This points out the direction of energy, usually

related to the vertebrae and a limb or two, the power that fuels the movement. Although I was a skinny, nearsighted, chicken-hearted youth, I was a regular player in the nonbruising, non-bone-smashing sports and still have an understanding of how the body moves under stress and the importance of balance and weight transfer.

These physical insights have proved to be useful tools, obviating a ton of toil and frustration when I tackle design problems. I seem to "feel" the drawing as I skate pen over paper, and I work with a certain speed and confidence that must be traced to my salad days at the Mouse Factory.

When I am asked where I attended school, I invariably reply, "The University of Walt Disney."

On the Beach

Dick Kinney was a large, amiable Irishman who didn't seem to mind my tagging along, asking interminable questions about the animation business, or inviting myself to join his car pool. He was also a good audience, his laughter emerging as a high-pitched snicker, and he enjoyed keeping you a bit off balance with the unexpected remark.

Someone gave us a skeleton of an old sailing-boat hull, so Dick, fellow-inbetweener Bart Doe, and I spent long nights and weekends during the winter rebuilding this twenty-five-foot sloop in Bart's Burbank backyard—with stars in our eyes and visions of Tahiti and Dorothy Lamour in our heads. We actually put her into the water late in the summer of 1941 and spent four happy months before the mast cruising Los Angeles Harbor. Unfortunately, one day we discovered it stolen from its mooring. Dick

and I drove immediately to Harbor Island with blood in our eyes, to scour all dark nooks and crannies, searching in vain for the oak-planked object of our affection. In retrospect, we were lucky not to have come a cropper with some of the restless natives who inhabited that seamy side of town.

Dick and his bride, Virginia, found a house near the ocean at Manhattan Beach, so naturally I tagged along to help pay the rent, reduce the car-pool expense, and dry the dishes. I was assigned to the Murphy bed in the living room and often shared it with Jerry Payne or Bill McBurnie or other nice guys caught without a pad for the

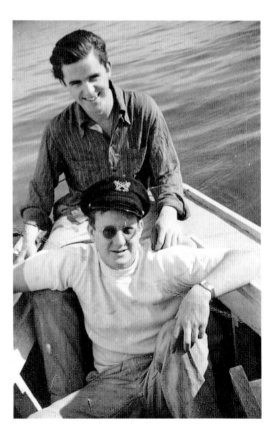

60

night. It was a rugged fifty-minute commute to Disney's through the oil rigs and rabbit warrens of Baldwin Hills, then into Hollywood and over Cahuenga, past the Warner Brothers lot, and over to Buena Vista and the Mouse Factory; however, the fresh salt air at the beach and the action in the bars of Redondo and Hermosa made it a good trade-off.

Early one morning we had the top down on the Mercury and were headed for Burbank when we came to one of those California four-way stops at a major intersection. It was a real traffic jam, with cars

inching their way into position to cross; by the time we arrived it was total gridlock. Whereupon a very frustrated Kinney hoisted his massive frame up onto the front seat, waited for the horns to subside, then shouted somewhat petulantly at the top of his lungs: "HEY, YOU GUYS, WE'RE SUPPOSED TO TAKE TURNS!"

About eleven o'clock one lazy Sunday morning, we were sitting on the beach watching yet another Japanese freighter take on a load of scrap iron at neighboring El Segundo, when we suddenly heard excitable babbling from someone carrying a portable radio a hundred yards or so down the beach.

"What's he talking about?"

"Damned if I know. Can you hear him, Jerry?"

"Yeah. The guy says the Japs have just bombed Pearl Harbor!"

"WHAT? Must be another one of those Orson Welles stunts."

"No! Now it's on all the other stations!"

A page was turned, and all of us solemnly began a new chapter.

The Draft Board Beckons

By the fall of 1941, the European conflict was going full tilt; my father had been on active Navy duty for a year, serving on the State Selective Service Board at Phoenix, and many of my older friends had already joined the Merchant Marine or had enlisted in the National Guard, successfully avoiding the Army Draft.

I had hay fever, bad eyes, skinny legs, and the thought of being a gun-toting doughboy gave me the creeps, so I hustled down to the Federal Office Building and applied for enlistment in the Navy.

All went smoothly until near the end of the physical exam. So that I could read the eye chart without squinting or making a mistake, I had to get within two feet of the chart. Normally they like to see you *twenty* feet away. The chief pharmacist's mate in charge suggested that I do without my glasses for a few days, take regular doses of carotene extract, and come back again. I repeated this routine so often with the same results that he gave me all the filled-out documents so that I could simply report directly to the eye specialist on my next visit.

In the meantime, I received a notice from my draft board to report for an Army physical. Government facilities were so crowded that they assigned conscriptees to private doctors for this preliminary exam. Everyone assured me that the Army only wanted a warm body, that I'd have no trouble passing the exam. They might even supply a seeing-eye dog.

I was depressed and must have looked like a lost soul when I ordered the beer. Bartenders all seem to have simple solutions to most complex problems, and this guy was no different.

"Look, kid," he muttered out of the corner of his mouth, "no reason for you to get hooked into that lousy outfit. Stall 'em until you can pass the Navy eye test."

I shrugged. "But what can I do? I report to this doc next week!"

He waved to a departing customer, stubbed out his cigarette, and leaned across the bar. "You like cucumbers?"

"Cucumbers?" I couldn't imagine what he had in mind. "No, not especially. Why?"

"Why? Because soon you're gonna belong to an elite group—the Cucumber Corps!" he rhapsodized.

I shook my head, swallowed hard, and shoved the empty glass forward. "I don't

"WHO THE HELL WRITES YOUR STUFF?"

follow. Another one, please."

"When's your physical?"

"Wednesday morning, 9:30."

"Okay, now listen to me: Tuesday don't eat nothin' but cucumbers. Cucumber salad, cucumber sandwiches, cucumber malts, cucumber soup—and in your martini guess what?"

"Don't tell me. C'mon what's the gag?"

He chuckled and lit up a smoke. "No gag. This is on the level. After that medicine man takes your blood pressure, there's no *way* he'll let you pass. The needle on his thingamajig will fly off the wall!"

The whole scenerio sounded so phony—so . . . so weasely. But, like I said, I wanted no part of Fort Dix. I slapped a dollar bill on the mahogany and slid off the stool. "Thanks, keep the change. Gotta run. See ya later."

I stumbled out of the dark hole and into the blinding Los Angeles sunshine, my head

throbbing with confusion. I resented the bartender and hated myself. Yet, I rationalized, it wasn't unpatriotic; I honestly *wanted* to join the Navy. Well . . . what the hell; why not!

The following Tuesday was Cucumber Day, and I gagged down as much of the stuff as I could swallow and went early to bed. I couldn't feel any difference. If my pump was working harder it was surely in anticipation of the morning's appointment.

"You've been taking good care of yourself, young man." The neighborhood medic peeled off his rubber glove and put his stethoscope on the table. "Get dressed and come into my office."

A tight elastic band cut off the circulation in my right arm, and now I carefully watched while he pumped the rubber ball and glanced casually at the stand of mercury. He stopped . . . took off his glasses and looked closely . . . pumped again . . . stopped . . . repeating three times, then slowly dismantled the apparatus, shook his head, and mumbled something about "diastolic pressure" and "endocrine glands."

"Do you have a history of heart trouble, son?"

"Why . . . er . . . no, sir. Except that it's always been on the high side," I answered in all honesty.

"*High* side?" he blurted. "Wonder you're still alive."

He scribbled some Latin notes on a prescription pad. "Take one of these pills after each meal and get plenty of rest. I'll see you next Wednesday, same time."

He patted my shoulder, went back to the examining room, and the nurse showed me to the door.

"What have I *done*?" I thought. Now I *could* feel the wild thumping in my chest. I crumpled the prescription slip and tossed it away, got into my car and drove home—sheepishly. A few days later I gave explicit instructions to the bartender as to what he could do with his cucumber.

Artful Draft Dodgery

In mid-December of 1941, Dad came over from Phoenix and spent a few days at the beach before we caught the "blacked out" train to Seattle. No one was sure about the position of those sneaky Japanese submarines, so the Western Military Command ordered "lights out" from Bellingham to San Diego.

As we rattled our way north, my incomplete physical examination papers were carefully tucked into my coat pocket with hopes that some Saint Nicholas would soon "sign and approve," relieving me of having to report back to the California Draft Board.

Two days before Christmas I was meandering through my old haunts in the center of town when I ran into my former geometry teacher, now Lt.(j.g.) Vernon B. Johnson, USNR, and resplendent in his new uniform.

"Well, Henry! How great to see you again. Is it true what I've heard that you're working for Walt Disney?"

"Yes—I mean, I was," I replied." They let some of us go, what with the draft and all, and. . . ."

"The draft? But aren't you joining the Navy? We need your special talents now more than ever."

I then explained my predicament and showed him the official documents. Mr. Johnson, or rather, Lieutenant Johnson, smiled and placed his friendly arm around my shoulders. "Follow me, Henry."

He steered me into the entrance of the

Federal Exchange Building, down a flight of steps, and through double doors marked "U.S. Navy—Medical Department."

"Hey, George!" he waved to an officer in the corridor. "You're just the guy I was looking for. Meet Henry Ketcham, one of my favorite former students at Queen Anne. Henry, this is Dr. Campion."

"Nice meeting you sir," I stammered, not quite understanding the significance.

My old "square of the hypotenuse" tutor quickly briefed the doctor, handed over the well-thumbed exam sheets, and we moved across the hall into a small office, closing the door behind us.

"These papers seem to be in good order." Dr. Campion rummaged through his desk drawer. "Odd that they didn't complete them."

"It was on account of my eyes, sir. They didn't think...."

He held a pencil-thin flashlight close to my nose. "Look up...now, down... close your left eye...the other... hmmmmmmmm." He pointed to a sheet of paper tacked on a door about fifteen feet away.

"Now take off your glasses and, without squinting, tell me what you can read on that chart."

"E," I responded with the utmost of confidence.

"I see no reason why you shouldn't be in the Navy," he said with a straight face. The good doctor signed, dated, and stamped the papers. We shook hands, and I floated

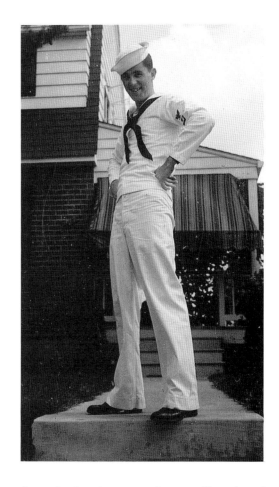

through the door wearing a silly grin of disbelief. That "E" was at least a foot tall.

On the morning of 2 January 1942, Henry King Ketcham was sworn in to the United States Naval Reserve as a photographer's mate third class.

Yes, Virginia, there *is* a Santa Claus.

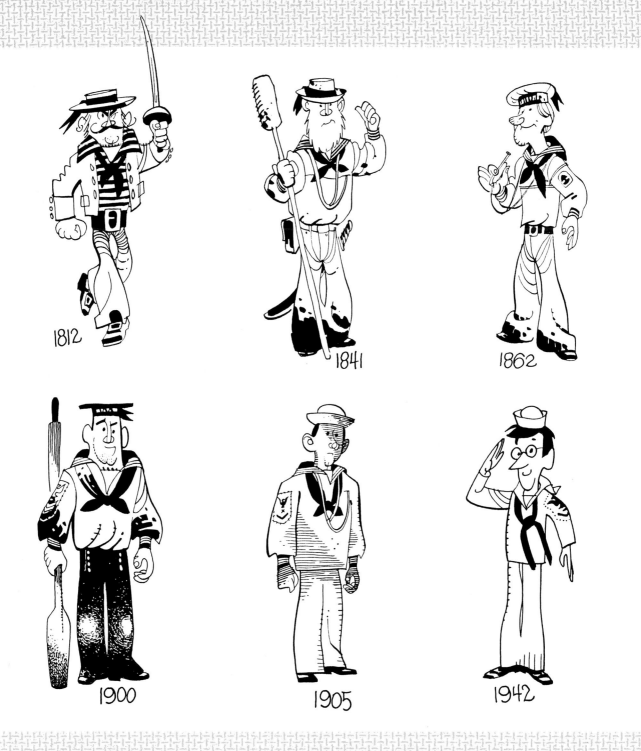

U.S. Navy, 1942-1946

The Cartoon Sailor

In the Navy, I discovered a completely new and expanded vocabulary, a language that all sailors understood and had spoken since the day they first put on their ill-fitting uniform. It consisted of short, terse-sounding words that could be used as nouns, verbs, and/or colorful adjectives. They were easily remembered and made you feel like "one of the boys." However, once you left the plantation and began mixing with the civilian world, caution was advisable. I quickly discovered that, after weeks of constant usage, it was an extremely difficult task to come to conversational grips with society.

On my first Liberty weekend, I invited a buddy to join me for one of Grandma Ketcham's sumptuous dinners. She had a flock of culinary tricks up her sleeve, loved all the fuss, and was dying to spoil her grandson again. After our steady diet of uninspired chow at the Bremerton Navy Yard's groaning board, Manga's pot roast with mashed potatoes and gravy was an easy sell. As advertised, it was a glorious feast, served with elegance, comfort, cut glass, real silverware, and linen napkins!

But in between bites, it was utter agony. I was terrified that in my enthusiasm I might blurt out a string of embarrassing salty-dog words, so I remained uncharacteristically silent, just smiling and nodding approval, pretending that my mouth was always full.

Dear Manga delighted in watching her young warriors wallow in the trough and seemed to understand our early departure, knowing only too well that "sailors need lots of sleep and aren't allowed to lounge around in their hammocks much after sunrise."

It was such a relief to get outside the house. I was sure I was going to explode. I felt terribly chagrined and was ready to give serious thought to getting my act together to avoid further anguish and embarrassment. I would start for sure on Monday

Wearing the old flat hat and pea jacket, the fledgling sailor also puts on a smile of hope that some admiral will hand him a pen, a bottle of ink, and a chance to prove he is quick on the draw.

morning. After all, this was Saturday night and we were on a *bleep* streetcar headed for the *bleep* Seattle waterfront, the *bleep* Purple Barracuda, and the *bleep* dancing dollies!

Whadda you say, Charlie? Are we gonna get a *bleep* tattoo tonight?"

We were both artists, working in an office at the Navy Yard. Our sea duty so far had consisted of two ferryboat rides across Puget Sound. Shiver me timbers, mate!

Shortly after reporting for active duty at the Bremerton Navy Yard, I fell ill with what they called "cat fever" and was placed in the infirmary, sharing a large ward with a bunch of youngsters from the USS *Maryland* who had barely survived the Pearl Harbor attack. These sailors were suffering from shock, exposure, concussion, and amputation. I had the flu.

As I stood in line at the Yard personnel office, waiting to check in following my release from the infirmary, I overheard a couple of chief petty officers chatting about "Walt Disney," "Hollywood," "Donald Duck," and other familiar topics.

"Excuse me, Chief," I interrupted, "but, eh, what about Walt Disney?"

"Oh, some lucky guy is being transferred to Washington." He paused and looked at the rating badge on my sleeve. "Say, what's your name, Sailor?"

"Ketcham, Henry K. Just checking back in from the hospital," I answered.

"Well, don't bother. You have orders to proceed immediately to the Photo Research Lab at N.A.S. Anacostia, Maryland."

I guess "immediately" meant as fast as the Great Northern Railway and Illinois Central could get me there. I was accompanied on this five-day choo choo trip by a salty boatswain's mate first class who sported three hash marks from his World War I service. He spun amusing yarns and gave me a concise run-down of "dos and don'ts." At each of the many stops along the way we were greeted by crowds of applauding and appreciative Americans who treated us like heroes, plied us with more booze than we could possibly consume, and urged us on to a quick victory against "those dirty Japs." Every man in uniform was enjoying similar accolades early in 1942.

I felt a bit guilty knowing that I would be attacking the enemy with nothing more lethal than pen and ink.

Washington, D.C., 1942

On a rainy March afternoon in 1942, one week before my birthday, my Washington neighborhood was briefly enlivened when a Navy ambulance rolled up to my Q Street rooming house and hauled my ailing body to the Bethesda hospital. Apparently I had never fully recuperated from whatever bit me while I was stationed back at the Bremerton Navy Yard.

Even without Mother's loving application of mustard plasters and steaming bowls of chicken soup, I somehow quickly regained my strength with only a gaggle of *APC* capsules. I reported back to "temporary duty" at the Office of the Secretary of the Navy, War Bond Division, 17th and Constitution Avenue, fit and eager to do battle with pen and ink and typewriter.

Geared up for World War II, our nation's capital was awash in gold braid and silver stars, and also swimming in an eye-catching assortment of attractive young ladies— most of them lonely. This situation turned out to be a stimulating morale-builder and

land, had me in a happy tizzy for weeks until I finally slipped the tiny gold ring onto her finger on March 10, 1942.

At last my boardinghouse/rented room/ bachelor apartment days were over. No more cleaning up after hairy-chested roommates, no more sitting at a dinner table with a bunch of strangers with whom I had little in common, and no more having to queue up in a drafty hallway, towel over shoulder and toothbrush at the ready.

Personal cartoons always seem to work wonders, and, in a matter of a few short weeks, we were able to move into a new two-bedroom duplex apartment in Arlington, a thirty-minute bus ride from the Navy Department—all because of a drawing I sent to the landlord, humorously describing our homeless plight.

Chalk up another victory for the pencil.

In retrospect, my war was a comparative picnic, living ashore the entire four years in the suburbs of Washington, D.C., involved with cushy, nonmilitary art and publishing assignments, and with all those pretty young chicks running around loose throughout the establishment—gracious!

As the work load in the Navy War Bond Division increased, I called for help, and sailor Ned White, formerly an editorial cartoonist at the *Akron Beacon-Journal,* reported for duty. Another pen-and-inker, George Sixta from the *Chicago News* (and the creator of *Rivets*), had his office down the hall in the Public Relations wing and came aboard as the third leg of a cartoonist triad. We spent a good deal of time talking shop, lunching across the street in the huge cafeteria at the Department of the Interior, or brown-bagging it on the grass alongside the Reflection Pool, wondering how much longer we'd have to wear the monkey suit.

helped soothe the fevered brows of local warriors and kept their minds off the horrors of war.

Actually, it kept my mind off everything else, and before you could say "Remember Pearl Harbor," I was walking up the aisle with the former Miss Alice Louise Mahar of Malden, Massachusetts, beneath the extended gold dress swords of the six naval officers attached to the War Bond Office. This charming little brown-eyed accounting secretary, with an ever-ready smile and pert Irish features reminiscent of Judy Gar-

The assignment to create a series of food conservation posters was my first opportunity to work in such generous proportions and for such a large audience. They were well received and enjoyed circulation to the entire fleet and all the shore installations.

Along with other enlisted men in the building, I was assigned a monthly "security patrol," an all-night vigil of walking the corridors of the creaky old Navy Department (a temporary building from World War I), with a .38 caliber pistol on my hip, canvas leggings around my bell-bottoms, and an official brassard on my arm! Looking sharp and feeling silly poking my nose into other people's business (checking on the night workers and cleanup crews in the Secretary's offices), I was mighty proud to be guarding the Navy's secrets and to be doing my part in keeping our nation safe from harm.

My unusual assignments always demanded the involvement of naval officers, so my skipper, Captain Gerald Eubank (an old Prudential Life Insurance hand), probed the possibility of my securing an ensign's commission to place me on equal footing in this tightly structured society. He was informed, however, that no naval officer under the age of thirty could be assigned to Washington, D.C. So, that was that, but the captain (soon to become admiral) saw to it that I was quickly bumped up to petty officer first class and then finally to chief petty officer, a welcome change of uniform, and a much easier way of life.

With the added income, we bought a 1938 Buick convertible and moved out of the tiny apartment and into a real house in a real neighborhood with a real lawn to mow and a garden to keep. On any weekend you'd think I was a civilian. But when the novelty wore off, I was anxious to climb more challenging mountains. I had experienced minor success in the magazine and advertising market, and even though I knew that I had an animation job awaiting me in California, I still had my eyes riveted on New York.

Potomac Moonlight

Frank Owen was an active cartoonist during the forties, appearing regularly in *Collier's* and the *Saturday Evening Post*. His stuff was funny and well drawn, and he was especially clever with his pen-and-ink handling of dogs. I had admired Frank's work for several years before I ran into him in early March of 1942 at the Navy Department Printing Office. We were both wearing white hats and black neckerchiefs and were happily assigned to cartoon projects far, far away from swabbing decks, the briny deep, and the big guns that go boom in the night.

While we both waited for the gigantic photostat machine to turn out copies of our drawings, I expressed my wild desire of someday becoming a regular contributor to the big New York-based magazines. "I know it's going to be tough to get accepted, what with all those famous cartoonists already entrenched and...."

"Piffle," he scoffed. It sounded like a word out of "Major Hoople's Boarding House," a popular newspaper panel of the time. "It's really quite simple, Hank. All you have to do is draw a funnier picture than the other guy."

Suddenly the wall of ice disappeared, the mystique had vanished. How utterly stupid of me not to have understood the logic years ago! But now I was on a downhill slope and beginning to gather speed! Hallelujah!

By the time winter of 1944 swept through Washington, D.C., I had already spent two years at the drawing board in the Office of the Secretary of the Navy, creating sales and training material for the War Bond program and, during off hours, trying to establish myself in the free-lance magazine

THE CHIEF

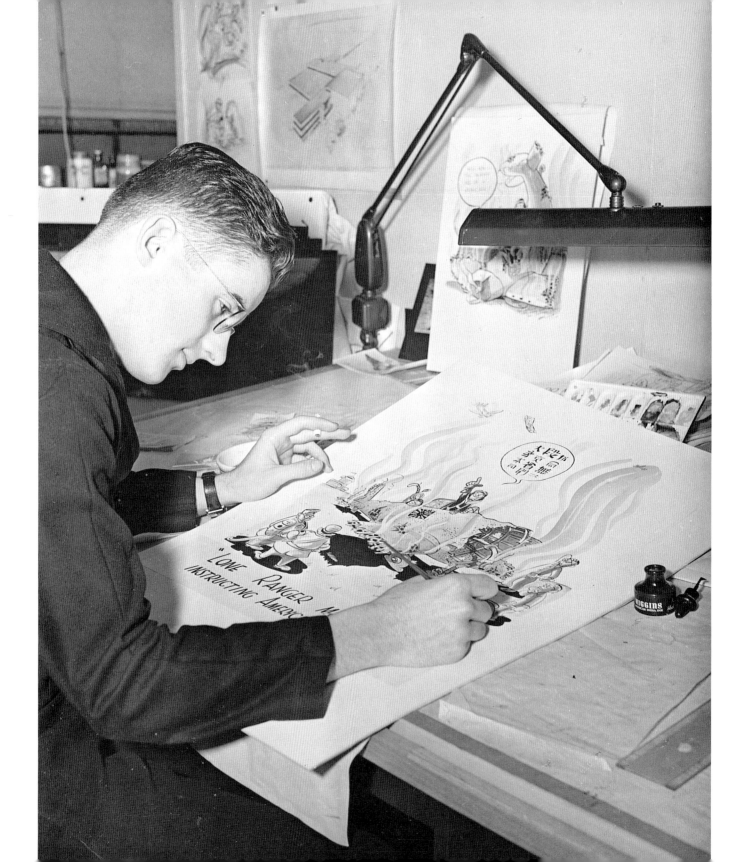

market in New York City. It was almost inevitable that I would come up with a cartoon presentation that featured a short sailor—given my daily involvement with bell-bottom trousers, a little white hat, and the bursting enthusiasm I have shown since childhood for anything relating to the United States Navy. And short, because that was what I felt most comfortable with after working years in the shadows of the Seven Dwarfs, Andy Panda, Mickey Mouse, Donald Duck, and Jiminy Cricket.

My first inspiration was the development of a sawed-off sailor with a large beak, Seaman Hook, who became the hero of a six-minute animated cartoon promoting the sale of War Bond allotments to U.S. Navy personnel, a full-color production entitled "Take Heed, Mr. Tojo." I made a persuasive pitch for it to my skipper and a brace of admirals in the Secretary's Office during a special storyboard session where I went through all of the sketches, waving my arms, imitating guns and planes and villainous Jap pilots. It was a huge success, as none of these officers knew the slightest thing about the animation business, and they were intrigued that such a serious subject could be so successfully treated with humor. They bought it on the spot, and I had no problem convincing them that I must personally take this to Hollywood and stay with it to completion.

To call my reaction joy would be understating it. The very thought of exchanging cold and dank for warm and sunny engulfed me in ecstasy, and I lost little time making arrangements to board the westbound American DC3 flight at Washington National Airport. It was a smooth trip with excellent weather, and we landed on schedule at the Burbank airport nineteen hours after takeoff and ten years before

"jet lag" entered the language of travel. The Disney Studio was then up to its mouse ears in production for the Air Force, so I managed to maneuver Walter Lantz into the act. It was like old times, a happy reunion with good friends. Helen and Vip Partch then lived in North Hollywood and very thoughtfully took the young sailor in off the streets.

Unfortunately, after a glorious six weeks we wrapped up production, and I was issued orders to return to the icy Potomac. But what a fantastic war I had fought for those forty-two days! Oh, the film. Yeah, well, it was so popularly received that I plunged back in and developed another storyboard, this time a series of three-minute black-and-white animated "commercials," and this, too, was quickly accepted and funded for immediate production. Only this time the skipper gave me the gimlet eye and a brace of lowered brows.

"I'm under the impression, Ketcham, that you've been busy with more animated-cartoon projects so you can boondoggle your way back to another cushy assignment on the Coast."

"No, Sir! Our first show is a success, sir. And we all agreed that we need some follow-up sales promotion, something of quality that will draw attention and act as a motivating force . . . sir!"

"I understand all that, but if you think for one minute I'm going to give you orders back to Hollywood for another six-week vacation, you're dead wrong!"

My dander, of which I have precious little anyway, was up. I couldn't bear to see my baby left on the doorstep of some old animation studio and put into the insensitive hands of bumbling civilians who could care less about the Navy War Bond Allotment Program and the future of Seaman

Hook! In a trice I was no longer in the Navy. There were no uniforms to salute. It was just him and me.

"If you believe in this project and want to see it done properly, then you will issue my orders to go to California and direct it!"

I turned without waiting for a reaction and stormed out the door. As livid slowly drained from my system, and remorse crept in, I spent anxious moments reflecting on my foolhardy behavior. My Irish skipper was a past master at temper tantrums, and minor skirmishes such as this one went almost unnoticed. The next morning he called me into his office to discuss my forthcoming trip, this time to Warner Brothers, the home of Bugs Bunny.

A New Kind of Hitchhiking

During my Hollywood years, I had done quite a lot of hitchhiking along the West Coast, and after enlisting in the Navy I continued to bum rides. Only this time I needed air transportation, so I retired my thumb and hung around the local Naval air stations and waited for hops going my way. I had planned to spend the Christmas of 1945 with friends and family at Seattle and got lucky with a seat in the aft machine-gun turret of a TBM (Torpedo Dive Bomber) that was being ferried to San Diego. From there it would be easy to catch a plane to the Northwest. We left the Potomac River basin on a clear, crisp mid-December afternoon, just me in the crowded tail compartment of the plane, sitting on my parachute and reading the instructions, and the skipper all by himself up in the cockpit fiddling with the controls. We climbed to 5,000 feet on a southwest heading and settled down for our ride to New Orleans, where we would spend the night. (Military ferrying operations were done only during daylight hours.) A couple of F4Us (fighters and faster'n hell) flew alongside, teased us with a few wingovers, and disappeared. The skipper tuned in on the commercial radio band and, as the winter sun dropped lower on the horizon, he locked onto a Charlotte disc jockey playing Bing's theme song, "When the Blue of the Night Meets the Gold of the Day." I put my feet up on a crate of electronic gear and listened to der Bingle croon —dreaming of mistletoe and eggnog, and feeling good all over.

Suddenly the engine sputtered, coughed a few times, and then stopped. Our nose went down in anticipation of meeting North Carolina head on; I braced my foot against the emergency hatch release lever, grabbed the ring on my chute, and peered up through the narrow passageway for instructions from my leader to bail out. We

Aurielus Battaglia (former Disney artist stationed at the Navy Department) apparently couldn't resist offering his version of the new CPO.

The creation of Sylvester for the National Retail Lumber Dealers Association was a moonlighting boon to my postwar plans.

Opposite: "Half Hitch" became a regular back-of-the-book feature for the Saturday Evening Post *and elevated me into the ranks of Big-Time Cartooning. The panel appeared weekly until the war's end.*

were losing altitude at an alarming rate, and the excitement factor had reached excruciating dimensions. The skipper was flapping his arms around, looking from one side of the instrument panel to the other and on the floor between the seats, searching furiously for something. Then I heard a welcome sputter, followed by a joyous series of coughs, and finally the gorgeous roar of our engine at full throttle, gratefully acknowledging the G force as we pulled out of our silent nosedive. Wheeeee!

A sheepish-sounding Navy lieutenant who had been in charge of this expensive flying machine buzzed me on the intercom and apologized for the unexpected interlude. He had been assigned to other aircraft for almost a year, hadn't been near a TBM since, and quite frankly, had forgot to switch fuel tanks. In the ensuing panic he couldn't find the auxiliary pump. "Sorry 'bout that, Chief."

As my "military duties" demanded no more than a regular eight-hour day, I directed my newly found enthusiasm to the spare bedroom drawing board in an after-dark effort to enhance a meager Navy paycheck. Rejection slips flew thick and fast, but in 1943 I made several breakthroughs into some minor markets, and my confidence surged. By 1944 I was cracking the big publications with regularity, the likes of *Collier's, Saturday Evening Post, True,* and *Liberty.*

Cartoon features dealing with the Army were all over the place. The Navy had precious little humorous representation in the newspapers and magazines, so I quickly filled the gap with "Half Hitch," another sailor of diminutive proportions, whose antics aboard a battleship were entirely in

Shipmate Ned White, former political cartoonist for the Akron Beacon-Journal, *got carried away with this cheerful accolade.*

Opposite: Although the regular check was enormously appreciated, I was somewhat relieved when hostilities came to an end and the Post *cashiered my bugeyed sailor. Mime comedy has its limitations, and I was getting close to the bottom of the barrel.*

mime—no dialogue balloons, no captions, just the sort of ridiculous activity we used to enjoy in the silent movies. I sold it to the *Saturday Evening Post,* and this weekly pantomime cartoon panel was just gaining momentum when hostilities ended. So "Hitch," like the rest of us, retired from active duty.

In August of 1946, when the sheer weight of my monthly War Bond Allotment magazines, sales brochures, and food conservation posters finally crushed the enemy, the war ended. And proof that no one was paying much attention when I was given my Honorable Discharge, they presented me with a Good Conduct Medal.

New York, 1946-1948

Free-lancer

Having tasted just enough success from my part-time efforts in the free-lance market the last year of the war, I had no difficulty in deciding not to return to a guaranteed job with Walt Disney but to tackle New York head on. It wouldn't be necessary to live smack in the expensive heart of Manhattan (cartoon editors made themselves available to the artists only on Wednesdays), so we uncovered a nifty little New England saltbox on a wooded acre just outside Westport, Connecticut, renting for $75. It was a refreshing welcome back to civilian life, midst rolling hills, stone fences, little traffic, a sweet village where one knows all of the shopkeepers—and where the men don't salute each other.

In November, the Norwalk General Hospital recorded the birth of Dennis Lloyd Ketcham. By early spring, the clothesline was loaded with diapers, shirts, and tiny pajamas, and my upstairs studio had become a nursery. So, rather than risk the perils of

Pablum, I moved my cartoon tools into a Westport rental unit.

Wisdom must have been out to lunch when we decided to add a cute little three-month-old Great Dane to the household. Christy's head was soon as large as his entire three-month-old body had been. You couldn't let him loose in the neighborhood, you couldn't keep him tied up in the basement, and you could hardly take him for a walk without him taking you! And he consumed three pounds of horsemeat a day! So, the diapers and p.j.s were dried in the kitchen while the black beast got his exercise shackled to a clothesline run out by the garage. Another fine mess we had gotten ourselves into!

Perry Barlow, a *New Yorker* regular, and I were the only cartoonists living in Westport, but the woods were full of topflight designers and illustrators. Steve Dohanos lived just around the corner, and all within a few miles were Al Parker, Ben Stahl, Rob-

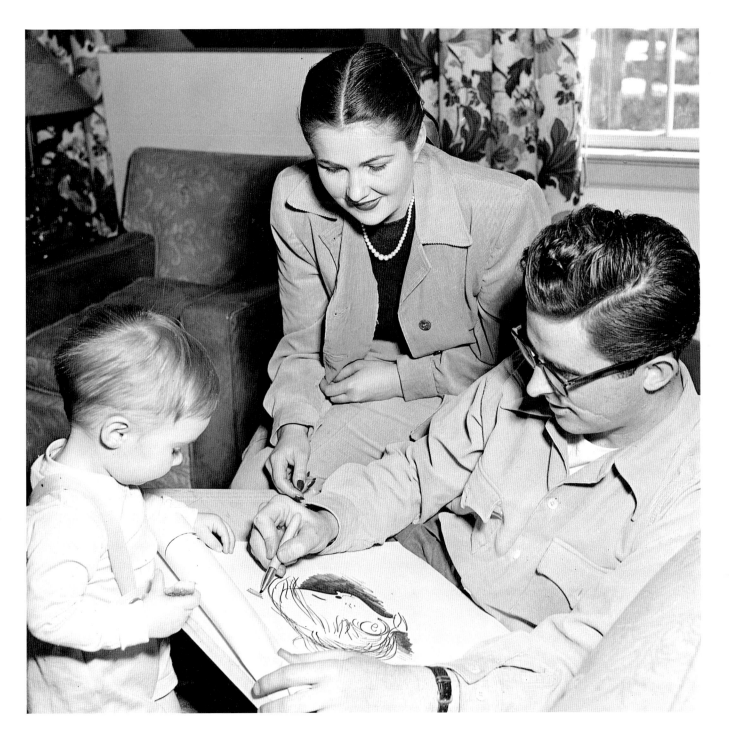

ert Fawcett, Dick Lockwood, Austin Briggs, Harold Von Schmidt, and many other outstanding talents. These men were the core of the Westport Artists, a group of congenial souls who regularly assembled for dinner and shoptalk. I was thrilled to be invited to meet with artistic celebrities whose work I had admired since the days I lugged a big sack of *Collier's* and *Saturday Evening Post* to my customers on Queen Anne Hill. I'll never forget the evening that Norman Rockwell spoke to us and told me, "keep up the good work you are doing for the *Post.*" That made my day!

The high point of the week began each Wednesday morning when I boarded the 8:11 train to Manhattan. It was a ritual performed throughout the greater New York City area by perhaps forty or more cartoonists (mostly men), hopeful of getting some "holds" and making some sales, while dropping off batches of their rough drawings to various cartoon editors who would respond by mail the following week.

It was a social delight for most of us who lived in different communities and met only on "market day." I could count on running into Ed Nofziger, Stan Hunt, and Chuck Saxon seated early on the bench outside of Gurney Williams's cubbyhole at *Collier's.* Kirk Stiles, Jeff Keate, Tom Henderson, Henry Boltinoff, and George Wolfe would be among those waiting patiently in the lobby of the *Saturday Evening Post* to see dear Marion Derrickson, later replaced by John Bailey. And over at *This Week Magazine* I would greet the brothers Salo, Al Ross, and Herb Roth, a very productive family. Mischa Richter, Barney Tobey, and Dave Gerard would show up about two times a month; most of the *New Yorker* steadies were on a contract and handled everything through the mail.

At noon, many of us would gather for liquid refreshments and lunch, alternating between the Pen & Pencil and Danny's, a few steps away on East 44th Street. Costello's Bar on the corner and the Palm Restaurant up on Second Avenue attracted the newspaper syndicate guys, while agent John Kennedy would congregate with his boys at Joe & Rose, around the corner, under the Third Avenue "El." I usually dropped by a few of the smaller markets in the afternoon and caught the 5:02 out of Grand Central, which got me into my garage on Meeker Road by 6:30, tuckered out, reeking of double martinis and the fumes of the crowded smoking car.

Like I said, Wednesday was a social delight.

"Morning Coffee" was a visual concept that germinated during my animation years, and I developed dozens of similar drawings for Collier's.

The Words Come First

Those of us toiling in the laugh and giggle business, who must deliver humor on a regular basis, would wither away were it not for gagmen—those nameless, talented men and women who prefer cash to the credit.

Bob Hope surrounded himself with an army of gagmen during his years of weekly radio shows. Milton Berle, Johnny Carson, and Jack Benny, just to name a few, employed staffs of full-time mirth specialists. Nightclub comedians have traditionally bought a total package of material, an entire routine, which they would use night after night until the end of their scheduled engagements. They would then arrange to appear on a network TV variety show and use the tired routine one more time before replacing it with fresh stuff from the gag-writers.

The entire comic industry depends on gagmen for a continuing supply of fresh-ness and brilliance. Without their special point of view, we would be wallowing in a slough of repetition and mediocrity.

In the very beginning of a cartooning career, the ideas must necessarily spring from your own headbone. But once you start selling and your stuff gets published regularly, gag-writers will start offering batches of one-liners, mailed to you via the magazines or newspapers where your drawings appeared. Many of these erst-while humorists fall flat on their Under-woods. You must become a selective editor, separating the junk from the jewels.

My lifeblood has been gag-writers, and at one time or another in my career, the following stars have made outstanding contributions for which I will be forever grateful: Al Batt, Ralph Bess, Bob Bloomer, Leonard Bruh, Jerry Bundsen, Hugh Burr, Gene Butts, Irv Cohen, Kathy Deiter, Virginia Ebright, Harold Emery, C.C. Foster, Herb Gochros, Bob Harmon, John Harold,

Don Horrigan, Eddie Hughes, Byron Langenfeld, Phil Leeming, Arch Moen, Jeff Monohan, Ira Nickerson, Jr., Art Paul, Bob Rafferty, Jennie Roberts, and Bob Saylor.

My drawing was deplorable in the early days. I don't know how I ever managed to sell. But perhaps many of us wonder "how did I ever get off the ground?" or "what did she ever see in me?" As time passes, our perspective changes and we wonder how on earth the younger generation is going to survive, somehow forgetting our own youthful deficiency in judgment and wisdom. Come to think of it, I don't know how I ever got *my* act together and ended up with so much sugar and spice and everything nice.

During the Wednesday rounds in New York, I would sit in Gurney Williams's office at *Collier's* magazine and carefully watch the expression on his face for any sign of success while he leafed through my small stack of roughs. Gurney was previously cartoon editor of the old *Life* magazine and one of the experts in the business of ferreting out top-quality funnies. Years of exposure to cartoon humor had inured him to the extent that he seldom smiled during this period of scrutiny, much to the disappointment and anxiety of the visiting cartooner, But, in the course of normal conversation, Gurney grinned from ear to ear and laughed easily—as long as he wasn't looking at something you thought was hilarious.

As inadequate as I think my drawing ability was at that time, I did submit a bunch of funny gags that I still laugh at today and am disappointed they never sold.

Tools of the Trade

When I first became intrigued with drawing funny pictures, I used whatever tools I could find, which usually meant inexpensive ink-dipping pens, the kind you see in post offices and banks. While employed with the Walts, Lantz and Disney, I drew only with pencils, since the final art was to be traced onto cels by the young ladies in Ink & Paint. During my Navy years on the banks of the Potomac, I had to make my own finished art. I found it terribly awkward to work with a penholder and a stiff nib, so I decided on the more "user-friendly" red sable brush instead. It seemed to do the job nicely, except for the little nitty-gritty details that I quickly learned to leave out.

The Navy employed a raft of talented artists in those days, many of them also working at 17th and Constitution Avenue. Robert Osborne, Harry Devlin, Martin Provensen, Dick Lockwood, Aurie Battaglia, Jack Miller, and Noel Sickles were a few I re-

"JUST THINK, MAURICE! SIX WEEKS AGO I COULDN'T DRAW A STRAIGHT LINE."

"THE CARPENTER SAID THEY WERE A NICE LITTLE COUPLE. THAT'S ALL I KNOW."

member. Sickles, a fantastic illustrator, got his artistic feet wet in the newspaper comic-strip business, creating *Tailspin Tommy* and then moving over to shepherd Milton Caniff through the transition from *Dickie Dare* to that eyepopping blockbuster *Terry and the Pirates.* Bud Sickles was a genius, Caniff was a fast study, and the vibrations are still being felt throughout the world of cartoon art.

Louise and Bud Sickles dropped by my Connecticut studio shortly after our mutual release from "active duty." I was just get-

ting a toehold on the free-lance market in New York and was anxious to show them samples of my labors. Bud had always been most supportive, encouraging me in whatever project I was involved, and he was gracious in answering my barrage of dumb questions. He always bolstered my confidence and made me feel good.

I recalled an early correspondence art course from the W.L. Evans School of Cartooning that suggested I start out with a Ladies Pen, the Gillotte #170, manufactured in England. It had a flexible and du-

rable nib, a much different feel than the brush, but with a little practice I soon felt almost comfortable, gliding delicately across the two-ply plate-finished Strathmore. I wanted to show Bud how I was progressing.

"Looks as though you're scared of that pen," he chuckled. "You seem a bit tentative, afraid you might hurt it."

"Well, I guess I don't want to bear down too hard and splatter the ink all over." I wasn't quite sure what he meant.

"That copper nib is perhaps the cheapest thing you've got in this studio; if you lose a few, it's no big deal."

He pulled up a stool, sat down, and rolled up his sleeve. "Now, here's what I like to do as sort of a morning warmup: put a new nib in the holder, rub it with a soft graphite pencil, dip it deep into the ink, wipe it clean, dip again, and then attack the drawing paper with a variety of swings, crosshatches, swirls, and thick and thin arcs like this, bearing down in an effort to actually *break* the nib. See? Sure, it'll crack, but only under extreme pressure, probably much more than you're willing to exert."

All I could utter was a raspy "Wow!"

Sickles handed me the pen. "Here, give it a whirl. It's not only fun to be freewheeling, but you'll discover a few new wrinkles and, more importantly, you'll know the outer limits of the pen's performance and not be afraid to vacillate between a lacy thin line and a gutsy swath that looks like a bold brush stroke."

He had me try holding the pen differently, even turning it upside down for a special effect. I was thrilled. Boy, the stuff they never teach you in art school!

Since then, the English company that manufactured the Gillotte line of pen nibs

"G'BYE, AL, AND THANKS A HUNDRED."

"I WISH YOU'D LOOK AT THE GARAGE, DEAR. IT'S BEEN MAKING A FUNNY NOISE WHENEVER I DRIVE IN."

smock behind the counter. "Good afternoon," I ventured. Then, rather hesitantly, I inquired, "Would you by any chance have a supply of the old Gillotte nibs?" I placed the accent on "old."

The gentleman lowered his head to peer at me over his reading glasses, which were held in place by wisps of white hair. "Do I hear a note of despair in your voice, sir?" He wore a gentle smile, and I suddenly had a feeling that I had come to the right place.

Mr. Poole was most sympathetic and showed me some letters from artists and calligraphers from all over the world, each requesting some sort of special piece of equipment that has long since all but disappeared from the shelves of regular distributors. He blew the dust off a small plastic box, opened the cover, and revealed the last of his inventory of the now-precious original copper 170s, and allowed me to take what will surely be a supply to last several years.

I could have danced all night.

The House of Ross, 1947–1948

The *New Yorker* was the cartoonist's "Bible," and to make a sale there was akin to being knighted and/or anointed. Those were the glory days of Peter Arno, James Thurber, George Price, Charles Addams, Gluyas Williams, and Helen Hokinson. They were the royalty, the rest of us were groveling peasants.

Many of them, by that time, were living in the country, and few ever bothered to come into the city on a regular basis. But they, too, worked with gag-writers, and it was not unusual for cartoon editor Jim Geraghty to buy ideas for them that were submitted as rough drawings by those of us who paraded our wares every Wednesday

Opposite: This was my initial effort to get into newspaper syndication immediately following the war. King Features held "Little Joe" for several weeks and finally rejected it. I was told that for years they kicked themselves, thinking that they had seen and rejected Dennis.

has changed hands, and I think the quality of their products has diminished alarmingly. During a recent visit to London, I spent the better part of a morning tramping through art supply stores searching for some of the original penpoints. None of the stores even carried the line anymore, and I was shunted from Knightsbridge to Picadilly Circus to Covent Garden, and finally down a narrow Drury Lane to the Philip Poole Pen Store, a small, dusty establishment full of boxes and cardboard cartons and little cubbyholes containing a vast selection of writing tools.

I slowly opened the door, taking a moment for my eyes to adjust to the darkened interior, and noticed someone in a white

morning. Shortly after son Dennis was born, I received this letter:

Dear Mr. Ketcham:

I'm very sorry to have to report that this drawing didn't please our editors. I'm going to suggest that you permit a more experienced cartoonist to try it. I really think you will learn more that way than by listening to me. I can tell you what we didn't like, but I simply cannot tell you what we will like.

Working for the *New Yorker* is a long term proposition and, I'm afraid, it isn't much easier to become one of our regular people than it is to become a lawyer.

This isn't a very cheerful letter for a brand new father, but the case isn't hopeless.

Congratulations on parenthood, and thanks for the cigar.

Jim G.

I was not easily discouraged and continued to drop off a batch every Wednesday. Most of the cartoon editors saw you in person, looked over your drawings, held what they wanted to mull further, and sent you on your way, but Mr. Geraghty remained cloistered, preferring to review the material in a more leisurely manner—alone. How-

" THE TROUBLE IS, ALL THE COWBOYS IN YOUR STORY ARE A BUNCH OF IGNORANT, BLOOD-THIRSTY SAVAGES. "

ever, when he was interested you would receive a letter discussing the merits of your work and the best way to present the gag in question—a welcome critique, and something you seldom received from other editors.

Dear Ketcham:

We like this idea. I notice on the back of the sketch a lot of symbols which suggests that every cartoon editor in America has seen the drawing.

If you feel strong enough to try a finish for our art meeting, by all means do so.

JG

True, most of us kept book on the backside of our rough sketches, jotting down initials for the various magazines that had seen the material. But, in reality, the *New Yorker* didn't mind since they were looking for something quite unique, ideas that other markets would likely pass up. I did try a finish for this one, a rather simple gag showing a matron carefully steering her new Buick toward a large target mounted on the back wall of her garage. This was the year that Buick's hood ornament was designed to look like the sights on a rifle barrel. They bought my finished art!

In another batch of roughs, I included one showing a middle-aged customer in a radio-TV-sales & repair shop who had brought in some odd-looking headphones and a small, boxlike apparatus. The clerk turns to his repair man and asks: *"Know anything about crystal sets, Ed?"* I received the following response:

Dear Mr. Ketcham:

I've got an entirely new switch on this idea—it's still the same idea—that will require a drawing of the caliber of Mary Petty's—it's a picture of an elderly woman asking for something as anachronistic as a crystal set, only funnier, with the humor dependent entirely on the character of the woman. The question is —will you let us use the idea? I don't think it will make your idea unsalable elsewhere—not close enough to detect, but we will of course pay you the regular price of $20, plus $10 for professional cartoonists.

This request doesn't mean that we don't want you to try finishes. We operate on the theory that all cartoonists can't draw any idea. The best are specialized.
Sincerely,
Geraghty

A friendly reminder from Mr. Geraghty that it isn't what is said that is funny, but who said it. Another rough that caught their attention featured a radio commentator seated before a microphone and sporting a black eye.

"In my opinion, the temper of the American people is changing. I have noticed this especially in the women of America. They have lost a great deal of their old warmth and friendliness. For instance, yesterday, in a crowded elevator"

This seemed to be right up the *New Yorker*'s alley, but the message read:

Dear Hank:

Sorry to have to return this drawing to you, but it just doesn't seem to work. I can't think of anything to suggest that would be helpful, I'm afraid. Mr. Ross feels that the idea isn't very funny unless the right character is reading the line. We haven't decided just what the right character would be like but we do know this drawing is not the answer. Perhaps we should set it aside, for a while at least.

JG

I agreed with their point and gave them another drawing that they did like and published. Since then, the F-R Publishing Company has been sold, and others are now trying to perpetuate the phenomenal success that began in 1925 under the jaundiced eye of Harold Wallace Ross (Thurber described him as "that irascible genius").

Perry Barlow was one of those *New Yorker* "regulars" who seldom bothered to go into the big city—for any reason. I certainly wouldn't classify him as just a cartoonist; he was an excellent illustrator with extraordinary drawing skills who discovered a humor market that needed a steady volume of production, in which he received top dollar for his stunning black-and-white drawings.

Perry worked in a neat little wooden shack of a studio in his garden, just a few yards from the kitchen door. He had a large north light, a Franklin stove, storage shelves everywhere, and even stuff hanging from the beamed ceiling. And no telephone. An artist's heaven. He invited me to visit whenever I had the time, and I took advantage of this hospitality on several occasions. He would go over my roughs and offer helpful suggestions to the visiting greenhorn. Perry was a cherished friend, anxious to help me get off to a good start, and had introduced me to his neighbor James Geraghty, cartoon editor of the *New Yorker*. Because of Perry's connection I enjoyed a comfortable relationship with Jim, who took the time to try bringing my thinking into sharper focus—to make it more *"New Yorker*ish." During my Westport years I made several sales to this elite publication, but, for whatever reasons, Mr. Ross was not impressed.

I recall showing Perry one particular gag that already had been given the okay for finished art by *Collier's.* It was a scene on a lonesome country road, probably in Nebraska, showing some important-looking businessmen in a sedan that had pulled up alongside a farmer clomping along in his horse-drawn wagon. The man in overalls answers:

"Westerville? Sure. Goin' there myself. Just follow me."

DISCIPLINE

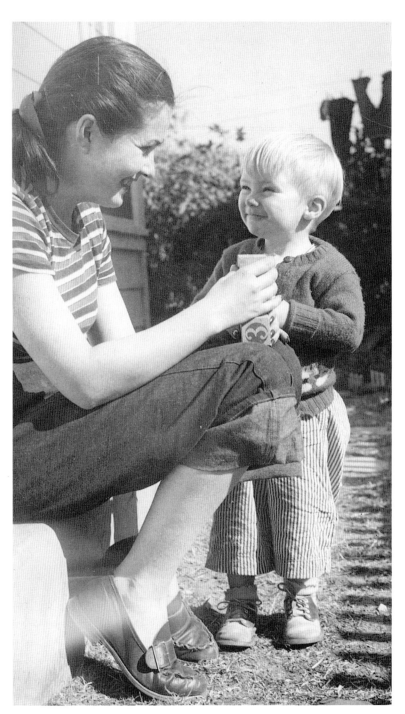

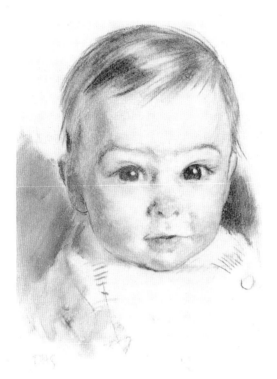

The idea was so solid that no matter how it was drawn it would have been funny, but Perry offered a few minor thoughts that, for me at least, added charm and credibility.

"Farm wagons," he said, "generally have a lantern swinging from the undercarriage. And in most cases the farmer's dog will be loping behind."

I was impressed with his insight, and from that moment on was more sensitive and aware of details that might enhance the art.

Perry's wife was Dorothy Hope Smith, who created the original Gerber baby, and she was a delightful counterpart to this creative team. When Dennis was but a few months old, I carried him over my shoulder while she shot several feet of black-and-white 16mm film, from which she extracted "just the right expression" to use as a study for a terrific charcoal portrait—not entirely unlike the cherubic face seen in supermarkets everywhere on jars of apple sauce and mashed carrots.

New England was a relief from the weather pattern surrounding Washington, D.C., but after six years of East Coast climate changes—ranging from ice storms and falling trees to scorching near-drought summers—I was ready to call it quits and move back to California where your only concerns were smog and earthquakes.

I called Virgil Partch for suggestions. I knew he had long since left Disney's and moved up the coast to the Monterey Peninsula. I reasoned that he must have considered several locations before making a choice and wanted to pick his brains.

"Come on out, Hank," he enthused in his startling basso profundo. "You'll never see a better chunk of peace and quiet than the Carmel Valley. We love it!"

That was all I needed. At a suggestion made in song by Nat King Cole years earlier, I called AAA for a Triptik to California and made plans to motor west on the highway that is best—through Kingman, Barstow, San Bernadino. . . .

A rambunctious two-and-a-half-year-old in the back seat saved us from becoming bored. Seething with rage and frustration perhaps, but never bored.

Carmel, 1948-1959

It Happened in Old Monterey

I had not seen the Monterey Peninsula until 1939, when I kept Jerry Payne company as he drove a delivery truck from Los Angeles to San Francisco. We spent one night sleeping on the sandy Carmel beach at the foot of Ocean Avenue. Nine years later Carmel was still the rustic and quiet seaside village I had remembered. I agreed with Partch that he had made the perfect choice, but within six months he and Helen had returned to Southern California and settled near Newport Beach. For a short spell, there had been three cartoonists in the area. Now there were two: me and Jimmy Hatlo *(They'll Do It Every Time* and *Little Iodine).*

Real estate was beginning to move, and I was attracted to a twelve thousand dollar offering that included construction of a two-bedroom redwood house on a lot in Carmel Woods. I couldn't resist, and while waiting for the house to be built, we rented a cottage on a hillside in New Monterey that overlooked "cannery row" and Doc Rickett's Pacific Biological Lab, where John Steinbeck spent some creative hours.

During the sardine season, night or day, whenever a boatload of fish returned to the harbor a cannery whistle would blast, sufficiently rending the air to alert workers that they'd better hustle down to the factory. So in time we got used to the clumpity-clump-clump of heavy boots passing by our front door and the "sweet smell of success" that permeated the Monterey side of the peninsula when the reduction plant ground excess catch into fish meal. But to most of us, it wasn't worth a scent.

A group of retired colonels ran the Monterey Peninsula Country Club and allowed military veterans a special membership that made it comfortably affordable to belong. The Pebble Beach Company in those days was also friendly, and I could play that magnificent, uncrowded golf course for only five dollars!

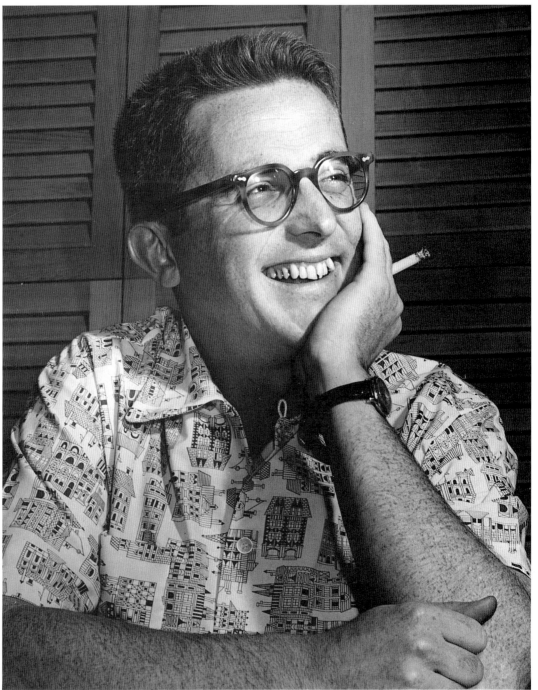

Mother and son check out the construction of their future Carmel home—the young man looking more "menacing" each day.

My cartoons were selling briskly, and advertising commissions arrived regularly from New York. I was on a roll.

The Spark

At four years of age, Dennis Lloyd Ketcham was a thirty-six-pound handful. Too young for school, too big for his playpen, too small to hit, not old enough for jail—and one hundred percent Anti-Establishment.

One October afternoon in 1950, I was at work in my tiny studio, finishing a drawing for the *Saturday Evening Post* when I was startled by a sudden outburst of mother noises coming from the bedroom area of our new home in Carmel.

The little darling was supposed to be taking a nap. Instead, he had spent the better part of one hour quietly dismantling his room—bed, mattress, springs, dresser, drapes, and curtain rods. When the accidental load he carried in his underpants was added to his collection of plastic toys, cookie crumbs, and a leftover peanut butter sandwich, it formed an unusual mix. Enough to drive an Irish mother to the brink.

Now he was "my" son. Her rich expletives, most of them coined in Boston, were spliced with suggestions of abandonment and threats of bodily harm. After informing me that I could jolly well clean up his room, her parting shot was, "YOUR son is a MENACE!"

"Dennis . . . a menace?" I mused.

Let's see, there's *Tillie the Toiler* and *Felix the Cat.* Why couldn't there be— DENNIS THE MENACE?! Wow! Why *not!* I hauled out the shoe box where I stored my gags, picked out a dozen kid ideas and feverishly translated them into rough pencil sketches that I air-mailed to John Kennedy, my agent, and waited for the explosion.

It arrived ten days later by way of Western Union:

BOB HALL NEW PRESIDENT OF POST SYNDICATE VERY INTERESTED STOP WANTS TO SEE ANOTHER TWELVE SAMPLES STOP LOOKS LIKE WE MIGHT HAVE A SALE

JOHN

Just Another Okay

"How did you feel," I am often asked, "on that October afternoon back in 1950, when

WATCH
OUT!

HE'S COMING
MONDAY!

This 1951 photo session was set up for publicity shots, but Dennis couldn't resist the opportunity. And, boy, did it smart!

you signed the once-in-a-lifetime, strike-it-rich jackpot contract? Were you stunned by it all? How did you celebrate?"

As I recall, we opened a few beers and made some phone calls, but there was no dancing in the streets. After all, for more than four years I had been making a comfortable living producing cartoon panels for magazines and advertising accounts, so the sale of a daily newspaper feature was just another okay from another cartoon editor, only this guy ordered a rather large batch, sort of a continuous roll with no end in sight. It had all the earmarks of a steady job.

Dennis the Menace was released in March of 1951 to sixteen newspapers—not much of a tribute to the sales department of the Post-Hall Syndicate. Most of these clients were paying three to five dollars a week, and had it not been for the dear *Chicago Tribune,* which agreed to a $100 rate for its circulation area, *Dennis* would still be in the ink bottle.

This income enabled Post-Hall to pay the nut, the expenses of engraving, billing, and mailing, but, until more sales were made, it left precious little for the boy cartoonist. Fortunately, Bob Hall added two top syndicate salesmen to his staff, and very shortly Ira Emerich and Glenn Adcox hit the road with samples and a bundle of blank contracts. The results were staggering, and before the end of the year, *Dennis* was appearing every day in more than a hundred newspapers. The sales chart was not an upward curve but more the flight of an arrow.

Everyone began to breathe more easily —except the bespectacled chap at the drawing board who was still huffing and puffing.

November 1950

The release date for *Dennis* had been announced as 14 March 1951, appropriately enough, my birthday. This gave me a good four months to work myself well ahead of deadlines, and I rushed pell mell in all directions gathering "menacing" material. I hoped to be at least sixteen weeks ahead once the bell rang.

(Nº 1. DRAWN OCT., 1950)

"GO AHEAD, DADDY —— SQUIRT IT RIGHT IN HIS EYE !"

At this moment all I had was one character, Dennis, so I quickly had to come to grips with other members of the cast. The name "Mitchell" had a nice Yankee ring to it, and leafing through the San Francisco telephone book I discovered several Dennis, Alice, and Henry Mitchells. I felt more secure and completed the needed christenings without hesitation or champagne.

The name *Wilson* came from my Sunday School superintendent (who lived to be 102). *Margaret* was my schoolboy crush and *Wade* was the last name of our kindly neighborhood grocer. *Gina* was inspired by the pert Italian actress, and *Gillotti* was chosen as her family name in honor of the Gillotte #170 penpoint I use in inking the drawings. *Joey, Tommy,* and *Dewey* just fell into place as we needed them.

Aware that Dennis must have someone besides his Teddy bear to play with and listen to his problems, I came up with an unlikely looking dog—big and fluffy and with the gentle disposition needed to cope with an exuberant five-year-old. I sat at the drawing board with my son on my lap and made a sketch of this hairy hound, then asked Dennis what we should call him. Without hesitation, he pointed at the drawing and said "Ruff." I'm not certain whether he was giving me a sound effect or a name, but it was just what I wanted.

Now that we had the characters identified, our next chore was to dissect each character to establish age, family background, education, personality, net worth, religious beliefs, philosophical outlook, and how each would react under certain circumstances. It took considerable soul-searching and exchanges of dialogue with my writers and several years before any of us felt we really "knew" every member of the "Dennis family."

I use the plural form in all honesty. This sort of thing is rarely a "one man show." An individual quickly scrapes the bottom of his creative barrel and, unless he has professional assistance, the quality suffers noticeably. The readers soon lose interest, and the newspapers start to cancel.

Bob Harmon was the writer most responsible for breathing fresh humor, warmth, and uniqueness into the feature during the early days. We worked entirely by mail and didn't meet in person until many years later. Bob was an active seventeen-year-old when stricken with progressive muscular dystrophy, and since

Following a weekend visit, Dick Shaw sent us his vision of a future Hank Ketcham Enterprises, Inc.

Opposite, above: *Henry Holt & Co. published the first book collection of the daily* Dennis *panels, and it remained on the* New York Times *Best-Seller List for eight weeks. This picture was taken following a luncheon reception at the Washington, DC, Women's Club, which featured brief presentations by authors— among them Alistair Cooke, Carlos Romulos, Helen MacGinnis, and Herblock.*

then has spent most of his life in a wheelchair. Unable even to shave himself, he did have just enough energy to operate an electric typewriter—thank the good Lord. Although we never discussed it, I have a feeling that this tragic disability made him more sensitive to a child's world and the sheer physical challenges faced every day by little citizens—those who look you straight in the thigh and have a clear view of sagging springs under chairs, gum under the table, spider webs in the corner, and ants on the kitchen floor.

When Bob is with adults, he looks up with the same perspective a five-year-old does. When he leaves the house, someone must help him into the car and drive him to his destination. When there is something out of his reach, he must ask for help or concoct some clever way to retrieve it himself, much as Dennis might do in the case of the cookie jar.

Mr. Harmon retired from the daily *Dennis* merry-go-round several years ago, but his influence is still intact, as is my deep appreciation for his amazing contribution.

Readers were quick to respond to *Dennis,* and their warm notes of praise were encouraging. They all suspected that I was "peeking into their windows," and each letter contained family anecdotes for my inspiration. Sales surged at a meteoric pace, and by the end of 1951, *Dennis* was appearing in the hundred largest U.S. newspapers and starting to show up in strange places like Helsinki, Istanbul, and Frankfurt.

The harried author autographing copies of the Dennis the Menace collection donated to raise funds for the playground in Monterey. Writer Fred Toole refills the ink supply while artist Al Wiseman delivers another box of books.

There was an eight-month delay before any meaningful cash flow began to trickle from the New York money tree, so to pay the butcher I had to sandwich in free-lance work with this daily commitment.

Tacked to my drawing board was a pencil rough that had been okayed by a magazine then paying $25 for the finished art. I had not as yet received a dime from the syndicate, but, harboring dreams of glory, I began to regard this free-lance sale as bothersome and insignificant. Imagine, I thought, slaving over a hot drawing board for an hour or two for a paltry $25.

A cement and brick terrace was being installed at our Carmel cottage, so I decided to spend a productive day offering my services to the contractor. After six hours of backbreaking toil, along with a case of probable cement poisoning in both knees, I asked George Dietl, the contractor, what payment I might expect if I were regularly employed. He picked up a redwood shingle and began scribbling on it with a stubby carpenter's pencil. After deductions for withholding tax, union dues, and insurance, he announced, I could expect something in the neighborhood of $12.50 for my efforts.

No more delusions of grandeur.
No silly complaints.
Me one happy fella.

Inside *Dennis the Menace*

Having appeared in print every day for forty years, the panel has finally all boiled down to the Dennis/Mr. Wilson Show. Although sixty years separate them, George Wilson (with a combined personality of Ned Sparks, Edgar Kennedy, and W. C. Fields) is Dennis's grumpy hero. After all, he can play the ukulele, whistle through his teeth, juggle an apple and two bananas, and has the most fantastic attic in the whole world.

To Wilson, Dennis is an intruding pain in the neck—a nonstop irritant that interrupts his gardening, his stamp collecting, and his peace of mind. However, when push comes to shove, they are the best of friends. In time of need, Wilson would be the first to protect and defend his short neighbor from bodily harm.

Martha Wilson plays the warm grandmother role, an opposite to her irascible husband of forty years. And she bakes a great cookie.

Alice and Henry Mitchell are merely supporting actors, necessary family bookends who play the often confused, frustrated, loving, questioning, upset, comforting, anxious, proud, disciplinary roles of Mom and Dad.

Margaret, Joey, Gina, and Ruff fill out the cast, but the stars are Dennis and poor ol' Mr. Wilson. But let's go in closer to see how they look in "real Life."

The Wilson attic

HIMSELF

⇨ ⓞ ESTABLISHES
ELBOW & KNEE
JOINTS

Dennis

Chronologically speaking, Dennis is, was, and always will be "five-ana-half." Each March, the instant he blows out the six candles on his cake he becomes five again. Nice work if you can get it.

Physically he is sturdy, active, agile, tireless, and hard-to-catch. Mentally he is lively, inquisitive, imaginative, and of an experimental turn of mind, which frequently leads him into situations he can't always control. Add an unruly shock of hair, freckles, a smudge on his nose, dirt on his pants, and traces of paint and chocolate on his hands, and you have Dennis, The All-American Handful.

One rainy afternoon, Alice Mitchell watched in horror as her energetic offspring chased Ruff through the front hall, tripped over the telephone cord, overturned the fragile table, and sent her precious lamp smashing into a jillion pieces of porcelain.

"That settles it," she rasped, "you're going to be an only child!"

And an only child he remains and will always be. His occasional requests for a brother or "an older sister" fall on deaf ears insofar as his mother is concerned, although his father is passively receptive to the idea. Meanwhile he has Ruff, an ungainly but amiable creature of an uncertain ancestry that runs to large paws, stringy ears, and lots of long hair. Much of the affection and companionship that might otherwise go to a brother is expended on Ruff, and on Teddy, a stuffed bear who shares Dennis's bed and often accompanies him on nocturnal strolls. He calls him his "Beddy Bear."

Dennis has toys enough for the neighborhood, and they tend to overflow his

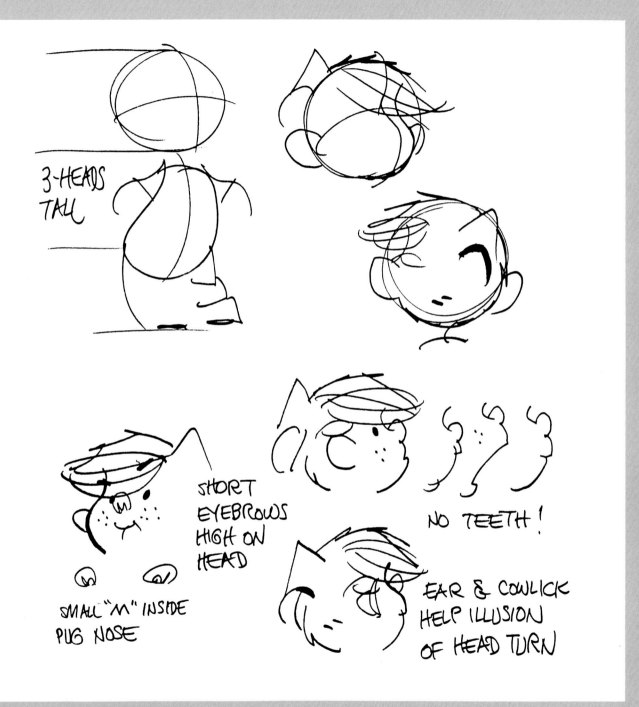

3-HEADS TALL

SHORT EYEBROWS HIGH ON HEAD

SMALL "M" INSIDE PUG NOSE

NO TEETH!

EAR & COWLICK HELP ILLUSION OF HEAD TURN

TOP OF HEAD OFTEN ROUGHED UP WHEN HE'S DISTRESSED

HEAD CONSTRUCTED ON CIRCLE

PEAR-SHAPED BODY

← DROOPY DRAWERS

TYPICAL ATTITUDE AND STANCE NOT UNLIKE D. DUCK

HAIR INDICATED BY 4 LINES BENEATH TOP OF HEAD (LINE)

CREPE-SOLED SADDLE SHOES

TEETH NEVER SHOWN EXCEPT TO EMPHASIZE A SPECIAL SITUATION

room and appear underfoot throughout the house—often resembling the after-effects of Hurricane Hugo. Walking through his room with a new friend who seems to be impressed with the disarray, Dennis casually remarks: "Naw, I never bother to clean up around here. I have a mother who comes in a coupla times a week." That mother's periodic cleaning forays, when all of his cluttered belongings disappear into chests, closets, and garbage cans, is a bone of the lad's contention. "Gee whiz, Mom, I like my room to look *lived-in!*"

He is the bane of every sitter in town, and his mother is often hard put to find one who has not heard of him or who is willing to sit with him a second time. Late one evening the Mitchells returned from a dinner party and found the middle-aged sitter standing on the front porch.

"He locked me out about eight o'clock," she said, "but I've kept an eye on him through the windows."

Old ladies and teenagers alike find him just too much of a handful, too physically and mentally active to control without constant vigilance, which leaves them frustrated and frazzled. Sometimes, worn out, they fall asleep on the sofa, leaving Dennis to greet his folks, bright-eyed and bushy-tailed, on their return from an evening out. The sitter conflict has been one of the basic Dennis situations over the years.

His favorite room in the house is the kitchen, and he has been known to throw impromptu refrigerator parties, dishing out chicken legs, root beer, and ice cream to a group of his friends. Or to Ruff and some of *his* friends.

He is hospitable and generous and takes it for granted that others feel the same, audaciously helping himself to the contents of their refrigerators, especially the one be-

longing to Martha and George Wilson, the next-door neighbors. He is not above cadging cookies or inviting himself to dinner when exceptional culinary fragrance beckons. And when his mother is on a baking binge, he hangs about hopefully, waiting for the first taste test.

As Dennis stuffs his mouth with freshly baked cookies, he tells his mom: "I think they turned out pretty good, but it's kinda hard to be *sure* with just three."

At such times he fully appreciates her sterling qualities and expresses his affection in the most extravagant terms, even allowing that he might get married some day if he would "find a girl who could bake cookies like *that.*" The cookie jar is a constant temptation, and his raids on it are frequent, even though he is often caught in the act and made to sit in the corner.

The corner is his least favorite place in the house, and he spends a good part of his time sitting there in his own little rocker, complaining volubly at the injustice of it all. His mother, used to this constant litany, ignores it. Ruff is his best companion in this time of trial, curling up at his feet in silent commiseration. Teddy is also a solace. His attempts to talk his way out of this Seat of Penance are seldom successful, whether sassy or dramatically tearful, except in the case of an urgently stated need to visit the bathroom. This is the only punishment meted out to him, except for single swats on the fanny administered in passing, or being sent early to bed without dessert for his rude remarks and complaints at the dinner table.

One day Alice heard a big commotion in the next room and ran to investigate, only to find that her son had propped poor Ruff onto the small rocking chair facing the corner. With his arms folded, a stern Dennis

RUFF

PART AFGHAN HOUND
PART ENGLISH SHEEPDOG
PART....?

CHARLIE CHAPLIN STANCE

told his mom: "He was bad today. He growled at a Seein' Eye dog."

His kindergarten palate is uncomplicated, so his taste in comestibles runs heavily to standard childhood fare, with hot dogs in the pole position, closely followed by peanut butter, root beer, and ice cream. And no meal is complete for Dennis without a liberal application of ketchup to almost everything in sight.

Contrarily, his greatest dislike is reserved for carrots, which he considers the most loathesome of vegetables, with green beans, turnips, and spinach bringing up the rear.

Sitting at the dinner table, a very resolute Dennis stated: "Even if carrots tasted good, I wouldn't like 'em."

Lettuce on a sandwich is "just in the way," and he prefers hamburger to steak because "it's faster." Cookies and cake are all-time favorites, with dinner or without, and he feels that it's wasteful to serve ice cream without "somethin' on it," although even he admits that ketchup in this application tastes "terrible." He never argues about having waffles, hot cakes, or "smashed" potatoes, but he doesn't have much patience for "empty" soup. He thinks peanut butter smells better than perfume.

The bathroom is invariably the scene of travail, as Alice attempts to get him into, through, and out of the bathtub. It is sometimes necessary to evict a collection of frogs, turtles, or creepy-crawlies before the tub can be used. Mitchell the Younger argues every step of the way and always loses, but once in the warm soapy water, he has a whee of a good time splashing about with the toy boats and floating animals. He is also given to running out of the bathroom stark naked to answer the phone,

Wilson bath

or to investigate the progress of an approaching fire engine, his mother in hot pursuit with a large towel.

Dennis considers his mother a bath freak, and late one afternoon when she plopped him into the sudsy froth he exclaimed: "I bet if I sat right here in the tub 'til tomorrow, I'd havta take another bath."

Bedtime presents a similar challenge to Alice and Henry, and getting their son and heir into the sack is almost as difficult as getting him into the bathtub. When he is finally piggybacked up the stairs, with his teeth brushed and his hands washed, it's time for a brief attempt to square himself and his activities with the Almighty. This simple theological gesture is a standard scene in the Dennis tradition, and in many instances it becomes a learning experience for his parents.

He seeks understanding: "You know how it is, some days *nothin'* seems to go right." He admits the uselessness of concealment: "There's no use tryin' to kid *you.* You know I done it." And, when he can think of no excuses, he offers the ultimate confession: "Well, God, I goofed again."

His father usually reads a bedtime story to him, often becoming so engrossed in it that he does not even miss his son, who has slipped off elsewhere. Sometimes it puts Dad to sleep, but seldom Dennis.

The one word that would sum up "Dennis" has not as yet found its way into the English dictionary, so we must settle for a weak equivalent, the word most frequently applied to him: *mischievous.* In Mexico, they call him *Daniel el Travieso.* He is a monumental mischief-maker, but not so much by intent as by definition. Mischief just seems to follow wherever Dennis appears, but it is the product of good intentions, misdirected helpfulness, good-hearted generosity, and, possibly, an overactive thyroid.

Insatiable curiosity is often the driving force as he ponders what might happen *if,* for instance, "this here caterpillar was to fall down Margaret's neck." Or *if* this bowling ball was to roll downstairs one step at a time. At Mr. Wilson's instigation he once asked his mother what sign he was born under and came back to deliver her answer: "Ignatz the Handful." And who would know better. But what a dull world it would be without any Dennises in it! Peaceful, maybe—but dull.

Henry Mitchell

Henry is a thirty-two-year-old White Anglo-Saxon Protestant who was born in a bustling mill town in central Minnesota. He stands six feet tall, weighs 162 pounds, is myopic, wears horn-rimmed glasses, and suffers from hay fever every summer. A good student, graduating from high school with honors, he was elected president of his Junior Class, ran the 220 low hurdles and the mile relay, and has always been an avid weekend golfer.

Following high school, Henry spent two years on active duty in the U. S. Naval Reserve and earned his yeoman "crow." He still keeps his uniform rolled up in an attic trunk and sometimes dons his old white hat, striking a pose and demonstrating to Dennis how he used to "steer the monstrous battlewagon."

Young Mitchell attended a small college and majored in business administration. He had no time for sports as his spare hours were spent at part-time jobs to help pay the tuition. He was a fry cook at the local Big Mac's, a valet-parking attendant, an emergency repair lineman for the phone com-

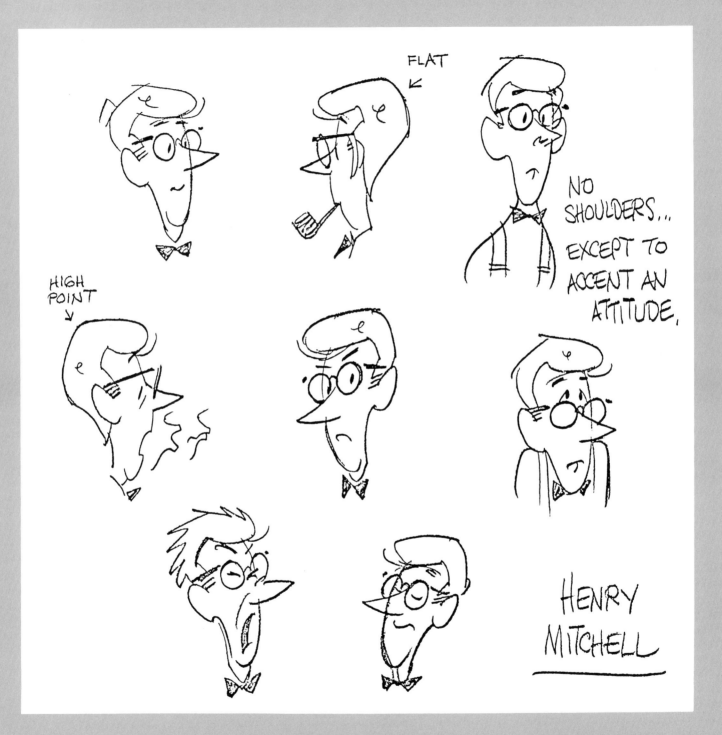

FLAT

NO SHOULDERS... EXCEPT TO ACCENT AN ATTITUDE.

HIGH POINT

HENRY MITCHELL

pany, and during the Christmas rush he loved working as extra help in the toy store.

The summer of his freshman year, Mitchell was a counselor at the YMCA camp up on the lake. During the break in his junior year, he and a pal bicycled through France and Switzerland.

At college he was active in the NROTC and earned his ensign's commission at graduation. He is currently a lieutenant (j.g.) in the Reserve and attends meetings once a month.

Henry invariably wears a bow tie and, in spite of protests from his family, he occasionally smokes a briar pipe.

He is the only son of Virginia (Miss Ginny) and Daniel (Hoss) Mitchell, both now deceased. His mother was the former Virginia Dean, a Montana rancher's daughter who, prior to her marriage, was a county librarian. "Hoss" Mitchell was born and raised in Social Circle, Georgia, but moved north to the Minnesota woods during the Depression and became foreman in a fiberboard mill. He was a disciplinarian of the old school and saw to it that young Henry toed the line. He was also a Dixie trencherman, especially devoted to hominy grits, black-eyed peas, homemade biscuits, smoked ham, and gallons of Coke. Needless to add, he was badly overweight.

Mitchell did not subscribe to the popularity of demon rum and allowed no alcohol in his home. Ever. But he did keep a pipe going, using the most evil-smelling acrid tobacco, much to the anguish of Miss Ginny.

He could never get Henry interested in bird-shooting, but he did lure him into fishing on some of the many nearby lakes and streams—a pleasant pastime Henry intends to pass along to his son, Dennis.

Henry Mitchell first noticed the Johnson girl one afternoon in late October when she

Typical neighborhood view

was working as a teller in the First National Bank. He was making his monthly payment on a secondhand MG and was smitten immediately. He was twenty-four years old and Alice had just turned nineteen. They were married the following June, and she bore him a son two years later.

Henry and Alice have been married for seven years and recently moved into a two-story, three-bedroom fixer-upper in a quiet residential neighborhood on the outskirts of Wichita, Kansas. We get an occasional glimpse of their courtship and marriage through a peek at their snapshots, home movies (now videotapes), and tender reminiscences exchanged when they think Dennis is fast asleep and Henry holds Alice on his lap, something Dennis finds hilarious.

Henry is employed by a highly successful aeronautical engineering firm, has been given an office of his own, and shares a secretary with a colleague across the hall. His annual salary of $40,000 plus a modest bonus at Christmas offers the Mitchells a comfortable cushion and allows Alice to remain a housewife and attend to the constant needs of her active offspring.

Henry Mitchell is a very lucky young man with an attractive, healthy family—and his company thinks that he is a "comer."

Alice Mitchell

Alice Mitchell was the youngest of two daughters born to Elizabeth (Dennis) and Carlton Johnson, members of a pioneer family descended from Augusta and Ebenezer Johnson who emigrated westward from Pennsylvania in the 1840s, settling on the rich farmlands of the then-virgin Ohio Territories. Alice never tired of listening to Grandmother Dennis tell the story of her

comparative sizes

Alice's father
(Grandpa Johnson)

own grandmother's thrilling journey into the unknown wilderness. As a bride, Augusta and her husband packed their worldly goods into a Conestoga wagon and headed west, first upon the deck of an Erie Canal barge, then aboard a Great Lakes steamer, and finally behind a pair of oxen and into the trackless forests of that faraway time. These family tales helped shape young Alice's character and imbedded the value of hard work and personal worth that she attempts to pass on to her son.

Following her high school graduation, Alice was urged by one of her teachers to pursue a career in diet and nutrition, whereupon she enrolled in the state university and began her four-year commitment to unravel the mysteries of calories and cholesterol.

Her sister, Irene, married a high school sweetheart and moved to North Carolina, so when their mother died unexpectedly, Alice felt it incumbent that she return home and look after her father, even though that sturdy individual insisted he was perfectly capable of taking care of himself. When this became apparent, Alice thought seriously about resuming her interrupted studies but decided that a year's experience in an actual job might be of value, so she accepted a position in the local bank and continued to live at home.

As it turned out, it was a good move. She was on the job less than a week when she became acquainted with one Henry Mitchell, who had just returned home after completing two years of military service and was making monthly payments on a secondhand automobile, a fire-engine-red MG roadster.

Young Mitchell wasted no time in rearranging his loan payments to a weekly schedule, opened a savings account, and

Mitchell Residence

Upstairs / Mitchell's

Mitchell Residence Elm Street Entrance

rented a safety deposit box, all of which to justify frequent visits to Miss Johnson's counter. For the first few weeks the security guard thought Henry was a temporary employee of the bank!

Henry's father had taken early retirement and spent much of his time fishing the local lakes and streams, seemingly fully recovered from the severe stroke he suffered the previous spring. The pert little Johnson girl made a tremendous hit with old "Hoss" Mitchell, especially when she demonstrated some of her recently acquired culinary skills on that memorable Thanksgiving afternoon when the two families sat down together at the Johnsons.

The glorious feast with all the trimmings was followed by some hilarious and uninhibited singing around the piano, an exchange of outlandish stories, and everyone poring through old family photograph albums. The chemistry was perfect, and Alice and Henry suddenly found themselves on a fast track that led them to the altar the following June.

No sooner had Alice left home and settled into married life than her father suddenly decided the old family house had served its purpose, put it on the block, and moved into an apartment in the city. Carlton Johnson (in school they called him "Swede") was catching his second wind and embarked on an exhausting schedule of travel throughout the country, investigating the outer boondocks and little-known villages seldom marked on maps. He was an enthusiastic booster of See America First and looked askance at those who spent their vacations in Europe. Alice's daddy was a debonair dandy and a genuine "character." He had mischief in his eye and bounce in his step—reminding you exactly of his grandson, Dennis.

The Mitchells receive postcards regularly from Grandpa Johnson, and once a year he descends upon them, usually to stay for three days, or until completely worn out from trying to keep up with Dennis. As the two are like peas in a pod, they get along beautifully together, but neighbor George Wilson is skeptical of Johnson and doesn't trust the one any more than the other; although I suspect there is a bit of jealousy involved as well.

After saying goodbye to the Mitchells, Grandpa Johnson always heads for the Atlantic seaboard to spend the weekend with Alice's sister, Irene, getting some much-needed rest as they have no children.

Alice adores her daddy and looks forward to these brief visits, as does Dennis who wants to grow up to be "just like Grampa"—causing Henry's eyes to roll ceiling-ward.

Alice's activities are almost entirely home-centered, although she is being drawn more closely into the PTA now that her youngster attends daily "kiddiegarter." Twice monthly she joins her afternoon bridge group, which meets on a rotating basis in each other's homes.

Alice Johnson was a strong tennis player in school, but Alice Mitchell will not be able to fit a sporting program into her schedule until next year when Dennis enters the first grade. And she can hardly wait. In the meantime, she keeps herself trim with twenty minutes of early-morning calisthenics.

She is on friendly terms with the mothers in the neighborhood, who often look after each other's children and carpool when needed. Other friends are mostly old college chums and a few bridge-playing wives of Henry's fellow executives. But Martha Wilson, her childless next-door neighbor, is

Mitchell backyard

truly a valued friend and confidant with whom she shares recipes, gossip, and Dennis.

The Mitchell house is neat and well kept though never quite "spotless," since the five-year-old whirlwind and his dog, Ruff, consistently manage to transport samples of the environment from the backyard to the kitchen and on into the bedrooms. Her broom, bucket, mops, brushes, rags, and vacuum cleaner are close at hand, and vibrations of the washer/dryer seem endless.

Standard items on the weekly shopping list are soap powder, detergents, paper towels, ketchup, peanut butter, root beer, milk, and bread. Although Dennis often "gets away with murder" in his weird assortment of snacks, the Mitchell family eats sensibly and well, thanks to Mother's early training in diet and nutrition—and to Daddy's ability to bring home the bacon.

The city bus stops at the corner, making the daily office commute for Henry almost effortless—fortunately, since parking in town has become a pain and Alice needs the car for shopping, to take Dennis to school, to pick him up again at noon, and for other chauffeuring chores, impromptu or planned. Henry secretly longs for his old MG roadster, and Alice, not so secretly, hopes they can soon afford to buy a station wagon; Dennis lets everyone within earshot know that he wants a pony!

Martha and George Wilson

George Wilson is a good man, a trusted neighbor, and a responsible citizen. He has retired from the U.S. Postal Service and enjoys privacy and time to fuss about in his garden. Regular intrusions by Dennis and his short and sometimes furry friends tend to increase his circulation and set his teeth on edge.

Wilson back yard
& potting/tool shed

George also collects postage stamps, a hobby he pursues during spells of bad weather. He does not engage in sports, although when he attended high school he was a substitute center the year they almost won the city football championship. He has suffered a "trick knee" ever since. However, during this scholastic period, Wilson was of a musical bent. He sang in the glee club and the church choir, played bass drum in the marching band, and strummed a guitar for his own pleasure at home. Now he likes to fiddle around with his ukulele and warble the favorites of yesterday—oddly enough, he recalls most of the lyrics.

Before he married Martha, George was an ardent exponent of dry fly fishing, more of an art than a sport. Today he doesn't often get on a stream but he still enjoys tying flies. Dennis muses, "That's funny! At our place we just *swat* 'em!"

I am under the impression that the Mitchells' portly neighbor takes an occasional nip and that Martha gently prevents him from overdoing. I have been told that he usually turns to the cooking sherry when he is under stress. Apparently he is never obnoxious or ill-behaved or out of control; his speech isn't slurred nor is his equilibrium disturbed. The sipping is carried on as a matter of course, although I have never seen him lift a glass.

Wilson is overweight, short of breath, and suffers from high blood pressure and a touch of emphysema as well. He is not adept at "fixing things around the house" and seems to be at odds with screwdrivers and hammers; he leaves these matters to Martha who handles them with quiet dispatch. However, when he steps into the garden, his thumb turns green.

The Wilsons have no children of their own, which is Martha's biggest regret, but she more than makes up for it by spreading her motherly warmth and charm to all of the neighborhood children and their pets. She is a poor man's Julia Child, directly responsible for the permanent yummy smells about the house, for her own generous girth, and for George's ample belly. She is also a whiz with needle and thread in spite of her arthritis. Martha has an unmarried sister who is an assistant librarian in Honolulu and an uncle living in Canada. George's father, going on ninety-two lives in a rest home in Arizona.

"Just give the boy a chance," she pleads, "and he'll grow on you," "Yeah. Like a wart," he grumbles.

Two years ago the Wilsons bought their first television set. For all these years they never believed in the virtues of the box, feeling that it was just another invasion of their privacy, and much preferred reading and listening to classical music on the radio. But they found themselves constantly out of breath running next door every time there was a special telecast and finally gave in to the twentieth century.

Their house has long been paid for, and they live quite comfortably on George's modest government pension. Martha also has "a little something put away for emergencies." She saves coupons and all sorts of stamps redeemable at the supermarket and scans the papers for sales and bargains. The Wilson automobile is almost a collector's item.

Neither of them has ever flown commercially. Martha experienced a hair-raising ten minutes in a barnstorming ride at the County Fair when she was a young lady, but since then has kept her feet on the ground. George simply doesn't believe in airplanes and refuses to accept this mode

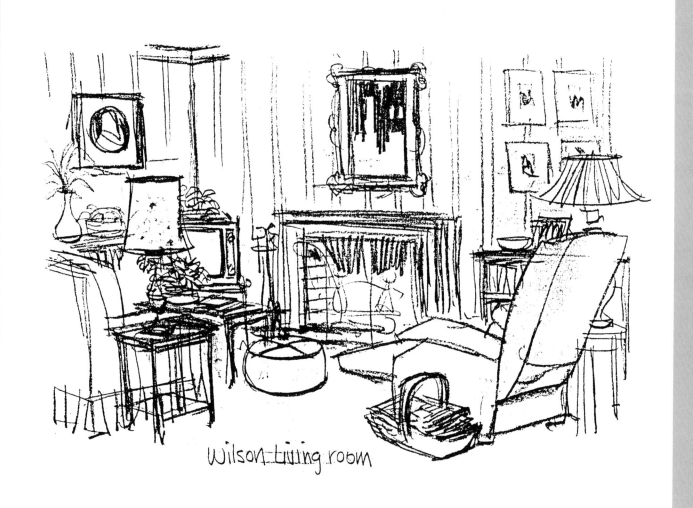

Wilson living room

Martha
Wilson

of transportation, although he allows his letters to go airmail.

George usually sports a floppy hat while working in the garden and, except for special occasions, seldom wears a suit and tie, much preferring the casualness and loose comfort of a soft, short-sleeved polo shirt, a large alpaca sweater, and some loafers. He sleeps in a nightgown and warms his bald head with a stocking cap.

To some, Wilson looks like an old hash-to-the-elbow chief petty officer; to others he recalls the image of a crusty top sergeant, a Marine drill instructor, or a chubby General Patton. Ironically, due to his flat feet, he never served in the military and rode out World War II in the Post Office.

Martha Wilson is sixtyish, grandmotherly, even-tempered, tolerant, and the closest of friends with her neighbor, Alice Mitchell. She is Dennis's refuge whenever George is on a rampage and takes the lad in stride, with an open invitation for cookies, hot chocolate, or for whatever is on the stove—chiding her husband for his cavalier manner. Dennis thinks she is the greatest, and she thinks Dennis is all boy and all right.

Her favorite expression is, "Oh, George . . . he's only a little boy." To which George responds, "Ghengis Khan was a little boy once, too."

Martha Wilson is of Scandinavian extraction and a religious person, attending church regularly each Sabbath. She is also active in the sewing group, a dozen ladies who brown-bag it at ten o'clock each Thursday morning. George hasn't been inside a church in forty years.

"Poor old Mr. Wilson" has often vowed to sell his property and move far, far away where he will never ever have to put up with the likes of Dennis again. But it is all a

High forehead. Nose like her husband's...tho a bit smaller

soft hair on top of head

Hair rolls tightly around head

Granny glasses

Ample/plump wears corset

Heavy legs

bluff, though heartfelt at the time. He gets over it, but is never really reconciled to the agitations and the bold intrusions that disrupt his peace of mind. Blissfully unaware of the incipient high blood pressure he arouses, Dennis considers Mr. Wilson his very best friend, an ever-handy source of wisdom and conversation. Viewing the Wilson property as an extension of his own home, he sashays blithely in and out at all hours, never conscious of a lack of welcome nor sensitive to George's sarcastic attempts to get rid of him. Sarcasm, Mr. Wilson's prime weapon, is wasted on Dennis, so he will occasionally come right to the point with an invitation to "get lost!" Dennis regards this as only another facet of his neighbor's fascinating personality.

The youngster treats him as a grandfather figure and assumes that this affection is mutual, which is close to the mark, though Wilson would as soon choke as admit it. And indeed Dennis aggravates his long-suffering "best friend" almost beyond endurance, telephoning him at all hours, barging into his bedroom while he and Mrs. Wilson are still asleep, banging on the door until someone "hears" him, inviting himself to dinner, and otherwise acting like a member of the family.

As Wilson explains the situation, pointing to the house next-door, "He sleeps over there, but he lives here."

Joey McDonald

Joey is almost like a younger brother to Dennis, looking to him for guidance and inspiration, admiring him uncritically, and following his lead in learning how to cope with the unpredictability of adults, parents, and older kids.

Sometimes he speaks with a slight lisp, but it comes and goes. Occasionally he

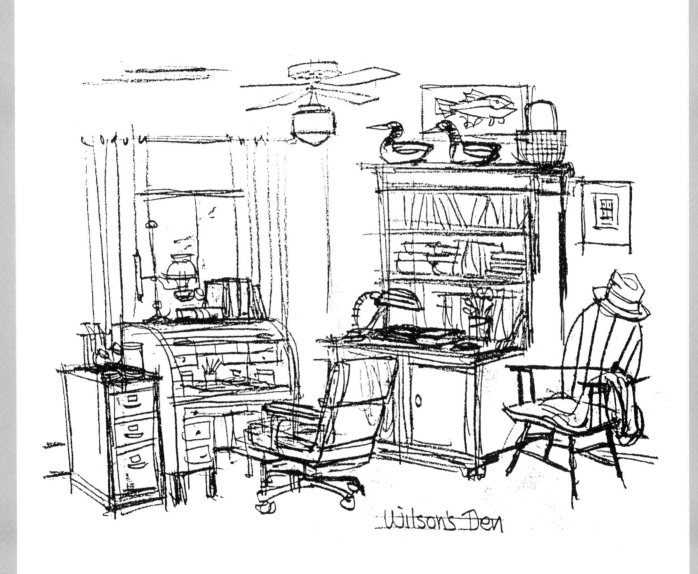

Wilson's Den

The Wilson front porch

A trio of
Joeys

places a forefinger to his lips as he ponders a situation—but he does not suck it.

He looks upon Dennis as a paragon of courage for his temerity in defying Mr. Wilson's verbal blasts; Joey himself will flee like a startled rabbit at the first intimation of adult hostility. Dennis constantly goads Joey to test his courage through such actions as ringing a neighbor's doorbell. But Joey's nerves always give way in the process, leaving him paralyzed and shaking on a strange porch, while Dennis explains helpfully from behind a bush. "He don't want nothin', lady; he was s'posed to ring it an' *run!*"

Dennis's mother thinks Joey is "cute" and often gives him a hug and takes him on her knee, which arouses spasms of unaccustomed jealousy in her real offspring. "Hey, get off! That's *my* lap!"

But Joey is like a shadow and follows Dennis wherever he goes, thinking his mentor has the answer for "everything." One of them is the I've-Been-Through-the-Mill Teacher and the other a Worshipful Neophyte.

Gina Gillotti

Gina, the attractive girl with long dark hair, personifies all the warmth, passion, and charm of her European ancestry. Impulsive and outgoing, she is attracted to Dennis, perhaps sensing instinctively the same qualities beneath his brash exterior. Theirs is a straight, aboveboard, man-to-man (or rather girl-to-boy) relationship. She plays it on the level and doesn't try to change or improve Dennis, although she may offer him a tidbit from her lunch to show that "there are more things in life than just peanut butter, paisano." She listens soberly to his opinions, offering only the comment, "Maybe you got something there," an atti-

BIG eyes
very mod

Gina

tude Dennis greatly appreciates. As he said to Joey: "Good ol' Gina. She tells it like it is but she never puts ya down."

To Dennis's great admiration, Gina never comes unglued in the presence of spiders, crawly bugs, or lizards, opining only that "He's a big one, all right." But when Dennis crows to Margaret, "You don't hear Gina shriekin' or hollerin' like some silly ol' girl!" she lets him have one across his backside with her parasol, informing him in no uncertain terms that, "I'm a girl, too. And don't you ever forget it!" Dennis later confides to his mom, "If there ever *was* such a thing, Gina would by *my* kinda girl."

This relationship has Alice somewhat baffled, but not Henry, who recognizes the attraction of a girl who doesn't bug you all the time.

Margaret Wade

There is a Margaret Wade in every man's life. James Thurber knew her simply as "Woman." Threatening, bossy, superior, always pursuing, the incipient castrater. Some of us marry her, some escape, and others are rescued. Here we see the problem in its haziest beginnings. If Dennis is lucky, Gina will rescue him. Otherwise he is a goner, for Margaret has been attracted to him.

Who knows why? Perhaps she perceives his freedom in speech and action as a challenge to be met. But more likely, the vitality and disorder of his very male personality appeal to her as a Woman's Problem: an untidy room to be cleaned up and put into order. Whatever the reason, she keeps coming on in spite of rebuffs, insults, put-downs, and outright statements of total rejection. All of this fazes her only momentarily, for her mind is made up.

Margaret Wade

The Menace's Nemesis

⅓ HEAD TALLER THAN DTM

LACE SLIP SHOWS BELOW HER SHORT SKIRT.

CURLS LIKE WOOD SHAVINGS.

SUGGEST A CHIPPED TOOTH

Specifically, she corrects his grammar, scoffs at his fantasies of Santa Claus, uses words like "nitrogenous" and "chlorophyll" that leave his head spinning, assails his lack of manners, and, worst of all, insults his dog. Dennis reacts to this with a blend of confusion and outrage, held in check only by his code: "You can't hit girls."

As you might expect, Margaret excels in school. She is something of a bookworm and a student of the piano, but her passion, aside from shaping-up Dennis, is for the ballet. She longs to float like a butterfly from flower to flower, an ambition that Dennis finds irresistibly hilarious. He tolerates her piano-playing as long as the cookies hold out. In fact, Margaret's cookies and fudge are the cement that, however shakily, holds their relationship together. As it has been since the world began, the way to Dennis's attention, if not his heart, is through his tummy.

She makes a concerted effort to impress him with her domestic talents, displaying her dolls and their wardrobe, saying proudly, "I make all their clothes myself."

Dennis finds all this neatness and domesticity a depressing experience, confiding later to Ruff that "You gotta feel sorry for anyone who has to live in a room like *that.*"

Occasionally he finds something to grudgingly admire about Margaret, like the time her roller skates zipped out from under her, leaving her sitting in a mad heap on the sidewalk, and he said to Joey, "Imagine *her* knownin' a word like that!" But theirs is mainly an adversary relationship.

Gina, the chic little Italian girl, has become a major irritant to Margaret. She sees Dennis being attracted by Gina's straightforward, unaffected manner and is resentful of her easy success in winning Dennis's respect, something all her airs and pretensions have been unable to accomplish.

Dennis, although he hasn't a clue, is up for grabs, as we all were at one time. While the conflict will never be settled on our level, the Human Drama has already begun to unfold as Gina and Margaret contend, all unconsciously, for his soul.

This is pretty deep stuff.

The Playground Caper

In the fall of 1952, the Monterey Planning Commission designated a rubbish dump for development as a children's playground. At about the same time, the first *Dennis the Menace* collection of cartoons was published by Henry Holt & Company and appeared on the *New York Times* Best-Seller List, which probably prompted the call from the Junior Chamber of Commerce. They had undertaken the building of this play area as their project and politely asked if I would donate some copies of my book and autograph them to kick off a fund-raising campaign.

"What sort of a playground did you have in mind?" I inquired.

"Oh, the usual kind. You know, swings, rings, wading pools, slides, and teeter-totters. . . ."

Without really thinking it through, I blurted, "Tell you what. I'll be happy to donate 500 books and autograph each one—on the condition that you'll let me design the playground." Until then, I hadn't realized you could slip your foot into your mouth so easily.

There was no mulling over or meditating on the other end of the line. "You got yourself a deal. Hank! Call us if you need help!" Click.

Since plunging into the world of pre-schoolers, I had become increasingly aware of the prevalence of playground accidents, many of them fatal, and been determined to someday become involved from the design side. But opportunity knocked sooner than expected, and now I was committed to the Peninsula Jaycees to come up with some innovative concepts.

My first move was a wise one, I hired Arch Garner. Arch had taught sculpture at

Occidental College, designed sets for several of the major Hollywood studios, and was living in Monterey, keeping himself occupied with some part-time teaching. When I described the project, his whole face lit up—even his moustache twitched with excitement. It was definitely "an offer he couldn't refuse," and for the next three years we wallowed in a nonstop creative binge, sketching, researching, modeling, and carrying on until all hours, often bringing the days to a close with a few rapid games of chess and a certain measure of liquid stimulants.

As every parent has observed, when the child tires of his choo choo train or his bathtub boat and other literal toys, off he

HK conducts a little research in a Carmel kindergarten.

Dennis the MENACE
PLAYGROUND

- DESIGNED BY ARCH GARNER & HANK KETCHAM
- FUNDS FOR EQUIPMENT BEING RAISED BY THE MONTEREY JR. CHAMBER OF COMMERCE
- MAINTENANCE, GRADING, IRRIGATION, FENCING, & PLANTING BY THE CITY OF MONTEREY

FOR THE FREE USE OF ALL CHILDREN!

Designer Arch Garner and his two costumed children assist Hank Ketcham at the 1956 opening ceremonies of the unusual playground in Monterey.

scoots to the kitchen cupboard to dig out some pots and pans, an eggbeater, a sieve, big spoons, and other exotic culinary treasures to hook up or stack or nest and to call it whatever he wants. A train can *only* be a train. A boat is a boat is a boat. But the wild-looking kitchen utensils can be *anything!*

Arch and I were in complete agreement and approached every design from an abstract point of view. Our single realistic play unit was old 1285, a huge steam switch engine and coal tender, donated by the Southern Pacific Company and moved to the site by the Corps of Army Engineers at nearby Fort Ord. The first thing we did was to remove the clapper from the bell, seal the fire doors, and add some handholds along the outside of the boiler. And what a success that turned out to be! Those little tykes would otherwise never have had the opportunity to inspect such a historic monster as this ancient steam locomotive, and

I believe that most of the parents were equally thrilled.

The Grand Opening was in 1956, and since then there have been several renovations. On February 20, 1988, after being closed for three months during major repair and new construction, a gala reopening, complete with a ribbon-cutting mayor, speeches, free cookies and root beer, was attended by three thousand exuberant youngsters who swarmed at the gates like dogs in a butcher shop. It was most gratifying, and I only wish that Arch could have been there to take a bow.

The Ranch

From the day *Dennis the Menace* was first released to the daily newspapers, the client list began to build quickly, and before a year had passed the syndicate wanted me to produce a Sunday page in color. This, I knew, would require an assistant artist and a secretary to keep me ahead of deadlines and my affairs in some semblance of order, so I abandoned the tiny bedroom studio in our Carmel cottage and moved into a vacant doctor's office in Monterey. I placed Al Wiseman behind a drawing board and Fred Toole at a desk with a writing machine, a telephone, and a file cabinet and felt quite organized.

Just when we were getting used to the pace, Pines Publications (which later merged with Fawcett) urged us to get into the comic book business. Fred, a serious humorist recently from New Jersey, was a capable writer and Al, a free-lance advertising artist, was a crackerjack with the pen and ink, but this was too much of an extra work load; so I cast about for additional art talent and came up with Bob Paplow, a seasoned pro from the Bay area, and Lee

Perched on the diving board just outside the cabana/studio at the ranch are sculptor Arch Garner, artist Bob Paplow, writer Fred Toole, syndicate president Bob Hall, and Hank Ketcham.

Holley, a young fitness nut and a clever cartoonist with a special affinity for the younger generation. We were in business! Other cartoonists who shared their pen-and-ink talents with me in those early days and who made unique contributions to *Dennis the Menace* were George Crenshaw, Vic Lockman, Homer Provence, and Owen Fitzgerald.

But I soon felt hemmed in and hungry for more space and some privacy, something faraway from the coastal fog and the bright lights, a spread with rolling hills, a swimming pool, maybe even a horse or two.

Then, glorioski! Just such an establishment was brought to my attention: a seventy-acre ranch situated on an oak-studded hillside in the upper Carmel Valley, completely fenced, with its own water system, and a mere forty minutes away from the Monterey Peninsula.

The charming Spanish adobe residence and guest cottage overlooked sweeping lawns and gardens leading down to the swimming pool and cabana, and in the distance were the typical California soft golden hills dotted with live oak trees. On the lower level of the ranch, near the main entrance, was a five-acre permanent pasture and a full-size barn and stables, along with shelters and pens for small animals. And on the edge of the orchard stood a Victorian-looking ranch house for the foreman and his family, designed in the thirties by Wilson Mizner. I felt that I had stumbled onto the Pastures of Heaven. I couldn't wait to move into this dream—which all too soon turned into a nightmare.

Fred McKenzie (Mac), with his super green thumb, turned the place into a veritable Eden. His son, Dick, was a fine horseman and a carpenter and maintained an efficient ranch management. On occasion I would donate a case of beer and he would bring in some of his cowboy pals and put on a rollicking family rodeo. Toshiko, our devoted housekeeper, would drive up from Monterey each morning, organize the laundry, and keep the place spotless. And holding forth in the large kitchen was cleaver-wielding jumbo Jim Chong, two hundred and sixty pounds of teeth and tummy—and a most obliging cook.

For months, though, I had felt that something was missing in Jim's large kitchen; then suddenly it struck me—a canary! Of course! What could be more appropriate in that sun-splashed room than a golden-throated songbird in a gilded cage! In a matter of days I proudly presented the ornamental grillwork and the yellow bird to Jim. Although typically inscrutable, he seemed surprised and pleased. The distant warbling was going to add pleasure for all.

The adobe main house of El Robledo, seventy heavenly acres in the Pastures of Heaven. Below: The pool and the surrounding studio quarters.

Jim had the weekend off and took the train to Sacramento where his son and his family lived. He also took the canary. When he returned on Monday, he presented me with a fresh ten-pound salmon wrapped in the comic section of the *Sacramento Bee.*

"My son say thank you for bird," said Jim with a polite nod. I caught a glimmer of his gold tooth, so I knew he was smiling. I wasn't. I felt sadly deflated, but what could I say? Well, so much for the warbling and trilling.

Aside from trolling for salmon and spearing bottom fish on summer camping vacations when I was growing up in the Evergreen State, I had very little fishing ex-

Ranch foreman Dick McKenzie and I try to stay awake counting sheep on the lower pasture.

perience. However, a few lucky kids in my neighborhood grew up in family traditions of weekend camping on mountain lakes and rushing rivers, pitting their piscatorial hocus-pocus against the innate intuitiveness of the ravenous gilled species. Listening to their outlandish descriptions of record catches and mouth-watering reports of elaborate outdoor cooking, I could hardly contain myself. But there was no sign of an Izaak Walton on the Ketcham family tree, so I never became acquainted with the Rod & Reel Society, but I always had a hankering to tackle (if you'll pardon the expression) the subject some day.

Shortly after acquiring my hilly retreat, I took a walking tour of inspection with Dick McKenzie, the ranch foreman, and deep in an oak grove, a five-minute stroll from the adobe main house, I discovered an attractive two-acre plateau that served no earthly purpose and appeared to be the an-

swer to an angler's prayer: an ideal location for a man-made trout pond.

Dick spent most of the ensuing six months on a bulldozer. He first built an access road, then gouged out an hourglass-shaped cavity twelve feet deep and an acre in .size, leaving a tiny desert island in the center. Arch Garner designed an attractive Japanese-style footbridge that bisected the pond. A dam, or dike, was carefully constructed along the precipice that dropped off to the nearby river bottom, where we installed a large turbine pump that delivered the pond's water to a fifty-thousand-gallon redwood storage tank on the hill. A stone fish ladder had been a *must*. This was an ascending series of tiny connected ponds that at the top became shallow sandy-bottomed spawning pools. The current flowed down through them in short waterfalls, around river boulders and huge redwood logs imported from the Big Sur, then plunged back into the lake in a majestic twenty-foot cascade. And this was only the beginning.

I wanted no lights or piped-in music, but I did install a cleverly camouflaged watering system in the surrounding oaks to irrigate the earthen dam and the lakeside area. An ichthyologist from the University of California offered his expertise on preparing the lake with ingredients necessary for future food and growth, along with advice on what, when, and how to stock the rainbow fingerlings and the necessity of monitoring the ph factor of the water. I really got myself all wrapped up in the project and even ordered a neat-looking six-foot wooden punt from an outfit in Maine so I could scull my way around this watery *Shangri La*. This was creating on a grand scale, and I felt like *God!*

The county agricultural offices were

My anticipated pride and joy, the two-acre trout pond, with the tiny island and the long earthen dam on the right.

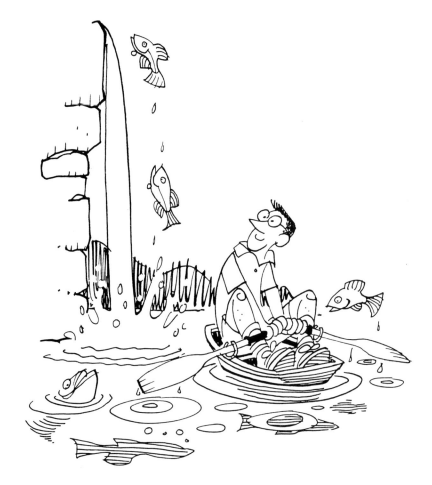

water was in place. Birds of all description were attracted, and after we had stocked the trout, kingfishers would perch on the oak limbs and await a dining opportunity and mallards would use the pond as a rest stop. Near the end of day, deer cautiously watered themselves at pond edge, preceding the nocturnal gathering of raccoon. And more than once I have glimpsed a larva wriggling to the surface, transform itself into a dragonfly, and instantly join the winged species.

The following winter was fraught with record rainfall. I was in New York City, meeting with the syndicate, the comic book people, and some advertising agencies, when I received a telephone call from McKenzie.

"I sure hate to interrupt your trip like this."

"Whatsamatter, Dick? You all right?"

"Yeah, I'm okay. It's the pond.... It's ... it's sprung a leak."

"A *leak?* Where? How come? We sheep-footed that mother to a fare-thee-well!"

"I know, but there was a small root that ran through the center; it just rotted out and allowed the water to seep through! And, what with all the rain we've had, the earth just crumbled; the seepage gave way to a massive release of the lake."

"And the fish?"

"The fish, too. And the people living down along the river are a bit upset with all the mud and brush and debris in their yards."

I was in shock. After all the time and trouble and expense—why me?

"Thanks, Dick. do what you can. I'll be flying back on Friday."

"I was hoping you'd come back sooner, Hank. There are more lawyers down there than bulldozers."

helpful, as was the State Soil Conservation Society, which, incidentally, talked us into producing a special conservation comic book, *Dennis and Dirt.* It was a subject I learned to know well.

It took four days and three nights to fill the pond. And what a glorious sight it was, even in its barren, raw condition. We introduced mosquito fish immediately to keep the pesky larvae under control. Six months later, three thousand slippery Rainbow youngsters tumbled into the brine, and we were in business. It was amazing to observe the ecological development once the

At the Navy Postgraduate School, Monterey, California, Gerald A. Eubank, Rear Admiral, USN, Ret., (HK's former CO) presents a "Letter of Appreciation" from the Secretary of the Navy, February 1955.

A representative from the US Treasury Department coaxed a group of cartoonists to meet for a Savings Bond rally in Beverly Hills at the home of Milt Gross. Back row, from the left: Zeke Zekley (worked with George McManus on Jiggs), Hank Ketcham, Bruce Russell (L.A. Times), Ferd Johnson (Moon Mullins), Don Tobin (magazine free-lance), Dan Spiegle (Hopalong Cassidy), Jeff Machamer (free-lance) hiding the head of Mik (Ferdinand). Front row: Gus Edson (Andy Gump), Billie de la Torre (Little Pedro), Buford Tune (Dottie Dripple), Rennie McEvoy (Dixie Dugan), singer Ronnie Kemper, Frank Willard (Moon Mullins), and Chick Young (Blondie).

It doesn't. But when the chemistry turns sour and the players become bored, disgruntled, and unruly, the fun evaporates, and you wonder why you went to all the trouble and expense just to see it go down the drain.

Eight-year-old Dennis was attending a private day school nearby, and he suffered severe learning disabilities that were not being properly addressed by the family. His mother, too caught up in luncheons, teas, and bouts with demon rum, couldn't focus seriously on much of anything. His well-intentioned father was buried in creative work, absorbed in the additions and improvements to the ranch property, and wasn't spending time with his small family nor paying attention to its immediate needs.

The winter of 1959 was a dreary, wet one, and when a tight-lipped Alice packed

The studio had been set up in the poolside cabana, and the troops happily commuted from the fog and drizzle of the peninsula to the sunny blue skies of the valley. I often wondered if the attraction was the weather or Jim Chong's chow, which he served up in ample portions each noon in the main kitchen. One might think that it doesn't get much better than this.

A morning poolside coffee break, with Fred Toole, Arch Garner, Hank Ketcham, and Bob Paplow discussing future projects.

Opposite, left: *Ed Dodd, creator of* Mark Trail, *gives me a few pointers during a meeting at his estate outside Atlanta, Georgia.* Opposite, right: *Milt Caniff, daddy of* Terry and the Pirates *and* Steve Canyon, *does a little mixing and matching with Dennis during a chalk talk in New York about 1956.*

her bags and moved into Carmel, it became a depressing and lonely one. It was a bummer. We had been on a collision course and nobody cared.

The little girl from Malden tried valiantly to cope. She was a splendid wife and a loving mother, but the world was spinning too quickly for her. She had nothing to hold her steady except the relief she found in barbiturates and alcohol. My patience and knowledge of the disease were woefully lacking, and, tragically, she succumbed shortly after her fortieth birthday.

Blind Rebound

In touring Disneyland a few months after it opened, I noticed a chap about thirty-five years old dressed in plaid shorts and loafers who was clutching an ice cream cone and going on the rides all by himself—with

no one to nudge! It was a sad sight and reminded me how much I depend on being *with* someone. This must be a reaction to all the crummy rooming houses and the lonely weekends and holidays I spent feeling sorry for myself. No question about it, I'd make a lousy monk.

Perhaps with that in mind, I agreed one evening to have a blind date with Jo Anne Stevens and sip liquid refreshment with mutual friends at the Hotel Carlyle in New York. While an exuberant Bobby Short kept the rafters ringing, I leaned closer and learned (much of it by lip reading) that Miss Stevens was a Tacoma girl, a former undergrad at the University of Wisconsin, and most recently a United Airlines flight attendant ("stews" we called them then), part of the charter crew for a campaigning Richard Nixon. The conversation was most interesting, but the smoky room was severely overloaded with decibels. We excused ourselves and rode down to "21" for a leisurely nightcap beneath the toy trucks and the airplanes.

Jo Anne described her association with a New York travel agency and seemed itchy to get on another tour. Although she had already traveled to remote boondocks in all corners of the world, she kept moving with the anxiety of a shark doomed to perish once he stops.

It was intriguing, almost hypnotic, and I wanted to continue the "interview." I extended my Gotham visit and spent an extra week dreaming of new horizons—becoming more and more enmeshed in the web of this cunning creature from another world. The next month, along with her mother and aunt, Jo Anne moved into the guest quarters on the ranch in Carmel Valley. A few weeks later, friend Walt Stewart flew us to Mexico in his Bonanza, making a brief stop

149

Toole, Ketcham, and Wiseman ham it up for another PR photo session.

at a justice of the peace in Carson City, Nevada, to legalize the affair.

But even while we were airborne, I started to have misgivings and pangs of doubt and realized then that the whole thing was dumb. Events had moved much too rapidly. I hadn't taken time to think things out, and I let myself slide hopelessly into a situation that my gut told me was a mistake. By the time we landed in Acapulco, a jolly old soul was not me.

Uncharacteristically, I grumped about everything: the food, the accommodations, the weather, and even the prices. However, once the sun slid over the horizon and the tequila sours took effect, I became a kinder and gentler soul and philosophically reappraised my predicament. Undue stress was obviously the villain. All I needed was rest and a change of scenery. Maybe something with an alp in it. I felt better about it. Everything was going to be hunky-dory.

THIS IS MY MOTHER, TOMMY. ISN'T SHE PRETTY?

Best of *Dennis*
—1950s

"DO YOU KNOW HOW TO COOK A PIGEON?"

"COME ON! THEY'LL BLAME IT ON US."

"WE HAD A PARTY THIS AFTERNOON! YOU MISSED ALL THE FUN!"

"NOW DON'T GET EXCITED! I'M JUST GONNA GIVE 'EM A GOOD MEAL AND SEND 'EM ON THEIR WAY!"

"IS THIS TOOTHPASTE OR SHAVING CREAM?"

"I DON'T CARE IF IT'S TEN BELOW ZERO—
THAT HAPPENS TO BE MY BEST SWEATER!"

"GET BACK ON THE SIDEWALK!"

"YOU DIDN'T CATCH US! WE RAN OUTA GAS!"

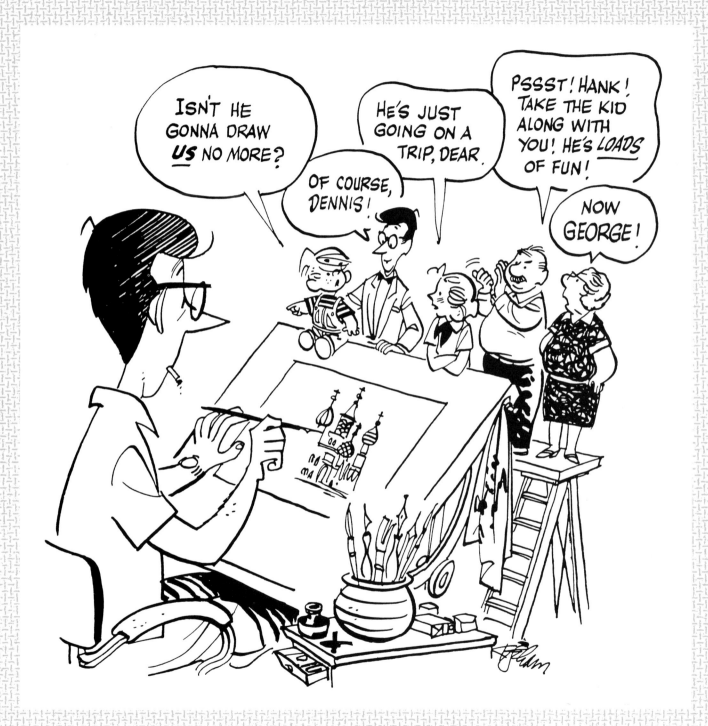

Russia-Paris-Spain, 1959-1960

CIA Cartoonist in the CCCP

My trip to Russia was necessarily planned several months ahead, and because I had announced my hope of establishing a "humor exchange" with countries in the Eastern Bloc, the item was given some media coverage. The timing was perfect, for President Eisenhower's People-to-People Program was in full swing and the State Department stood at the ready to open doors and assist in every way.

I had just mailed a batch of finished drawings at the Carmel Post Office when I bumped into Malcolm Millard, a lawyer friend I hadn't seen in weeks, and joined him for coffee at the Village Corner. After catching up on each other's current activities, my friend leaned closer and asked if I would "serve my country once more."

"Look Malcolm, if you mean going back into the Navy. . . ."

"Nothing of the sort, Hank," he laughed, stirring sugar into his java; then abruptly he became serious and lowered his voice.

"You're a widely known cartoonist and will soon be spending several weeks behind the Iron Curtain. . . ."

"Yeah, that's right," I acknowledged, now a bit apprehensive.

"Well, let me put it this way: your eyes are trained observers, they often see things that most of us overlook. And you have the ability to put your impressions down on paper."

I got the picture.

The barrister continued. "I have been asked only to sound you out, Hank. Certainly no one is trying to twist your wrist. It's just that you happen to be exceptionally well qualified for the assignment. You can turn it down cold right now if you like."

"Gee, I don't know. The thought of spending my life in a salt mine. . . ."

He picked up the check, and we ambled toward the cashier. "Sleep on it. If you're interested, call me in the morning and I'll set up the contact in San Francisco."

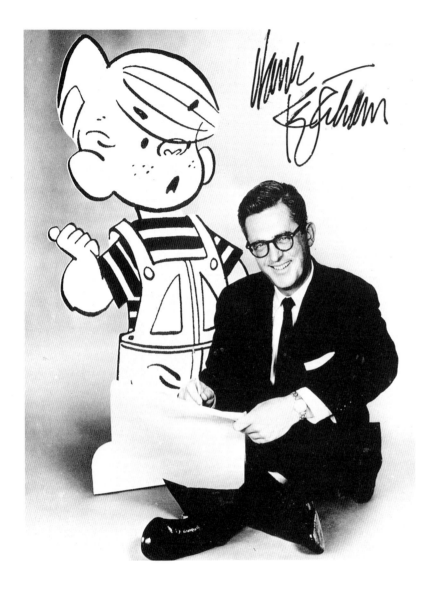

This was a publicity handout shot in New York prior to our departure on the SS United States for Southhampton and parts unknown.

"Yeah, okay. So long, Malcolm. Thanks for the . . . the coffee."

There was never any correspondence. Information was always exchanged by word of mouth, and telephone calls lasted no more than thirty seconds.

The following week I met with a Mr. Sullivan in his modest apartment on (of all places) Russian Hill. He outlined the basic plan and gave me another opportunity to back out. Not a chance. By now the intrigue was overwhelming, and I was eager to slip into my cloak and dagger.

My final briefing occurred in an obscure second-floor office in Washington, D.C., where I studied slide films, engineering plans, drawings, and photo enlargements of military and space hardware. Once I had emerged from the USSR, I was told to call a certain number in Paris for a debriefing —if I had anything to report.

Aeroflot, the Soviet airline, scheduled all routes over sensitive areas for night flights, which made it awkward for us spies. However, because I had an extensive itinerary, many of the short flights were conducted in daylight. On a few notable occasions, I was able to observe, several thousand feet below, what I thought were strange and mysterious shapes.

Bringing out my little black Minox 8mm camera would have been a dead giveaway, so I sat with a sketchpad on my lap, my head at the window, and drew circles, squares, railroad tracks, and other items of suspicion as the flight progressed. When curiosity consumed the stewardess in the babushka and she ventured down the aisle, I quickly connected some lines, blackened a circle or two, and transformed my military intelligence into a page of funny-looking cartoons. I collected several pages of these weird abstractions, but when I tried

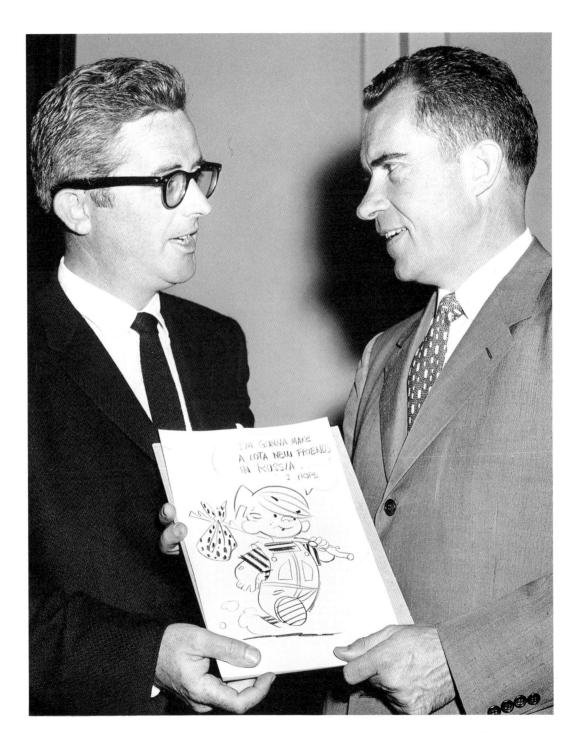

Vice President Nixon offers some advice before Dennis's daddy embarks on a "humor exchange" mission into the mysterious USSR.

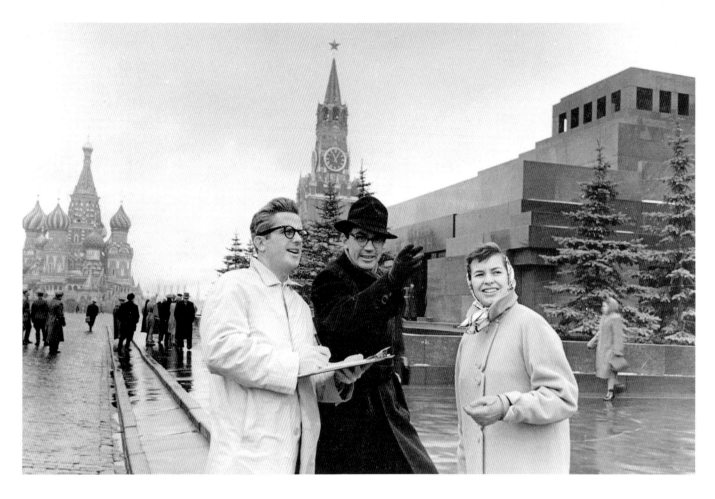

A cool day at the Kremlin as Intourist guide Vladimir Pushkov points to some historic landmarks.

to explain what they originally represented, I came a cropper.

Pearsall Helms was one of my regular golfing partners, and his brother, Richard, was at the time director of the Central Intelligence Agency. During a family gathering in Geneva many years later, I mentioned the incident to brother Dick.

"...and after all the time, preparation, and worrying myself half sick, I never *did* call your man in Paris," I laughed.

"Yes, I know," Mr. Helms said quietly, "and we haven't used a cartoonist since."

Before P & G
(*Perestroika* and *Glasnost*)

Forty days behind the Iron Curtain was a bit much. It was enlightening, often amusing, and always frustrating. I am thankful for the experience, but I believe I'll wait until the forces of *Perestroika* and *Glasnost* take a stronger effect before planning another visit.

As it turned out, the "Humor-Exchange" concept was a brilliant one. It opened em-

bassy and consulate doors through which I met newspaper and magazine editors and cartoonists from each country I visited. Of course there were translators, but they were seldom needed when the artists got together. Instantly, pads and notebooks and pens appeared and we communicated through our drawings and crazy caricatures and diagrams, all with a warm feeling of comradery and continuous laughter. The vodka, the suika, or the slivowitz added warmth to the cordiality.

A young, bright-eyed consulate officer in Belgrade was almost ecstatic about the possibilities of seeing *Dennis* appearing in Eastern European countries. I shared his enthusiasm, as I wanted to expose both cultures to the particular humor of each, to make us all aware that we have laughter as another common denominator.

"The All-American Boy Scout in you is showing, Mr. K.," he laughed. "What has me excited is that your 'typical U.S. family' lives in a two-story, three-bedroom house with a kitchen, running water, a bathroom, a color TV, a garage with an automobile, and a garden."

I was still a bit dense. "Yeah, Ed, I know, but what does. . . ."

"You take all of this for granted. It's the norm for most middle-class Americans, but in this Communist part of the world that kind of life-style is identified with the big shots! Can't you see, Hank? *Dennis the Menace* could develop into a tremendous propaganda coup for democracy and the capitalist system!" The thought had never occurred to me.

"Good point," I agreed. "I hope we can pull it off."

My tour of the USSR was going to be more elaborate than most, with visits to several different ethnic areas, so I requested from Intourist a guide to travel with us and simplify communications. Vladimir Pushkov, a pleasant young man in his late twenties, was given the assignment, and his first job was to accompany me to *Krokodil,* a humorous monthly publication that is festooned with cartoons and satire, reminding one of a cross between London's *Punch* and the *New Yorker.*

The offices of *Krokodil* were on the outskirts of Moscow, definitely in the low-rent district, and after a forty-five minute ride we arrived at what appeared to be the back entrance to an old warehouse. There was no identifying sign on the building and no apparent activity inside. We entered a drab reception hall and looked for some form of life when suddenly a door opened and a slender fellow in his mid-thirties motioned us to follow him. He led us through echoing, empty corridors until we came to a bare conference room furnished with a long oak

A Russian interpretation of Dennis being greeted by his Soviet peer, a creation of the dean of the Krokodil cartoonists, Ivan Semenov.

table and a dozen heavy chairs. I guess he had heard us whispering in the hall, so to our amazement he addressed us in perfect English.

"Please tell me the exact purpose of your visit," he asked.

I quickly described the humor exchange I had arranged in our nation's capital with the State Department. Washington was a place just halfway around the world, but, judging from the blank look on this lad's face, it might have been somewhere on the moon. At the end of my recital he pleaded with wonderful simplicity, "I do not understand."

"I'm a cartoonist," I repeated in exasperation. "A humorist. I make funny drawings for newspapers."

Not knowing what else to do, I dug out one of the *Dennis* buttons I had brought along to give the Russian kids. He peered briefly, and all at once his face lit up.

Dennis the Menace! he exclaimed. I could hardly believe it.

"But I read him every day in the Paris *Herald-Tribune!* And you say you are the creator? My dear fellow, welcome! I am Borovsky, specialist in foreign affairs for *Krokodil.* Come with me." (It must be noted that in Russia foreign publications are circulated only to authorized government departments, such as this periodical.)

He dragged us after him from office to office, talking with voluble enthusiasm in Russian to his colleagues. The only sounds I understood were "Dennis the Menace." It was positively dreamlike. "This is new to my experience," Vladimir said faintly.

"It's new to my experience, too," I answered in awe.

Finally we had eight men in tow, and back we went to the long oak table. Tea and grapes arrived ceremoniously, and I guessed that this is what our diplomats ex-

perience when they enjoy: a "fruitful discussion."

Borovsky walked to the end of the drafty room to close the window, but found it stuck. He dealt the sash a smacking blow with his fist and slammed it shut with a crash, cracking the glass and splintering the wood. "Dammit!" cried Borovsky, employing an appropriate American expression. He added bitterly, "That's the way everything works in this country."

Vladimir blushed. "We can, notwithstanding, boast of compensatory accomplishments," he murmured.

Krokodil, since the end of the Stalin regime, was no longer under so strict a political domination and could poke fun at anything and everything, including government activities. They were now producing a lot of political satire, the type of humor I wanted for distribution to U.S. newspapers —the theory being that if we could find subjects of mutual amusement and really laugh together, it might help to lessen the tensions between us.

One heavily built man, who had remained silent, now spoke, As we waited for enlightenment in a more familiar tongue, I noticed that Borovsky became dark with annoyance while Vladimir gave an embarrassed cough.

"This gentleman asks what possible interest would it avail readers in the Soviet Union to follow the adventures of a naughty child whose misbehavior is so self-evidently due to the defects of a capitalistic society . . . ?"

"Hold the phone, comrade!" I interrupted as emphatically as politeness allowed. I could not let this nonsense go unchallenged.

"Dennis is not a 'naughty child,'" I said. "He is a normal, curious, energetic little five-year-old boy with a pristine logic that all children seem to have. He communicates better with animals and toys than he does with grownups, as do kids everywhere. His dog, Ruff, is the only living creature he can talk to who won't talk back. When he's alone and insecure and feels like crying, he consoles himself with his soft, furry teddy bear."

I had to wait while Vladimir translated. The editor looked unconvinced, but I was relieved to notice that Borovsky was smiling and nodding his approval. Of course he was the only one in the group who was familiar with my daily panel. Then I tossed in the Al Capp quote that "the reason children felt insecure is because they are only half the size of grownups and don't have any money."

This produced a laugh and got me off the hook. A smiling Borovsky assured me that sixty percent of the Dennis humor could easily be translated and understood in the USSR. "That's remarkable," I said, "yet it supports my contention that, until they reach school age, children behave alike all over the world."

In Amsterdam, Dennis is called *Henkie het Huisgevaar,* and in South America, he is known as *Daniel el Travieso.* I quietly wondered what they would call him if he ever did appear in Soviet papers with Cyrillic captions: *Ivan the Terrible?* I wisely decided not to pursue the issue and addressed the logistics of my mission, which was to exchange the *Dennis* daily panels for humorous cartoons from the USSR on a simple drawing-for-drawing basis, disregarding any coin of the realm.

Borovsky *nyetted* and said that they would prefer to work out a price structure and be compensated in U.S. dollars, but we would have to accept the like in blocked

КРОКОДИЛА
(CROCODILE)

RUSSIAN JOKE....

...TOLD TO AN AMERICAN TOURIST...

...THROUGH HIS INTERPRETER.

rubles. Well, okay, I thought; they certainly need hard currency, but it sounded as though they were giving me a good old-fashioned capitalistic shafting.

"What sort of fee would you consider appropriate?" I asked.

"How about eighty dollars a drawing?" His promptness took me by surprise.

"Suits me," I said, "but tell me, Mr. Borovsky, how did you happen to pick an odd number like eighty dollars?"

"It was the arrangement," he replied, "that we worked out last year with columnist Art Buchwald." Our *Herald-Tribune* funnyman had gotten here first and rigged the pay scale!

In Bucharest we were greeted by short, bald, smiling Edgar Rafael, our Carpati guide. (Carpati is the Rumanian equivalent of Intourist.) In his mid-forties and dripping with professional charm, Edgar spoke excellent English and was visibly embarrassed when the customs officer made us open every piece of luggage. After the perfunctory Russian customs, we were somewhat surprised.

We again checked in with our embassy people and found them as cordial as they had been everywhere else on the trip. During cocktails the next afternoon with the Graham Renners and the Paul Wheelers in Paul's elegant apartment, we described the perils of touring the USSR, and they responded with a few hair-curlers of their own about Bucharest. We jokingly scoffed at the idea of Rumania being classified as a "hardship post." We thought everything looked just dandy here.

Paul Wheeler laughed. "It's all a matter of direction. You've just arrived from the Soviet Union. But if you had flown in from London or Paris, your impressions would be altogether different, I assure you."

He went on to explain that in diplomatic circles Rumania was considered an even more difficult assignment than Russia; it had been a Communist satellite state only since 1948 and was under tight-thumbed police domination. The daily lives of diplomats were filled with unusual tensions, fear, and suspicion, and secret agents followed them everywhere. That afternoon we were particularly grateful to be tourists.

Edgar arranged a visit to the Ministry of Culture to meet Gopo, the professional name of Jon Popescu, Rumania's young Walt Disney. He was a large man, six-foot-two, and about thirty years old. He wore bushy eyebrows, thick black hair, and an

amused expression, as though always on the verge of an explosive laugh. I thought of Suomalainen, the delightful editorial caricaturist we had met in Helsinki, and Ivan Semenov in Moscow, and other colleagues like Walt Kelly, creator of *Pogo* and George Lichty of *Grin and Bear It,* and it struck me that ours must be a happy craft. One rarely meets a morose cartoonist.

Gopo told us they would be happy to join us for dinner that evening, and then took us into his studio to watch two of his prize-winning animated cartoons. The technique was a bit old-fashioned, but his ideas were excellent. One entitled "Cow on the Moon," about an ox getting a ride to our neighboring satellite on Sputnik, was hilarious and had no trace of party propaganda.

By nine o'clock we were seated in the Rose Garden Restaurant enjoying dinner with the Popescus and the inevitable

Dennis's poor ol' dad pins a button on "Rumania's Walt Disney," John Popescu.

Edgar. I brought along a *Dennis* book for them, and they sealed the friendship pact with gifts of wine, a bouquet of violets, and one of Gopo's delightful drawings. As Gopo knew that I had worked for Disney years before, he was bursting with curiosity and full of questions. Edgar performed miraculous feats of simultaneous translating while we talked shop and sketched funnies all over the white tablecloth.

As we strolled out to the car, Gopo suddenly turned and ran back into the restaurant. A minute later he was back with a triumphant expression on his face and what looked like a bundle of dirty laundry under his arm. It was, of course, our mutual "masterpiece," which was decorated with Dennis, Donald Duck, Gopo's cow, birds, animals, caricatures, wine stains, and breadcrumbs. "Souvenir," he shouted, waving the cloth over his head. I looked back apprehensively, expecting to see an outraged waiter come pounding after us, but apparently he didn't care. Not everybody is an art lover.

Shortly after we emerged from behind the rusty, depressing Iron Curtain, a top secret U-2 reconnaissance plane, flown by Gary Powers, was shot down over the Soviet Union; the Cold War was restarted.

So much for my Humor Exchange.

Why Geneva, of All Places?

The excursion to Russia was the first time I had ever left the confines of the United States during my formative thirty-nine years, and, gently prodded by my travel-happy bride, I agreed that it was high time to seek other pastures, some intellectual stimulation, and some enlightenment as to

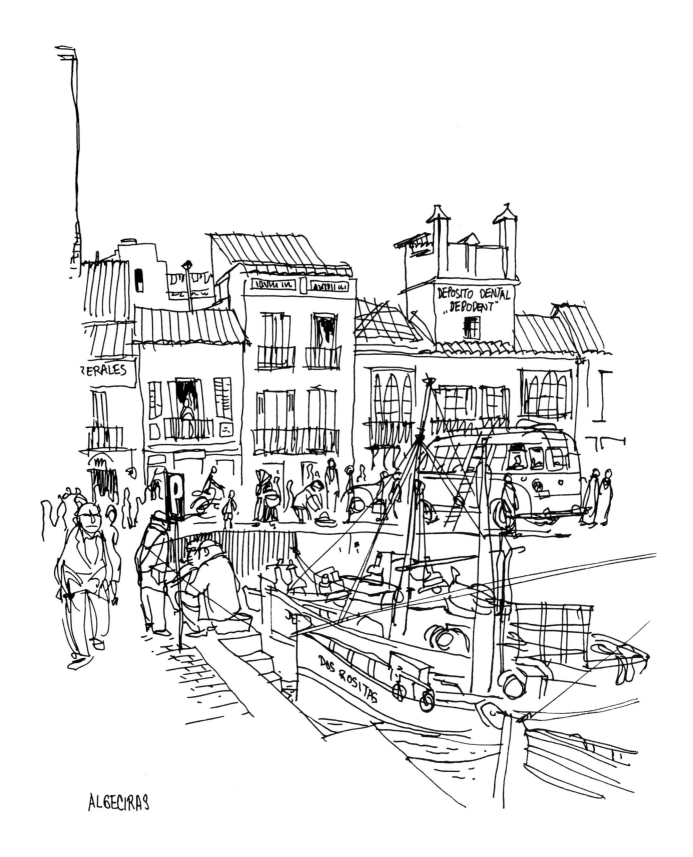

ZERALES

DEPOSITO DENTAL
„DEPODENT"

DOS ROSITAS

ALGECIRAS

what goes on in other parts of the world. However, residing abroad was never contemplated or even discussed—until then.

Shortly after sailing for Europe on the SS *United States,* with the Statue of Liberty just a faint silhouette in the afternoon haze, I was introduced to the Richard Hutchinsons of South Bend. They were making their sixth Atlantic crossing and appeared to be old friends of most all of the invited passengers at the Commodore's Reception. Dick was a vice-president of Studebaker-Packard, a former head of sales for the Far East, and a longtime resident of Shanghai. I had just read somewhere that Mercedes-Benz had appointed the Studebaker organization as their exclusive distributor for North America, so I dropped that bit of wisdom as my opening conversational gambit, much to the delight of this jovial supersalesman who proceeded to wind me around his pudgy little fingers.

By the time we met again during the obligatory lifeboat drill next morning, Dick had already talked to his South Bend office, which in turn had cabled Stuttgart, and the fat was in the fire. My 1960 220-SE Mercedes-Benz Coupe would be delivered to me in Paris—ebony black with burgundy leather upholstery, and all for $5,500!

While I may have few restrictions as to place of residence, I *do* have deadline commitments that under any and all circumstances *must* be met. This became only too clear when we had arrived in Paris and settled into our suite at the Hotel Georges V, exhausted and limp from cultural shock and digestive disorders following our forty-day tour behind the Iron Curtain. We were greeted by a foot of Telex messages from the Post-Hall Syndicate pleading for overdue batches of finished drawings. I couldn't even think of going home.

I unpacked my traveling cartoon studio and aroused the curiosity and amusement of the hotel staff while diligently plugging away with pencils, erasers, pen and ink, and room service for the ten days it took to end the emergency—temporarily.

It was then, when I came up for air, that we spent time with the Art Buchwalds and some of their friends. Art, still on the staff of the Paris *Herald-Tribune,* suggested that we linger on this side of the Atlantic for a while. He noted that the life-style was more refreshing, less hectic, and much less expensive; there was even an income tax credit given to U.S. citizens by the IRS. He was a convincing salesman; I was intrigued. Compared to the weird and depressing places we had just visited in the CCCP, Western Europe seemed like Disneyland.

I thought it was worth a try, but we still had three months on the Costa del Sol to mull it over, mainly because the Winchesters, friends in London, had offered us their staffed villa, an attractive stone edifice overlooking the road between Algeciras and Cádiz. Rather than run the risk of hurting their feelings, we snapped up the opportunity and celebrated my fortieth birthday sipping Tio Pepe and leafing through the English/Spanish Dictionary. *Bueno!*

The costs of maintaining the ranch in faraway Carmel Valley ticked on like a taxi meter, and those Pastures of Heaven, much as I loved them, now seemed out of scale for a small family, especially with son Dennis in boarding school. I decided to put the place on the market.

It didn't take long to learn the *cuerdas* (ropes), especially when I put my studies to practical use with daily trips to the market, loading up on fresh *naranjas, patatas,* leafy

Feeling like Sir Galahad but looking more like an Andalusian Don Quixote, the author inspects the rugged hillside behind Algeciras, Spain.

lechuga, pescado y carne fresca! It was easy to deal with the natives, some of whom were as balmy as the Andalusian weather but surprisingly full of fierce pride and good humor. From early morning the roads leading to town were littered with rickety trucks, diesel-belching buses, donkeys and wagons, daredevil bike riders, and the ubiquitous old ladies dressed in black. Motoring could be adventurous if you didn't pay attention.

My newly acquired Spanish vocabulary was limited solely to the market place, a frustrating handicap when you wished to express yourself on subjects other than the quality of the new cabbage or the outrageous price of once-brave bulls fresh from the Plaza del Toros. I became painfully aware of this late one afternoon while driving to the station to meet the Madrid-Andalusia Express to pick up the latest *Herald-Tribune,* by then three days old.

I slowed down to get a better focus on traffic conditions in the glare of the blinding, setting sun, when suddenly I was in the crossfire of a rock fight between a bunch of shirtless, wild-eyed youngsters on both sides of the street. I slammed into low gear, squealed around the corner onto a dirt side road to avoid further damage, and was promptly sideswiped by a runaway donkey cart loaded with crates of live poultry!

The car abruptly halted, the engine stalled, and my head banged against the window post. It was a rasping, noisy collision, accompanied by a torrent of scraping, braying, cackling, and shouting...which slowly faded into the distance as dust and tiny feathers settled on this Iberian nightmare.

I turned off the ignition and slumped back into the leather seat—unharmed but stunned and in mild shock. What the hell happened? And why *me?* With great effort I pushed the heavy door open, clambered to my feet, and then slowly turned to survey the damage. I stared in disbelief, shook my head, and almost cried. My once-spotless, glistening, elegant, black Mercedes-Benz was now just a feathered mess of ugly scratches, chips, dents, bumps, and chicken shit!

Despair turned to rage. The adrenaline started to flow, my muscles flexed, and I was ready to wring the first available neck. The rock-tossing delinquents had witnessed the travesty, howled with fiendish laughter, and scampered over fences, disappearing into back alleys. The terrified donkey was now but a small cloud of dust in the evening haze and still being pursued.

One of the smashed crates still remained straddled on my hood. I cursed, swept it to the ground, and kicked at some chicken peckers making themselves at home underneath a rear wheel. Turning towards town, I took a deep breath and shouted at the top of my lungs . . . to those miserable kids . . . to the curious gawkers who had gathered . . . to anyone within earshot:

"Come back here, you dirty *zanahorias!*"

"If I ever catch you, I'm gonna *calabaza* your *cebollas!*"

"You're nothing but a bunch of *huevos revueltos desayuno espinacas!*"

I was still livid but felt much better getting it off my chest—although I knew that even the most prim and proper little Spanish señora could not have been offended by my outbursts, purple-sounding as they were.

Gibraltar was an oasis of British goodies, where we found gin, tobacco, and coffee in ample supply, and toleration for modest smuggling. Lunch at Gib was always a highlight, and the change of menu, language, and the shopping and banking opportunities were refreshing. To avoid the hassle of getting Spanish license plates, I registered with the Gibraltar Automobile Club and received an impressive set of large silver and black GG plates, which have since remained in my garage should I ever want to get the car dolled up again.

Prudential Life's colorful big rock was populated mainly by the military and a mélange of Spanish, British, Maltese, Indians, Orientals, and a gaggle of gibbons, tail-less

PARLIAMENT LANE, GIBRALTAR

apes carefully protected by the Army. Residents carry papers identifying them as Gibraltarians, with all the assurances and guarantees due a British subject, but the status of the rock remains a sore spot between Spain and Britain, and the fate of the inhabitants is uncertain.

It was a cozy settlement and getting more so each year as baby buggies clogged the narrow streets. Of all places to have a population explosion! Since then, television has arrived and, as in the rest of the civilized world, it has greatly modified breeding habits.

It was a mere two-hour ferry ride to a fast-fading Tangier and the excellent French highways running south to Casablanca, Rabat, Marrakesh, Fez, and the endless sukkas, bazaars, and jam-packed marketplaces where women are seldom seen, where men run around in bathrobes and slippers, where smells are less than exotic—and where skies are not cloudy all day.

A glib, English-speaking eager-beaver, wearing a long maroon robe and matching fez led me into an exhibition of carpets and pointed to a thick white rug with an attractive design woven in black. The auctioneer was ranting and raving in Arabic, and when the guide told me that he was offering this woolen treasure for the bargain price of a mere $300, I mumbled that I wouldn't give him any more than $100 for it.

"Sold American!" instantly reverberated through the hall. I was had. They rolled it up tightly in heavy brown paper and secured it with hemp; for months afterward, my poor Mercedes smelled like dead sheep.

Being abroad was different, refreshing, and inexpensive, just as Buchwald advertised, but the Spanish mail was delivered at a snail's pace, the bureaucracy endlessly frustrating, the electricity shockingly erratic, and the telephone and cable facilities at best primitive. This was certainly no place for anyone so dependent on communications.

It was time to move along, but to where? I can live anywhere I please....

SOLD AMERICAN! FEZ/MOROCCO 1960

You've already said that a hundred times. Big deal, so what are you searching for? The midnight sun? Frosty schnapps, cool beer, shrimp sandwiches, and blue-eyed blondes? Or would you be turned on by autobahns with no speed limits? Buxom beermaids, stubes, kellers, a kurhaus, or cuckoo clocks? Or perhaps a large island would appeal, where everyone speaks a language you understand and everything on wheels must roll on the left-hand side of the road. No? Well . . . answer me!

Later. I'm not sure. But I'll know it when I see it.

I loaded my sheep-scented coupe with leftover bottles of sherry, dirty shirts, and my handsome new leather cowboy boots (hand-made for $12) and had her hoisted aboard the USS *Independence* for the overnight steam to Naples. I had decided to attack the soft underbelly of Europe.

A ton of trattorias, vats of Valpolicella, and a passel of pizza parlors later, we emerged from the north end of a long, dark tunnel and found ourselves, lo and behold, in Switzerland. Everything looked so sparkling fresh and squeaky clean and well organized. One could even direct-dial via satellite from most any alp to far-off musical-sounding places like Peoria and Puyallup! Six static-free radio channels were piped into the homes through telephone lines. There was no unemployment, no poverty—even dogs didn't beg. And Buchwald had never mentioned this pinnacled paradise.

Because I had studied French for four years during my Seattle schooldays, I turned left and headed for Lausanne and the countryside bordering Lac Leman rather than drive toward the Bernese Ob-erland, the Grisons, and places to the north and east where the spoken language sounds more like a throat ailment.

My calendar, which seems to tick faster than others, again flicked on the red warning light—meaning that time was running out, that I had best get my fanny in front of the old drawing board, dig out the pen and ink and be funny-for-money, or else!

Further meanderings through quiet back roads had to cease, as did discovering fragrant local wines, savoring scrumptious varieties of bread and cheese, and languishing on lakeside terraces, just an arched eyebrow away from another vodka tonic. All of these tantalizing activities had to be put on "hold" while Dennis's poor old dad cranks out another four weeks of daily panels and shepherds them safely to the nearest post office.

Turning left from the Simplon Tunnel, the road keeps company with the Rhone River, taking a sharp right at Martigny, and continues through Aigle, St. Saphorin, and Dezaley, the wine districts of Canton Vaud, then along the eastern shore of Lac Leman, a lake some fifty miles long and the largest inland body of water in Europe.

The village of Vevey is known worldwide for chocolates and Chaplins, while Montreux is famed for jazz festivals, songfests, and sanatoriums, and both seemed geared more for weekend tourists than permanent residents—or anxious artists. My Fielding *Guide* recommended (with red exclamation marks) the palatial Hotel Beau Rivage in Ouchy, the flowered lakeside quarter of Lausanne. My friend Temple was right on target, and we checked into a suite overlooking the chrysanthemums and the Chriscrafts. No reason to suffer in a broom closet when I had so much work to produce.

God's gift to roller skaters and bike riders Lausanne is not. But this hilly residential town enjoys a certain quaint and relaxed ambiance and has, since the Battle of Hastings, been particularly popular with hoards of British transplants. Until recently, there was even a small shop on the Place St-François that specialized in monocles, blackthorn walking sticks, tweed knickerbockers, and hand-crocheted tea cozies. Lausanne is a favorite, and I look forward to my next luncheon at La Grappe d'Or, probably the finest eating establishment that side of Lutece.

But the runways are located in Geneva, and I seldom drive when I can fly.

Between work spasms at the portable cartoon machine, we would slip down to the small end of the lake for a more serious investigation of Geneva, site of President Wilson's ill-fated League of Nations, home of Rousseau and Voltaire. Before his invasion of England, Caesar allowed his troops to rest on these shores and revive on the mineral waters that gushed from the hillside—only now the waters are bottled in plastic, decorated in pink, and sold at Red Label prices.

Geneva has physical impact and charm, and the more I saw the more I wanted. Impeccably maintained parks and gardens form a "green belt" around the port area, behind which the towers of Cathedral St. Pierre and the ancient facade of the Old Town form an elegant backdrop for the incredible Jet d'Eau, majestically rising 130 meters above the cluster of sailing craft, motorboats, and Victorian-looking lake steamers. If it only had a vacant apartment.

Through the offices of a Lausanne lawyer, I obtained a *Permis de Sejour,* permission to live in Switzerland for one year, after which there was a good possibility that it might be renewed—as long as I was a good boy. This gesture was primarily designed for the convenience of parents of foreign students studying in Switzerland and those suffering from ailments that are often cured by living at high altitudes. This does not entitle you to accept employment, but it does qualify you to rent a house or apartment.

For the summer months at hand we rented a small Swiss chalet smack on the lake at Celigny Port, just over the hill from the Richard Burtons. It was considerably less expensive than the Beau Rivage and a perfect solution, allowing us the time and space we needed. I had room to set up shop, we played house with a real kitchen, and it was only a thirty-minute drive to Geneva where I began an intensive search for an apartment.

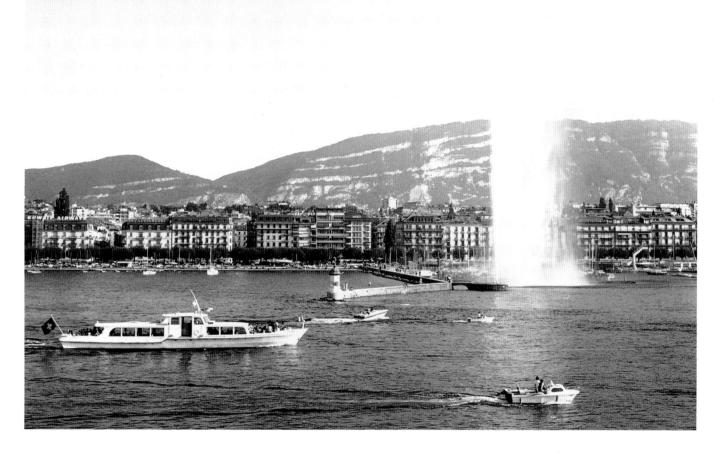

The entrance to the inner harbor of Geneva, with the Jet d'Eau and the Saleve mountain range in the distance, as seen through a long lens from the balcony of our apartment.

Dame Fortune, one of my nearest and dearest friends ever since I wet my pants coming home from school, only to be mercifully caught in a sudden downpour with still three blocks to go, again came to my rescue. This heavenly lady took me by the arm and, this time, calmly steered me into a luxurious, unfurnished, top-floor apartment that commanded a 180-degree view of Lake Geneva (the correct name once you leave Lausanne), the park, the Old Town, and that perpetual French ice cream cone, Mont Blanc.

The Chateau Banquet three-bedroom apartment had been occupied by an unfortunate New Dehli businessman who had lost his *Permis* and was forced to move out of the country. I agreed to buy his Christofle

My top-floor studio was tucked behind the Citicorp Bank building at the far left, dominated by Cathedral St. Pierre and Geneva's Old Town, which was built along the hilltop on the right some five hundred years earlier.

cutlery, a couple of beat-up chairs, and a 1958 set of *Encyclopaedia Britannica* in return for his lease! Allah be praised!

The Swiss take their communications seriously. They are meticulous and use ingenuity; I have often received letters from the States addressed simply: Hank Ketcham—Geneva. Dennis did not appear in a local newspaper, so I was really an unknown.

Now let me tell you about telegrams and cables: they are delivered unfolded in crisp five by seven windowed envelopes, appearing just to have been cleaned and pressed!

I succumbed easily.

As in San Francisco, you must try hard to find a bad restaurant in Geneva. Many of these calorie emporiums show up on inter-

Daughter Dania with Mother K against a backdrop of the Saleve cliffs, the Jet d'Eau, and the Ville de Genève.

national "gourmet" lists decorated with blue ribbons, stars, forks, medals, bells, chop marks, gravy stains, and fingerprints. And, as France literally surrounds the City of Calvin, the wine selection is outstanding and moderately priced.

The lady of the house, who rarely awakened before noon, for whom I provided airline tickets, furs, and rings, and whose luggage I carried, had finally become too much of a liability. It seemed that no matter how high on the hog she lived, it wasn't enough. Geneva became an agonizing, bitter end of what once was a promising rainbow—and the beginning of an entirely unexpected, glorious new life for me. Dame Fortune still had me within her grasp. (Or was it my Isle of Man heritage and the knack of always landing on one of my three feet?)

The extra-bedroom studio was entirely inadequate. I urgently needed elbowroom, a private phone line, a Xerox, and a secretary. In spite of the turmoil and ruptured domestic scene, the Impossible Dream continued, and I discovered permanent quarters for my Funny Factory in an air-conditioned penthouse high above the banks and chocolate shops in the center of town. I could throw stones on Harry Winston. Now if only Harry would have tossed his stones at *me*!

My mosaic began to take shape and, not at all to my surprise, Geneva worked like a charm. My wife Rolande and I first met there, daughter Dania King was born there, and son Scott Henry made his first appearance on my birthday at the Clinique Bois Gentil just four years after we greeted Dania there.

Best of *Dennis*
—1960s

"PARDNERS DON'T MAKE PARDNERS GO TO BED, PARDNER!"

"DON'T GET SO EXCITED, MRS. BELL! FROGS CAN *SWIM!*"

"LOOK, KID, I DON'T MIND YA DIPPIN' IN MY POPCORN, BUT WIPE YOUR HAND ON YOUR *OWN* PANTS, SEE?"

"OF *COURSE* IT'S NOT A REAL BATHROOM, DENNIS. IT'S JUST A DISPLAY OF....

DENNIS!"

"BEANS AN' HOT DOGS AGAIN! GEE, MOM COULD SURE LEARN A LOT ABOUT COOKIN' FROM **YOU**!"

"PSSSST! THERE'S A GUY OVER THERE EATIN' HIS DINNER WITH *KNITTIN' NEEDLES!*"

"HERE'S YOUR TROUBLE, LADY. PEANUT BUTTER ON YOUR VERTICAL RECTIFIER."

"WHEN ARE YA GONNA BE *FINISHED* WITH THE SWIMMIN' POOL?"

"WHEN ARE YOU GONNA LEARN ME TO DRIVE?
I KNOW ALL THE *WORDS!*"

Geneva, 1960-1977

My Productive Years

During my domicile in Switzerland, for reasons I cannot fathom, I seem to have exploded in a frenzy of creative activity. Perhaps it was a particular stage of life when all juices flow and one exudes confidence and exultation. Or maybe it was the scintillation of Geneva, the excitement of walking the same paths as Rousseau, Voltaire, and Calvin. On the other hand it may have been something quite uncomplicated: my anonymous presence. The Swiss accepted me as an eccentric American with a hobby of drawing funny pictures and left me alone. My social life was uncluttered, my business associates were a jillion miles away, and I enjoyed many years of relative peace and quiet—allowing ample elbowroom for my headbone, so to speak.

I had also established regular communication with my intellectual sparring partner, Bob Saylor. He was a gifted writer, a prolific gagman, a sensitive philosopher, and his nocturnal working hours in Los Angeles coincided beautifully with European time, enabling mid-morning telephone chats when the spirit moved us.

In the sixties a seed was planted, one that I hoped would sprout quickly and burst into full blossom as *Dennis the Musical.* Bob and I wrote our heads off, going up one road then down another, but we never did develop Act Two. Neighbor Norman Krasna, enormously successful playwright, author of *Dear Ruth* and *Sunday in New York,* a collaborator with the Marx Brothers, and a very amusing fellow, almost hung up the phone the first time I called to chat about the project. Even though he was a huge Dennis booster, he knew the perils, pitfalls, and pratfalls of Broadway and wasn't about to get involved.

"Anybody can write a first act," he said. "I don't want to hear anything more on the subject until opening night, Hank."

In one of my daily panels featuring the neighborhood library, I identified the lady librarian with a name plaque labeled "Marion." Shortly after it appeared, I received a warm and enthusiastic fan letter from Meredith Willson, who was thrilled with my allusion to his "Marion the Librarian" and went on to rhapsodize over my half-pint outlaw, saying that he and Mrs. Willson started each day with a fresh pot of tea and Dennis.

Later I paid a visit to this multitalented piccolo player from Iowa who thought the idea of putting Dennis Mitchell and George Wilson to music was brilliant. "All I need is the book," he said, and I sailed out of his West Los Angeles home on a pink cloud, convinced we'd have a script in a matter of weeks. But before we got anywhere with Act Two, our dear Music Man had departed, and the steam fizzled out of our boilers. However, for interested historians, germination of the Dennis musical comedy took place on the shores of Lac Leman.

The Canton of Geneva wanted me to draw a few cartoons to promote tourism, but instead I wrote and illustrated a four-page brochure, *Geneva Just for Fun,* which was widely distributed by Swissair, the Swiss Railroad, and most of the hotels catering to English-speaking travelers. This was fun, drew flattering comments, and gave me a refreshing vacation from the antics of my perennial mischief-maker.

Since the howling success of the Dennis Playground in Monterey, California, I developed a philanthropic itch to establish a foundation that would address the plight of children's playgrounds throughout the world and rid those areas of dangerous slides, teeter-totters, swings, and rings and replace them with colorful abstract shapes designed by outstanding artists and sculptors. This lofty inspiration actually went forward to the point of my publishing a presentation, hiring a director and a crew of designers, and renting office space. I flew to Washington, D.C., and received a million dollars in matching funds from HUD, after which the IRS changed the rules and most small institutions foundered. My Playart Foundation was no exception, and we sadly disbanded. Ugh!

Having watched children, bored with slick toy cars and trains, toddle into the kitchen to play with pots and pans, strainers and lids, and other odd shapes found in cabinets and drawers, I knew there was a market for a liquid container that, when empty, could be coupled or interlocked with others to form walls, floating mattresses, castles, and wild shapes made up of as many containers as you had accumulated. Instead of carelessly disposing of the plastic, you would be motivated to keep the colorful toy, and youngsters throughout the North American continent would be clamoring for their moms to buy a dozen more.

I had my pencil designs translated into rigid plastic shapes by a Swiss toolmaker and, in due course, obtained design patents in the USA. This project remains on the back burner while I refine the design, try to come up with a production technique to minimize cost, and seek out a milk producer or soft drink outfit that might be interested in this gem. Stay tuned.

Work Space

My first very own studio was a tiny converted closet upstairs under the eaves of our house on West Fulton Street, a surprise from my dad on my tenth birthday. He had installed a slanted drawing board, a shelf,

an overhead light, and a kitchen chair. I was bursting with joy. *Tack Knight's Cartoon Tips,* a paperback book of instructions, was all I needed to get started, and the following month Dad signed me up as a mail-order subscriber to the W.L. Evans School of Cartooning. My little world was becoming a very exciting place.

As it is with many others in the creative arts, I labor in isolation. But it is seldom lonesome, as I am consumed with the people, animals, and action taking place about eighteen inches from my pointed nose. Music permeates the studio while I am at the drawing board, soft, nonintrusive sounds that don't demand attention but fill the room with warmth and keep you company. On the other hand, when I am struggling with words, be it dictating a letter or writing a caption, I must have absolute silence. I now appreciate the legendary Ivory Tower concept and subscribe with pleasure. I doff my fedora to those talented wordsmiths hammering out news and editorials midst the confusion and din of the City Room.

In the mid-1950s, *Dennis* was produced daily in a cabana around the swimming pool on my ranch in the Carmel Valley. A few years later I hunched over my portable board in a suite at the Hotel Georges V in Paris, frantically catching up with deadlines after my visit to the Soviet Union. My traveling studio soon moved to the garden of a hacienda on the Costa del Sol near Gibraltar, where I lingered for three months.

During another memorable working vacation, I spent thirty days perched on the slate patio of Il Casteletto, an elegant and imposing Italian chateau that was used as an aircraft-spotting station during World War II. It was built of stone on the highest

A cardboard Dennis *became my* Charlie McCarthy *in this picture taken on the Geneva quai near the Pont Mont Blanc by* Life *photographer Ralph Crane.*

point overlooking Portofino—one of the world's most romantic harbors—384 steps below.

But my fondest memories are of those many years when the address of my Funny Factory was 78 Rue du Rhone, Geneva, Switzerland.

I discovered the penthouse space just as the building was being completed. As there were restrictions about business offices situated in areas above elevator service, it remained empty. I somehow convinced the authorities that this old silver-thatched artist merely yearned for a place to pursue his hobby. He was not peddling watches or wine and would be a threat to no one. Whew! It worked and I was given carte blanche to design the apartment as I pleased—at my own expense, of course, and in the very heart of the sector that

housed the likes of Patek Phillipe, Harry Winston, Hermes, and Cartier.

Within six months I moved into a white-tiled, lushly carpeted atelier with floor-to-ceiling sliding window/doors offering breathtaking views of the Old Town, the Pont du Mont Blanc, the Jet d'Eau, and the quiet display of lights from the grand hotels and establishments on the opposite bank of the Rhone. I was equipped with bath and shower, a neat galley, teakwood walls with

built-in storage, a hi-fi system, and a wrap-around outside deck. It was in this space where my most productive years were spent: 1966 until June of 1977.

It would never have worked without a top-notch secretary, and I was fortunate to find Marguerite Danich, a delightful young lady from Fribourg who spoke English, French, German, and a smidgen of Italian. Neat as a pin, always attractively dressed, she was well organized and prompt as a

Captain's quarters in the Rue du Rhone penthouse.

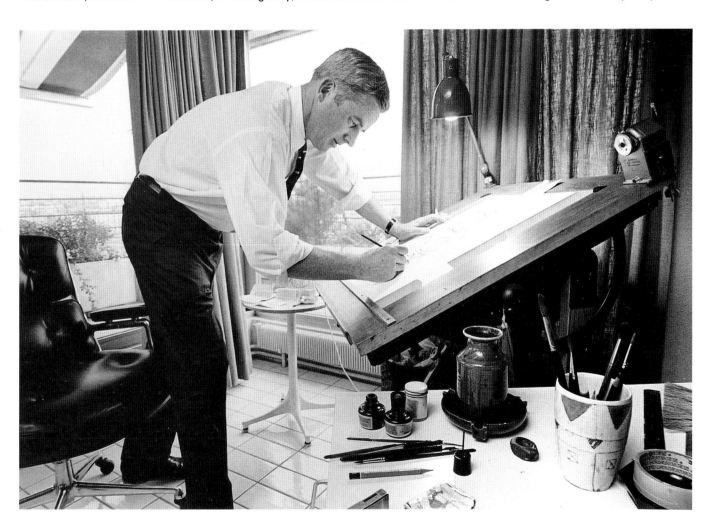

Supersecretary Marguerite Danich and the author confer on the studio balcony, with the Cathedral St. Pierre and the Old Town of Geneva in the background.

Swiss. Ms. Danich had just married, resigned from her job at Marathon Oil, and was interested in working only half days. This was a perfect arrangement for me, as I could spend the morning dictating letters, signing checks, and answering fan mail, leaving the afternoons for pencil pushing and ink slinging. It took an enormous weight off my mind and shoulders, allowing me the luxury of time to let my mind wander —a chance to explore the mysterious nooks and crannies heretofore unvisited. Some of the expeditions were rewarding.

The office hours I maintained in Switzerland were particularly important in that I worked six hours ahead of New York and nine hours in front of the West Coast. Needless to say, I conducted most of my international telephone conversations at home long after sunset.

Since moving back to California I have reestablished in an attractive historic location near City Hall in Monterey, with just enough room for a secretary, two assistant artists, and a few file cabinets. It is also cozy and comfortable and continues to represent self-coddling of the highest magnitude. Dottie Roberson picked up magnificently where Marguerite left off, and I'm loving every minute.

I am often asked why I don't play golf every morning and attend to my work in the afternoon. As long as I am my own boss, they say, why not juggle time to my convenience? Well, I have this thing about getting up early every morning, fresh, frisky, and rarin' to get started. Guess you'd call it an old-fashioned work ethic, but, whatever it is, I feel better adhering to a schedule that my business associates can understand. If I am needed, they know where and when I can be reached, that I'm not off in the boondocks smelling the roses when there is an important matter to discuss. Come to think of it, though—why couldn't they just call the pro shop and have a caddy deliver the message?

I rather suspect that I have become a victim of bad management.

Help from Cleveland

In 1965 the Dennis Machine was a healthy, fourteen-year-old, at the top of most newspaper-readership polls, and producing a successful comic-book line and a popular bi-annual cartoon collection in paperback. Everything seemed to be going smoothly except merchandising. In fact, the Hall Syndicate didn't even have a specialist on the staff for that sort of thing. However, there were spurts of activity with a Dennis doll, a collection of hand puppets, a line of children's clothing, and an assortment of inexpensive toys, but none of it amounted to much. In retrospect, I know that the lack of animated-cartoon TV exposure accounted for this dullness at the marketplace. The live-action weekly TV series starring Jay North was still strong in reruns but, because it was not a cartoon and did not relate to the newspaper feature, the manufacturers remained uninterested.

Arnold Palmer, Jack Nicklaus, and Gary Player were the dominant Big Three of professional golf that year, and an interesting story in the international edition of *Newsweek* described how these young athletes were being managed so successfully by Cleveland attorney Mark H. McCormack. It was an impressive article, and I wondered if there was room for a 10-handicap cartoonist in McCormack's stable, someone with a steady job whose income was not jeopardized by three-putting, double-faulting, or tennis elbow. There was only one way to find out; I put in a call to Cleveland.

"I'm sorry, but Mr. McCormack is out of town. Care to leave a message?"

"Can he be reached at another number?" I queried.

"I'm afraid not, sir. He is in London and...."

"Splendid," I interrupted. "What is his hotel, please?"

"Er...eh...Claridges, but...."

I left word at the hotel, and within the hour Mr. McCormack was on the line. Had I tried to reach him from California, I doubt that he would have been sufficiently interested, but the call from Switzerland undoubtedly tweaked his curiosity. I now felt like the Canadian Mountie who had finally "got his man."

A 1959 Screen Gems publicity shot for the soon-to-be-released *Dennis the Menace television series on the CBS Television Network. I am standing alongside Joseph Kearns (George Wilson) and Herbert Anderson (Henry Mitchell), with an eager Jay North holding the sketch.*

I caught a late-afternoon flight to Heathrow and was up bright and early the next morning for our breakfast meeting, a McCormack specialty. I did not arrive empty-handed, but detailed a proposal from Sears & Roebuck, a publishing offer, and several merchandising ideas that were awaiting development. Mark listened attentively, made notes on his three-by-five cards, asked a few pertinent questions, allowed that, yes, he was interested in representing me, and suggested we meet with his partner, Arthur J. Lafave, Jr., at his Cleveland office in two weeks.

I have been associated with International Management Group ever since, and although they do exact an arm and a leg for their fee, I have never suffered a serious limp.

The Joys of Stinkpotting

The sweeping view of Lake Geneva from our top-floor apartment offered periodic exhibitions of sailing regattas, water-ski ramp-jumping, breathtaking fireworks, and the ever-present Jet d'Eau, a vertical pillar of water that gushes five hundred feet skyward from a twenty-four-inch nozzle and falls gently back to the surface in lacy patterns designed by the prevailing wind.

I succumbed to temptation and joined the nautical parade on Lake Geneva in a twenty-foot Riva, a handsome speedboat made of wood and powered by an inboard Continental Red Seal engine. Visions of Gar Wood danced in my head. But hold on. Before I could putt-putt out onto the lake, there was the not-so-small matter of getting a *Permis de Conduire,* a proper license from the *Department de Justice et Police, Service de la Navigation.*

I am not aware that in any part of the USA such a license is required. You can write a check for a million bucks, step aboard your fifty-foot yacht, turn the key and awwwaaaaaayyyy you go!

"Oh-oh. Now let's see . . . how do you stop this thing?"

For some unfathomable reason, in America unqualified persons are able to own and/or operate powerboats and subject all hands in the vicinity to possible mayhem. But not in Switzerland.

I quickly made tutoring arrangements with a retired, no-nonsense Swiss lake-steamer skipper who spoke very little English. But with sign language, a phrase book, and my meager French vocabulary, we muddled through quite nicely. After a half-dozen lessons of docking, retrieving cushions tossed overboard, and reviewing the "rules of the road," I convinced the gendarmes that I knew the ropes and could be a trusted sailor in those waters.

Geneva is rather special in that you must know how to dock your boat with and against the strong current of the river Rhone, which flows through the lake, a challenge not unlike navigating in tidal waters. My instructor seemed to enjoy demonstrating his downstream technique, a determined approach to the dock with a last-minute roar of the engine in reverse, allowing the boat to back slowly into mooring position and leaving an easy step ashore to secure the lines. Apparently this is a standard maneuver for the Swiss sidewheelers, but, as I later discovered, frowned upon in civilized boating circles. It dramatically churns the flotsam and flora, bringing a variety of grasses and bugs to the surface, attracts the attention of those on the dock, causes minor aches and pains to the local perch, and is regarded as "hot-dogging." A responsible skipper brings his boat into the docking area and leaves in the same fashion: gently.

I was not interested in becoming a chauffeur for water skiers. I wanted only to leave the summer heat and the heavy traffic in my wake. I loved to goose the rpms and scud across the choppy blue wavelets toward Lausanne, past Morges and Ouchy and the romantic Chateau de Chillon, carefully weaving around clusters of Mercurys and Stars under sail, finally heading to the French side and coming to rest in the quiet cove near Evian. With the engine silenced, the Jacob's ladder hung over the side, and the thermos of Bloody Marys put into action, it was drifting and dreaming time, interrupted only by the soothing lap-lap-lap of water against wood.

Once we were relaxed and refreshed, a consuming interest in food would occupy the conversation, and in a matter of minutes the eleventh-century port of Ivoire, France, would receive luncheon guests. The restaurant Les Flots Bleu had its own slip, welcomed the boating public, and served mouth-watering portions of *Filet de Perche et pommes frites,* washed down with liters of chilled *Crepy, un vin blanc formidable!*

It doesn't get much better than this, folks.

As I Remember It

With smart remarks always in season, I gave little thought to a one-liner from a friend concerning "our new President, Lyndon Johnson." But I asked for a replay and was only then informed of the tragedy that had taken place within the hour.

The spirit of Thanksgiving suddenly disintegrated on that chilly November evening in Geneva. I, like most everyone in the Western world, was totally unprepared for this blockbuster, and the initial reaction was one of utter disbelief. A cruel joke. A huge mistake, or another diabolical rumor.

Blaring radios throughout the city were crackling out the news in a variety of lan-

THE WEEKLY TRIBUNE

Goldwater movement set up here

WE CAN'T LOSE, JOEY! NO MATTER **WHO** WINS THE 'LECTION ... WE'RE GONNA HAVE A **COWBOY** FOR **PRESIDENT**!

guages, but for those of us whose vocabularies in French or German were limited, the Voice of America affirmed the horrible truth. I spent the balance of the evening with a few close expatriate pals, alternately sipping whiskey, shaking our heads, and summoning up as much philosophy as we could muster. We felt like a crew without a skipper.

During the days following, I was regularly stopped on the street by complete strangers, Swiss, Italian, and German, each one anxious to offer condolence and to convey their personal sense of shock and loss directly to an American. (This scenario was replayed three years later following the death of Walt Disney.) It was a touching experience and certainly underscored the immense wave of worldwide popularity this young President engendered in such a brief period.

Citizens for Goldwater

A group of U.S. Republicans living in Paris wanted to organize a European campaign to promote Barry Goldwater's candidacy for President. In that most of us were not qualified to vote even as an absentee, our plan of action was to write letters to everyone we knew in the States and urge them to mark their ballots in favor of our man from Arizona. Clare Booth Luce and Colleen Moore (the cute little girl from the silent movies with the bangs and big eyes) hosted a meeting that included enthusiastic Yankees from all parts of the continent. When the dust settled, I found myself chairman of the Swiss committee.

Several days after my return to Geneva, I received a telephone call from the Gendarmerie, requesting my presence the following morning at 0800 for the purpose of

JAMAIS
JAMAIS
JAMAIS
JAMAIS
JAMAIS
JAMAIS
JAMAIS
JAMAIS
ENCORE!

SERVICE DES AUTOMOBILES
GENÈVE - 18 DEC. 1968

I sent this to my lawyer, hoping he would pass it along to the judge after I was apprehended for the third time for speeding within the city limits. My license was suspended for a month, and I became an expert on the Geneva bus system.

explaining my current "political activity" in la belle Suisse! If I draw an early tee-off time, it bothers me not a whit. Should my doctor want me to check into the hospital at the crack of dawn to prep for surgery, I'm eager to oblige. But to have my breakfast interrupted by a summons to appear at Swiss police headquarters is quite another matter.

My limited French enabled me to cope nicely with hotels, restaurants, and brief cocktail receptions, but it was grossly insufficient to deal with inquisitive city officials wearing imposing badges of office.

After I had explained that we Americans could not vote and were merely writing letters to friends back home asking them to support our candidate, the police officer was surprised at the revelation and seemed to understand our frustration. But, he reached into his desk drawer and produced a copy of *L'Ouvrier,* the workers (Communist) newspaper, and pointed to a front-page box that questioned why Americans were allowed to form political groups and be active in the Canton of Geneva!

He went on quickly to extol the warm Swiss-American friendship that had existed for years and to tell how he wanted to be of some help, but the last thing his country wanted was to allow the Communists an excuse to become politically active. I agreed, of course, and with considerable relief disbanded the committee, shredded the stationery, returned the box of pins to Paris, and went back to the old drawing board.

I wonder whatever happened to Barry Goldwater?

Another Tour of Duty

In the late sixties, when we were entangled in Vietnam, I went through another patriotic spasm. What with *Steve Canyon, Terry and the Pirates, Beetle Bailey,* and G. I. Joe around, I felt that our Navy was getting the short end of the stick and decided to take *Hitch* out of mothballs. Only this time I needed elbowroom to tell more of a story, so I turned it into a "strip" format and gave our hero a speaking part. To support the half-pint salt, the cast of characters would include Captain Carrick, Ensign Sweet, Chaplain Charlie, Chief Petty Officer Grommet, Cook Ding Chow, Zawiki, Fluke, Bos'n Buckle, assorted girls on active duty, and a

delightfully sassy-talking seagull, who answered to the name of Poopsy.

I sent the presentation to my syndicate, Publisher's-Hall, with the positive certainty that, because of the huge success they were having with *Dennis,* they would jump at the chance of distributing my new feature and make any kind of business arrangement I suggested.

Wrong. Bob Reed, the editor, was very slow to respond and was not about to give me any special concessions. My business agents at IMG in Cleveland tried to negotiate a reasonable deal, but Reed dragged his feet to the point where I gave up in frustration and sent *Hitch* over to King Features. Milt Kaplan, president of King, called me in Switzerland to tell me how much they liked it, that they wanted to make a deal, and would I fly to New York to finalize things.

When Bob Hall got wind of this juicy piece of news, he called to apologize for the "unfortunate misunderstanding" and offered anything my little heart desired if I would only let him handle the property. I told him it was too late. I had already made a handshake and would not go back on my word. Sorry.

I had my hands full with the *Dennis* daily panel, overseeing the Sunday page produced by Bob Bugg in Connecticut, and working closely with my writers in developing ongoing material. There were not enough hours in the day or energy in my bones to become active in another newspaper cartoon feature on a regular basis. Having produced the original concept and made the sale, I was now going to find a top gag-writer and a supertalented cartoonist, put them together, and simply orchestrate this silly symphony from afar.

The new Half Hitch *cast, a fun drawing I sent to the fans.*

Herb Gochros, with whom I had collaborated since my free-lance years, became the first writer. Dick Hodgins, Jr., a fine cartoonist with a sparkling pen technique and an outstanding designer, happened to be between jobs and agreed to be responsible for the flow of ink.

King sent out the promotion, the salesmen followed up with personal visits to all of the major newspapers, and by the time we released the strip, we had a client list numbering well over a hundred. Then one day I received a call from Joe d'Angelo at King Features, urging me to come in for an urgent meeting. After six months of euphoria, the initial popularity of *Hitch* was fading in the readership polls and, even worse, we were starting to lose papers in large Naval-population centers like San Diego, Honolulu, and Newport News. I was horribly disillusioned. Obviously, the gags had to be sharpened, the subject matter reexamined. Maybe we should introduce some new characters to get the reader's attention. Something had to be done quickly.

I hustled back to Switzerland with my creative tail between my legs, pored over the galley sheets, and tried to analyze where we were missing the boat (certainly a serious dilemma for a sailor!). It was evident that the humor wasn't appropriate for the seagoing venue; the jokes could apply to most any background, and there was no attempt to build personalities. *Half Hitch* was not living up to its promise. I called Bob Saylor out in California and asked him to form a rescue party and come aboard. Bob was an outstanding comedy-writer and could perform miracles on his typing machine while you waited. He agreed and went right to work. In the meantime, I flew to Washington, D.C., to conduct some basic research and somehow arranged to have a meeting with the top sailor, Admiral Elmo Zumwalt. When the admiral became chief of Naval Operations, he began to introduce some eyebrow-raising changes to spark up the morale, increase efficiency, and, in general, to make the Navy a more enjoyable and rewarding career. He would release regular Z-grams describing new

Opposite: An example of Half Hitch *in his early days in situations that could have taken place almost anywhere. I had not conducted any serious on-the-scene research, thinking that the jokes alone would carry the feature. Little did I know. Below:* King Features Syndicate promotional material.

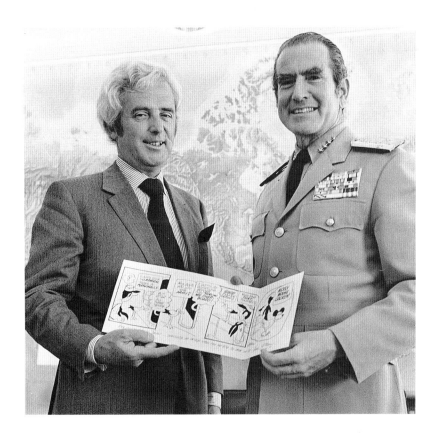

At the Navy Department in Washington, DC, Admiral Elmo Zumwalt accepts a special Half Hitch *strip that commended his new policy.*

areas of special interest and discussing how the Navy could assist. I was flushed with excitement, so grateful for the admiral's enthusiastic interest and cooperation. This, I felt, was exactly what we needed, some fresh writing and some on-the-scene research to add credibility.

Ten days later I was met at the Nice airport by two US Navy pilots, decked out in their flight gear, wearing everything but parachutes. I was escorted out to a Charlie One Alpha, strapped myself into the right-hand seat, and watched transfixed as we flew over Corsica, Sardinia, and across the Mediterranean, well to the south of Italy. We landed (abruptly) at noon onto the canted flight deck of "Building 59," the USS *Forrestal,* which from our altitude of 5,000 feet resembled a stick of chewing gum. My hosts, Admiral George Talley, Captain Leonard "Swoose" Snead, Captain Dempsey Butler, and their executive staff were rolling out the red carpet as we arrived, and at that moment my fascinating Tour of Investigation began. Now, at long last, I felt I was a part of the Navy—thanks to a little help from friends in high places.

As night operations were scheduled that week, the skipper moved up to his sea cabin to be close to the action and offered me his regular accommodations, a gigantic blue-carpeted bedroom suite complete with a desk, TV, couches, dining table, many pictures and paintings, and two cabin stewards at the ready to respond to my every need. They also provided a public relations officer as a guide and the services of a photographer's mate to record my every move. I was in high cotton—except that the head in the skipper's cabin didn't flush.

procedures, and in addition to some astounding changes in the uniform for enlisted personnel, he announced a more liberal policy regarding the length of hair and the wearing of beards and cookie-dusters. He was a man of refreshing imagination and a man of action. My kinda guy.

"You know, Hank, we're a bit embarrassed," was his opening salvo. "You shouldn't have had to go to the trouble of seeking us out, we should have called you long ago. You've got something the Navy can use. Now, what can we do to help?"

Yeah, I wondered, why *didn't* they call me a year ago? I was stunned with delight and thrilled by his positive attitude. We spent the next twenty minutes outlining

Armed with camera and sketchpad, I scrambled all over the immense aircraft carrier, drawing quick studies of ladders, hatches, watertight doors, and all of the strange-looking hardware, as well as interviewing and snapping pictures of crew members below decks, pilots in the Ready Room, and the weary mechanics coming off duty. I was very impressed with the teamwork mentality of these proud, dedicated, young Americans. Most of them have very dangerous and dirty jobs—and considerable guts.

I was soon aware that my luxurious cabin was situated directly below the flight deck, and the intermittent violent crescendos of catapulted launchings and cable-arrested landings made mockery of any thought of rest that evening. About every three minutes, I heard what sounded like a truck crashing through a guardrail. I sought refuge in the tiny, darkened quarters of my

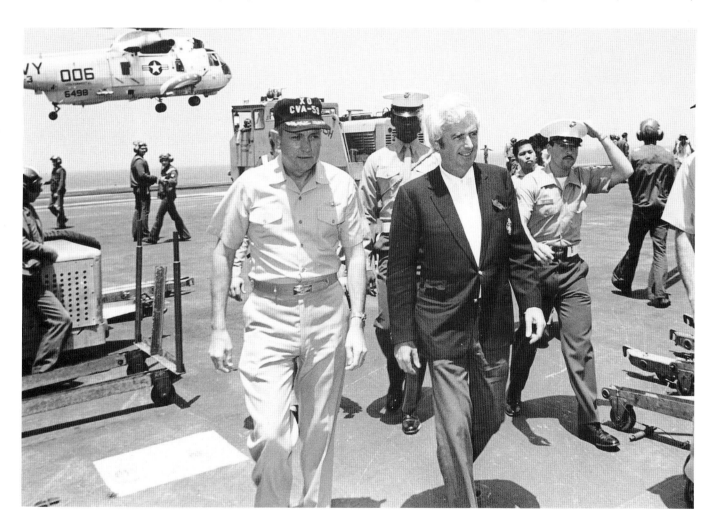

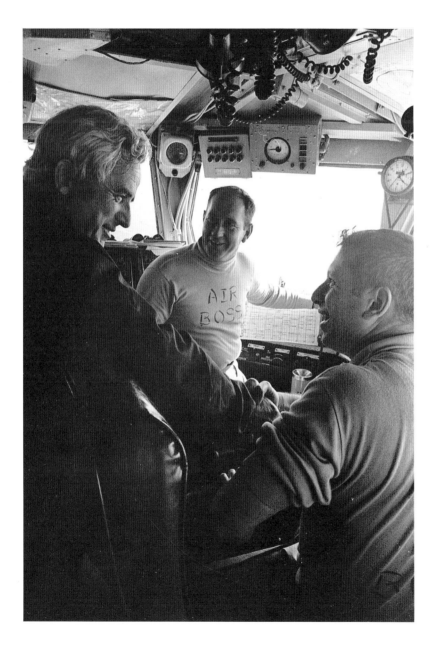

tour director, Ensign Sweet from Public Relations, where we quietly compared notes and sipped on some tasty rum concoction that mysteriously appeared from the maze of ventilating pipes in the overhead compartment.

I had been oohing and aahing so much about the gargantuan size of CVA 59 that the operations officer suggested I might be getting the wrong impression; perhaps I should investigate the other side of the coin and visit one of the destroyers in the Task Force to observe operations from a more modest base. I concurred but questioned how this could be made possible while both ships were at sea. He smiled and told me to meet him on the quarterdeck at 1100 hours.

In the meantime I paid a lengthy visit to the Flight Bridge where the air boss and his crew keep tabs on the incoming and outgoing traffic. He was juggling thirty-two birds and coping with crowded parking conditions on deck. The action is here, and the pressures can be horrendous.

At the appointed hour I was escorted over to a medium-size chopper, introduced to a Marine sergeant who seemed to be in charge, and by the time I strapped myself into a seat, the giant rotor blades were churning the air and we were airborne and climbing above the choppy Med en route to a neighboring destroyer escort. During World War I, because of their bobbing behavior on the high seas, these rather small, narrow-hulled vessels were called "tin cans."

Happily, that day was cloudless, filled with sunshine, and blessed with a smooth sea. The USS *Sellers* appeared over the horizon, steaming along at fifteen knots and chattering away on the radio, detailing our imminent rendezvous. The sergeant had me

Somehow I felt like a spy taking roll after roll of 35mm shots—necessary research to keep Half Hitch *up to speed. It was exciting beyond words.*

Opposite: Dennis fans *were everywhere, even on the flight bridge of "Building 59," where I engaged the air boss in a quick study of flight operations.*

on my feet and was fitting me out with a "horsecollar rig," a harness made of cable that was going to hold me in position while they lowered me fifty feet onto the fantail of the tin can! They hadn't briefed me on this little escapade, but it was exciting to contemplate and I was more than game. After all, what could go wrong? I was in the hands of experienced professionals. Well, wasn't I? C'mon, *say* something!

The helicopter and the ship reduced their speed to ten knots, and I was delivered smack on target without a hitch. Barnum & Bailey would have been proud. The visit was primarily an opportunity to share a midday meal at the Chief Petty Officer's Mess, absorb another aspect of Navy life aboard ship, and get some colorful input from these older and wiser men of the sea, several with hashmarks to the elbow. A big bowl of cheese soup and a generous helping of Southern fried chicken

put me in a very mellow mood. A nice bunch of guys, and because of its relative smallness, the *Sellers* seemed more like the Navy than Building 59. A most unusual and worthwhile afternoon.

Before my tour came to a close, another helicopter whisked me across the Bay of Naples to Gaieta and onto the fantail of the USS *Springfield,* flagship of the Sixth Fleet, to pay a visit to Vice Admiral Ike Kidd. I was given a detailed briefing on "the Big Picture," which involved locations, bases, and movements of the Soviet Navy. Verrrrrry interesting! That afternoon they transferred me to the ancient USS *Intrepid,* the last carrier with a wooden flight deck. Now retired, she is serving as a floating museum. The *Intrepid* was quite a bit smaller than the *Forrestal,* with about 2,500 aboard, and served then mainly as an anti-submarine unit, employing mostly piston aircraft but equipped with super exotic electronic gear.

I returned to my Geneva drawing board loaded with a treasure trove of photographs, notes, and sketches and eager to get my report out to Bob Saylor. Dick Hodgins was arriving the following week and would stay until we had completely restructured the strip. Saylor had been doing his homework and responded brilliantly. I finally had a good feeling about the feature and felt confident that we would soon regain lost ground and zoom to the top of the charts. But, before our research and training program was over, I summoned Hodgins to another Geneva summit meeting, after which the two of us flew out to San Diego and were shuttled aboard the USS *Coral Sea* for additional indoctrination off the Mexican coast. We visited everything but a tattoo parlor, and at long last started dealing with some confidence.

SHIP OVER or SHOVE OFF...

What's your pleasure?

Above: *I developed several special booklets for the Navy during the Half Hitch years. This one dealt with reenlistment. Right: After being dropped safely from the chopper onto the deck of the USS* Sellers, *I paused to reload my Nikon.*

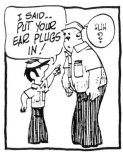

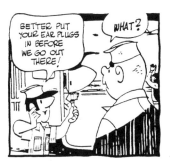

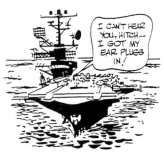

Once the new material was fed into the pipeline, conditions stabilized, and we started receiving encouraging batches of favorable mail. *Half Hitch* was finally back in stride and starting to climb the readership polls. Things were starting to happen. The Navy Department even put me to work writing and illustrating a reenlistment pamphlet and a brochure describing the glories of electronic engineering and posters covering a host of subjects and, my pride and joy, a Boot Camp booklet! I was having a

ball! But the major newspaper clients we lost the previous year were never recaptured. Editors are an obstinate lot; once they drop a comic there is no turning back. Regardless of the avalanche of supporting mail and threats of cancellation if the strip isn't returned, they stoically turn a deaf ear and calmly replace the questionable feature with something that has been waiting patiently in the "on deck circle." Though mortally wounded, we hung in there until 1975, then pulled the plug. A pity, really, we

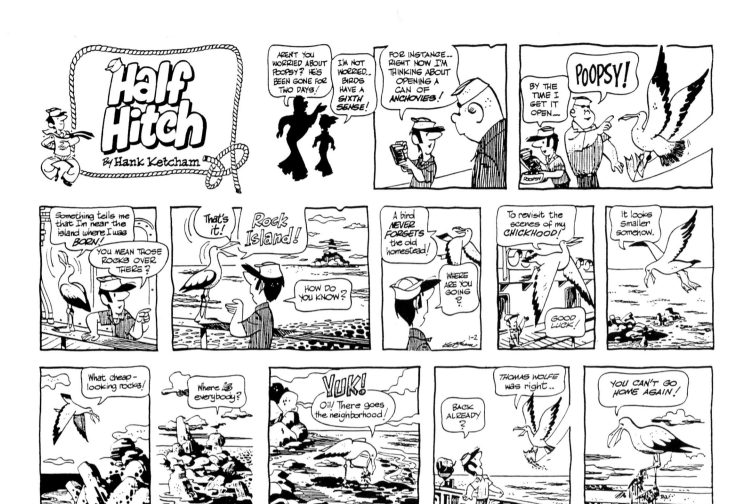

This most refreshing comic strip found artist Dick Hodgins and writer Bob Saylor operating at their very best. While I orchestrated it, the glory belongs to these two outstanding talents.

were all having so much fun. But, in retrospect, it was a blessing. Bob Saylor, the driving force behind our New Look, died unexpectedly the following year, and I doubt that he could have been replaced. He was sheer genius—on *any* subject— and I still miss him terribly.

I gathered up all the original art and made arrangements for the Navy Department to take over the property and use it wherever it could be effective. It was a natural for them, and I hoped they would run with it. But, alas, Hitch became waterlogged in the bureaucratic whirlpools of the Bungling Sea. He occasionally comes up for air but then slips away, never to this day fulfilling his salty potential.

He's another old friend I miss having around. And that goes for Poopsy, too.

Swinging with Bing

Golfing crony, Bob Fisher, the Keokuk Cornstarch King, phoned late one Sunday after-

noon from Kenya, smack dab on the equator. He was loaded with chitchat about the safari they had just taken and said that a mutual friend, one of their big guns, was flying to London the following day and would love to make a Geneva stopover if golf was a possibility.

On Tuesday evening, just as I pulled up to the entrance of the Hotel Richemond, out he strolled, looking tanned, fit, and casually debonair, playing the role of Bing Crosby to perfection. We dined on Rolande's exqui-

site Tafelspitz und Apfel Strudel, sipped on a savory '64 Bordeaux, and sat entranced as our eloquent guest, comfortable as an old shoe, warbled a few bars to newly born daughter Dania. He brought us up to speed on jokes from the jungles of Nairobi and Hollywood and gave a report on recent golfing conquests.

As well known as he was, and as much as he was adored, for the most part the Europeans left him alone, a luxury of privacy hard to come by in the States and

On occasion we would feature the RAC (Retired Admirals Club) and poke fun at salty nostalgia.

208

much appreciated by traveling luminaries. Bing was fond of an occasional cigar, especially the vaunted Cuban species, so, the next afternoon we sauntered around the corner to Davidoff's, one of the world's leading importers of these top-quality, hand-rolled tobacco tubes. After much browsing and sniffing, he emerged looking like the cat who swallowed the canary and clutching a fistful of Monte Cristos, about as expensive as they come.

I couldn't resist. "You've come a long way, Mr. Crosby."

"How do you mean?" he chuckled as we ambled across the streetcar tracks and toward the passage leading to my studio.

"Well, back in the early thirties, remember? You used to do a fifteen-minute broadcast every evening for Cremo Cigars." Though hardly a candidate for the spittoon set in those tender years, I was an avid listener.

He guffawed and chided my memory for trivia but did agree that he had indeed "come a long way." The Cremo was a nickel cigar.

We were fellow members of the Royal and Ancient Golf Club of Saint Andrews, and it was on those pastures we later played as a threesome with a local stonemason, the chap who edged out H.L. Crosby in the third round of the British Amateur fifteen years earlier. It was a thoughtful, sentimental journey for the two former competitors, and while they were reminiscing, hacking their way through gorse and heather, the boy cartoonist was quietly putting together an impressive string of numbers.

Although we cautiously arranged the game to be a private one, by the time we reached the twelfth hole, there were a hundred or more enthusiastic Scots in the gallery, politely reacting to each shot, rooting for their hometown boy, applauding the fluid swings of Misterr Crrosby, and wondering just who was that white-haired chap in the plaid cap?

As we approached the famous Road Hole, the wicked seventeenth, the crowd was so thickly clustered around Bing that he couldn't safely swing his club.

Somebody's going to get hurt if I continue," he murmured. "You've got a great game going, so you and Tim finish out and I'll meet you back at the clubhouse."

Whereupon he dissolved into the crowd, clattered over the Swilken Bridge, and quickly disappeared behind the ominous gray walls of the R & A. By the time the gallery realized that we were only a twosome, I was on the 18th and two-putting for my par and a round of even fours, my very best effort. Yes, we were under clear blue skies and, no, the wind was not a factor. True, this was a friendly game, not a competition—but just a doggone minute, you guys! I shot a 72! My career round! And I'm proud as a Palmer or a Nicklaus! So let's hear it for *me*!

Whew!

It was almost nightfall—gloaming, if you please—the telephone operators had alerted the township, and by now the castle was surrounded by eager-eyed fans, many with pencils and pieces of paper, and all of them chanting for a glimpse of their idol of idols. There was no easy escape route, so the hall porter arranged for a decoy operation. A car and driver arrived, and shortly thereafter two gentlemen climbed into the back seat and waved to the staring bystanders as they were whisked away toward the village.

During this little charade, Bing and I stood at the service bar, away from doors

and windows, thoroughly enjoying the hospitality of two young lassies who insisted that while waiting we sample a variety of different whiskies stocked by the club. We needed little prodding to participate in this pursuit of spirituous knowledge, and by the time we made our exit, there was nary a soul stirring in the neighborhood.

"ME 'N JACKSON ARE EXACTLY THE SAME AGE. ONLY HE'S DIFFERENT. HE'S *LEFT-HANDED!*"

Black Was Beautiful

Back in the late 1960s when minorities were getting their dander up, painting signs, joining in protest marches, and calling attention to their plight, I was determined to join the parade led by Dr. Martin Luther King, Jr., and introduce a black playmate to the Mitchell neighborhood. I named him *Jackson* and designed him in the tradition of Little Black Sambo with huge lips, big white eyes, and just a suggestion of an Afro hairstyle. He was cute as a button, and in addition to being a marvelous graphic, he would reflect the refreshing, naive honesty of preschool children as yet unexposed to prejudice and rancor. It was a splendid opportunity to inject some humor into the extremely tense political climate. I urged my writers to give this priority and rolled up my sleeves with enthusiastic anticipation.

Caricatures are usually cruel—often amusing, but seldom complimentary. For instance, take needle-nose Henry Mitchell, or frumpy Martha and her potbellied George, a combination of W.C. Fields and the Terrible Tempered Mr. Bang. Or, for that matter, consider the kid himself, Dennis. He looks like a midget running around with a load in his pants! But, as in the real world, once you get to know these funny-looking folks, you enjoy them and no longer consider them grotesque.

My introductory drawing had the two boys in the backyard, with Dennis talking to his mother standing in the kitchen door:

"I've got a race problem with Jackson. He can run faster than me!"

A harmless little play on words and, I felt, a soft, amusing beginning. Not so. The rumble started in Detroit, then moved south to St. Louis where rocks and bottles were

thrown through the windows of the *Post-Dispatch*. Newspaper delivery boys were being chased and hassled in Little Rock, and in Miami some *Herald* editors were being threatened. The cancer quickly spread to other large cities.

I first heard the news in a midnight transatlantic telephone call to my Geneva apartment from the syndicate in New York. I was shocked, then frustrated, then mad as hell, and, at the request of my beleaguered colleagues fielding complaints from all over the country, dictated a statement to the client newspapers involved. I made a point *not* to apologize but to express my utter dismay at the absurd reaction to my innocent cartoon and my amazement at the number of "art directors" out there. Any regular Dennis-watcher would surely know that I am never vindictive or show any intent to malign or denigrate. But I guess those violent protestants were not avid followers of newspaper comics. And they weren't complaining about the "gag"; it was my depiction of Dennis's new pal that got their tails in a knot. I gave them a miniature Steppin Fetchit when they wanted a half-pint Harry Belafonte.

It seems that Sammy Davis, Jr., was the only one who could safely poke fun at the minorities. To this day, Jackson remains in the ink bottle. A pity.

More than thirty titles of the annual Dennis *collections of daily panels are still in print, and more than 50 million copies have been sold.*

Hank the Yank

Recent studies have concluded that creative people reach the peak of productivity midway in life. I became a resident of Switzerland shortly after my fortieth birthday and, as if to prove the point, produced an impressive amount of material during the ensuing ten years.

This complete change of surroundings, culture, friends, and language apparently recharged my batteries and stimulated the creative juices, and I began to experience an unusual feeling of freedom. Released from the bonds of boring daily routine, off the hook with the social circuit, completely anonymous, exhilarated with the challenge, I was eager to roll up my sleeves and wallow in this refreshing new environment. Especially since the Swiss authorities had just granted me a *Permis de Sejour,* meaning that as long as I behaved myself I was welcome to dwell on the shores of Lac Leman for a period of twelve months, after which my case would be "reviewed." Obviously I was the epitome of good citizenship as, ten years later, they presented me

Luncheon at Geneva's Hotel Richemond where P&G executive Pick Pickering and I savored the '66 burgundy, a monthly ritual that put a delightful dent into the afternoon.

a more permanent arrangement, the *Permis d'Establissment,* by which, except for the privilege of voting or the requirement of serving in the Army, I enjoyed the same rights as the natives. Another two years and I could apply for a Swiss passport, providing I first went to our embassy in Berne and renounced my United States citizenship.

As much as I detested Lyndon B. Johnson's politics, as much as I could not stomach our handling of the war in Vietnam, and as much as I resented paying US income taxes without the right to vote in a Federal election while residing abroad, I could not turn my back on Old Glory. Many of my friends did, and with excellent reasons, but I am too much of a Straight Arrow, and, besides, I just couldn't visualize the "father of the short All-American Kid" becoming a turncoat.

Bernie's Leftovers

Bernard Cornfeld, a yankee pioneer in the Department of Wheeling & Dealing, Creative Investment Division, was riding high on a Swiss hog in the sixties and seventies, until he came a cropper and spent some time in the Geneva pokey while his Fund of Funds and other assets were being liquidated.

A miniscule piece of his leftovers was a small vineyard in the Haut-Medoc section of Bordeaux, near Pauillac, which was already producing some fine wine. About twelve hectares of land was under cultivation, and there was a chateau on the property. (Not insignificant, for when French wine is chateau-bottled, the vineyard can add one extra franc to the price.)

C. Henry Buhl III, one of Bernie's associates who was still running around loose,

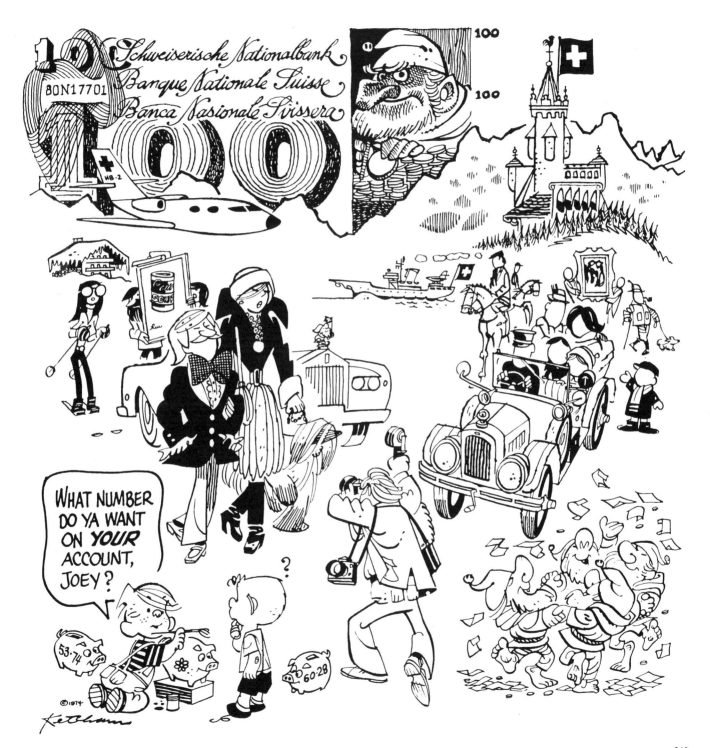

called one morning to advise me that Chateau Le Fournas was up for grabs. He was going to set up the financing as a joint venture with a group of twenty or thirty friendly oenophiles willing to contribute ten thousand dollars for openers and another ten at a later date, and would I be interested? He admitted that there were more promising investment opportunities elsewhere, but the appreciation should more than offset the risk and, in any case, annual dividends would arrive in bottles with my name on the label!

I couldn't resist.

Many years ago, some of the vineyard land belonged to the Swedish royal family, so our association's president, Curt Eklund, decided that it would be appropriate to add the name *Bernadotte* to the label. Not surprisingly, much of the production is sold to the Swedish Wine Monopoly. With further purchases of small parcels and lease agreements with neighboring farmers, there are now twenty-two hectares (about fifty-five acres) involved.

Through the years we have received periodic shipments of Chateau Le Fournas Bernadotte, much of it in festive magnums, and enjoy sharing it with dear friends without waiting for special occasions. And I must admit, *c'est magnifique!*

But thirty wine prima donnas soon became unmanageable. Fingers pointed, voices were raised, suits were filed, so the painful process of liquidation was put in motion once again. For my share of the participation, however, instead of accepting a check in French francs, I opted for delivery of enough cases of this delectable juice from the merlot and cabernet grapes to guarantee at least one bottle on my table each night until the twenty-first century.

And my name is on the label. Cheers!

Geneva 1976

The Swiss franc gained relentlessly against the dollar, soaring from a value of twenty-two cents to sixty-five cents within a few short years. Consequently, my U$A income became alarmingly diluted. And when I had to fork over five bucks for a jar of peanut butter, I knew it was high time to seek leaner pastures.

For my Austrian roommate, taking a holiday in the States was something she always cherished, but the thought of emigrating to America was a sobering one. Could she bring herself to say *adieu* to the Rue Marche and the elegant boutiques, to the stunning view of the lake and the distant Mont Blanc looking like a strawberry ice cream cone at sunset? Could we kiss *au revoir* to a magnificent golf club and the precious friendships we had enjoyed over

"When the blue of the night meets the gold of the day..."

Thanks, Bing.

the years, the implied security of Switzerland, the *filet de perche* and *pommes frites, rosti,* spaghetti carbonara, Dezaley... Williamine...? AGONY! Even I had second thoughts. However, that summer we decided to put our toes into the water and take our three-year-old on an international test run, renting a spacious house in a forest of Monterey Pine that overlooked a deer-studded golf course and an ocean sunset.

The thirty-day sampler was a success, and we started mapping out serious plans to return to the Monterey Peninsula, not realizing that the following year our family would consist of four members.

I received my coveted invitation to play in the Bing Crosby Pro-Am, so in January, this time alone, I made the my annual pilgrimage to the Beach of Pebbles. As Rolande had remained at home, preparing for a March delivery, she urged me to scout the housing market for "something conveniently located, tastefully designed, and surprisingly affordable."

With a little help from my friends, I managed to uncover what turned out to be an attractive fixer-upper, but the snapshots I brought back to Geneva were not enormously convincing. Nevertheless, it was a done deed and the count-down began. Scott Henry arrived on my birthday and, three months later with nanny Martine in tow, we flew to London and boarded TWA Flight 110, nonstop to San Francisco, The New World—and all of the bureaucratic rigamarole necessary for Rolande to gain permanent residence. I had signed documents guaranteeing that my wife would never become a ward of the state, that I would underwrite the expense of her room and board, gowns and jewels, and miscellaneous amenities forever and ever. Apparently they were not concerned with the kids as they were already registered American citizens, but their mother was photographed, fingerprinted, interviewed, and required to carry her two-by-three-foot chest X-ray through the Immigration process.

Opposite: *A contestant prepares for an upcoming Crosby Pro-Am. The notorious wet and windy January weather on the Monterey Peninsula inspired this piece of art for the program.*

I started off the day in Geneva feeling so proud of myself. The gratifying contemplation of bringing my family back to the land of my birth, with the promise of introducing them to Freedom, Democracy, and Opportunity, filled me with joy. But, after the tiring fourteen-hour flight, as we sat waiting in the hallway for our disinterested government servants to spring into action, I felt depressed, embarrassed, and downright agitated, and left with a feeling that it would have been much easier for us to swim across the Rio Grande.

In early 1978 we moved into our current Pebble Beach home, an attractive box sitting on a flat acre of dirt and clay with one live oak tree for decoration. Although the children missed having an elevator, we were most thankful to be out of the apartment and into our very own home. But now the fun would begin, inside and out! One of my priorities was to design a large playhouse for the kids. Something they could call their own, where they could entertain their friends, where they would be out of the way, and a structure that offered a host of different activities and would never ever become boring. (It ended up costing almost as much as I paid for my first house, built just two miles to the south thirty years earlier.) If decibel level is any indication, it remained a howling success for ten years, until the youngsters started to gravitate to other activities. Termites forced us sadly into demolition and a farewell to the sixteen-foot tube slide, the fire pole, two rope swings, a sling swing, a tire swing, and all kinds of tunnels, trapdoors, ladders, and secret hiding places, and room enough to accommodate a dozen active kids. Kinetic art at its finest, and an end to a very fulfilling era.

Our home has at long last become a very comfortable, livable, usable shelter from the elements, and we enjoy it immeasurably—but we're still not through fiddling. About every two years we embark on another major project, and we have some dillies up our sleeve. I would be distraught otherwise.

Best of *Dennis*
—1970s

"THIS IS MY WEDDING PICTURE."

"IS THIS SKINNY GUY YOUR *FIRST* HUSBAND?"

"HE SAYS HE FEELS SO WELCOME! WHAT AM I DOING *WRONG*?"

"OH, *THERE* YA ARE, MR. WILSON! THE WAY YOUR PHONE JUST KEPT RINGIN', I THOUGHT FOR A MINUTE YOU MIGHT BE ASLEEP."

"IF I HAVE TO SIT IN THE CORNER FOR SAYIN' IT, AT LEAST YOU COULD TELL ME WHAT IT *MEANS!*"

"I BEEN WANTIN' A *HORSE* FOR A LONG, LONG TIME...
MAYBE YOU CAN HEAR ME A LITTLE BETTER UP HERE."

"JUST SAY 'HELLO', HUH? IF YOU ASK HER 'WHAT'S NEW?', WE'LL **NEVER** GET TO THE MOVIE!"

" YOU DON'T HAVTA SHOW **ME** THE WHOLE HOUSE... JUST THE KITCHEN AN' THE BATHROOM !"

"I'D LIKE A BAG FULL OF SURPRISES FOR MRS. MITCHELL.
SHE'LL COME IN AN' PAY FOR 'EM LATER."

"I'M THROUGH. WHILE YOU'RE FINISHING, I'M GONNA TAKE
UP A BONE COLLECTION FOR RUFF."

Pebble Beach, 1977-

So You Want to Be a Cartoonist?

Producing a daily newspaper feature that concerns itself only with humorous incidents—no continuity, no politics, and nothing timely—is a joy. There are the unrelenting deadlines, to be sure, but there are no restraints to pouring on the steam and accumulating a fat backlog of material so you never fret about coming down with the flu or give a second thought to zipping off on a jaunt to the Caribbean. I struggle to stay eight to ten weeks ahead, but my dear departed wacky colleague Vip Partch *(Big George)* was more than *two years* ahead when his life was so tragically snuffed out. Alex Graham, the talented little Englishman from Rye, the creator of *Fred Basset,* is always more than a year in advance of his release date. How I would love to be in that position of utter leisure and relaxation! My longest lead time was sixteen weeks when I sailed off on my maiden voyage to visit Russia many moons ago, and even then I ran out of cushion and had

to hole up in various hotels to maintain the schedule. Maybe if I simplified my style a bit, worked with stick figures, and didn't get so fussy with details—nah, forget it, Henry. It wouldn't be fun anymore, and those marvelous, flattering letters from art students would cease forever.

Editorial cartoonists, the poor chaps, are really on the firing line, usually working directly with the editorial staff, most of them marching in lockstep with the news. Of course they break the tension with cartoons of general interest, and the top men in the field usually produce only three drawings a week. But stress and burnout are constant threats, and I am most thankful to be in the entertainment wing of the profession.

Major holidays usually get my attention, especially the busy days leading up to Christmas—certainly the high point of the year for all youngsters the age of Dennis. Valentine's Day and the Fourth of July offer

excellent opportunities for fun, and sometimes I'll slip in a Mother's Day panel; then after school starts in the fall come Halloween and finally Thanksgiving. I follow the classic weather patterns on the calendar, using rain and snow, wind and sunshine as a chef would use his herbs and spices.

The panel seldom acknowledges events such as the World Series, the Superbowl, the US Open, or even the Olympic Games. A five-year-old is too young to attend, too little to participate, and, quite simply, doesn't give a rip. But I did make a giant effort to celebrate our Bicentennial in 1976. *Yankee Doodle Dennis!* And what great fun it was! Bob Saylor, my supertalented writer, developed a bundle of daily panel ideas featuring the Mitchell family coping with life in New England in the days leading up to the American Revolution. Understandably, the research involved was staggering, but I was so stimulated with this concept, so turned on by the costumes, architecture, and artifacts of the period, I could barely contain myself. The first drawing was released on June 6, and the series ran for two weeks. It received such favorable attention that I have since been mulling the possibilities of portraying the Mitchells during the Civil War, or the Mitchells and the Wilsons rolling along in a covered wagon on the Oregon Trail with Lewis and Clark—and all those cowboys and Indians! Too bad we no longer produce the Dennis comic book; that would have been a natural!

Creativity

Creative creatures, those fortunate folks who subsist on rewards offered them in exchange for contributing something entirely new, fresh, original, and desirable to society, usually face the dilemma of having to make split-second decisions hours on end during their periods of productivity. This applies particularly to those who are engaged in efforts that are of a spontaneous nature, such as novelists, watercolorists, and designers of the pen & pencil school—of which I am one. This mental agility is ingrained through years of experience, enormous confidence, and a flair for positive thinking, along with the backup insurance of erasers and extra sheets of clean paper.

Perhaps this insight helps explain why this group has a reputation for making lousy business decisions, a propensity for buying funny-looking clothes, and, in many notable cases, making disastrous marital moves.

How do I know so much about the subject?

Please . . . I don't care to discuss it.

Once the creative seed has sprouted, there is no letting up. Images, words, colors, numbers, and sounds flow from some inner fountain of inspiration in a steady trickle—and sometimes, as though to fill a vacuum, they arrive in a gush. On such an occasion, the atmosphere crackles with the electricity of fresh options, new directions, and heretofore unimaginable combinations. They burst in such rapid succession that trapping them all on paper or even getting them properly organized in your head becomes impossible, and many of these instantaneous bubbles pop and disappear, until, possibly, the next time around.

These unexpected fits of fever-pitch creativity seem to occur following prolonged periods of relative calm. This might compare to being on a starvation diet for weeks when suddenly you are seated at

I WONDER WHAT THAT LITTLE KID WILL DO *TODAY* ?

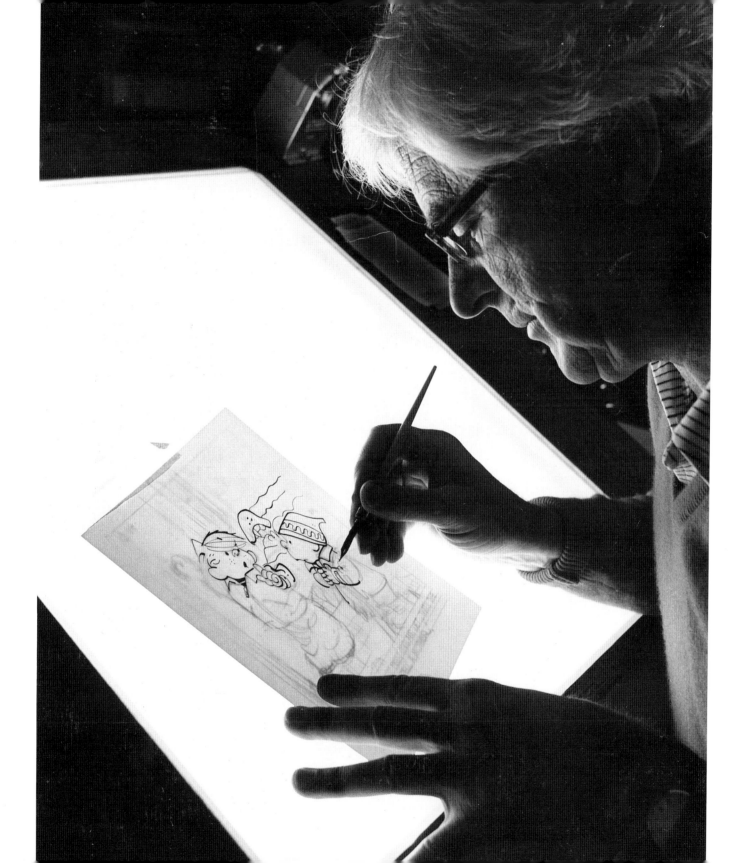

"ALL RIGHT...WHO'S SINGING POP GOES THE WEASEL WHILE THE REST OF US ARE SINGING GOD SAVE THE KING?"

In 1976 our national Bicentennial celebration gave me a marvelous chance to show how Yankee Doodle Dennis and his family would cope with the Revolution. The two-week series was great fun.

"THEY SURE DON'T MAKE STUFF LIKE THEY USETA, HUH, MOM?"

The Ketchams emigrate to America and decide to settle in Pebble Beach, conveniently close to Daddy's favorite golf course. Scott rides on my shoulders while Rolande holds our five-year-old daughter, Dania.

Grandma's Thanksgiving dinner table. Bon appetit! What joy!

The man with creative genes in his soul perceives the world through the eyes of a critic. He is often hard to please, totally uncomfortable with the status quo, and eager to apply his point of view to the areas of his discontent. The congested urban environment, with so much in obvious need of change and improvement, usually proves too frustrating, so he seeks shelter and peace of mind in the hinterlands. This doesn't stop his wheels from turning, but at least while the TV is off, exposure to sleaze and great hoards of the unwashed is minimized, allowing freedom to concentrate on directing the creative juices toward more meaningful pursuits.

A professional is usually described as "one who arises each morning and does his thing whether he feels like it or not." No waiting around for the muse to strike or for his birth sign to move into the House of Venus. He just sits down and does it. This is certainly true in my case, where deadlines come with the territory. I'm at my drawing board at 8:30 A.M. and on my way home by 5:00 P.M. Keeping regular hours reduces the stress, insures that the work will get mailed on time, and makes me instantly reachable by my writers and business associates around the country via phone or fax.

Each morning I selectively skim through two local newspapers (the *Monterey Herald* and the *San Francisco Chronicle*) and the *Wall Street Journal.* Stacks of weekly periodicals seem to accumulate faster than I can digest them. To find the time to get caught up and stick my nose into a novel once in a while, I set the alarm for 5:30 and rapturously enjoy ninety minutes of uninterrupted peace and quiet. Thus, my Late Late Show usually fades to a finish half-way through the 10 o'clock News.

However, I do turn away from commerce for regular golf games and try to play two or three times a week. I find this sport to be a huge relief to my overworked eyeballs, which are riveted daily to pen and pencil lines a mere twelve inches away. The joy of inhaling fresh sea air and the pleasure of a five-mile stroll through heavenly pastures of grass and trees (and sand) is a welcome physical change from the confines of my drawing board. The business of being creative is invariably a lonely one, as I work pretty much by myself; and because my product has no relationship with the community, I come in contact with few people. Once again, golf comes to the rescue and brings me together with three other dedicated masochists, offering some balance to my social life.

Opposite: *My vaulted-ceiling studio was built over the double garage, and it took me about 45 seconds to commute to work each morning. The slightly tattered two-star flag hanging in the window was a gift from a retired rear admiral, an avid* Half Hitch*-watcher, who flew it over his Texas headquarters during Hurricane Caroline.*

I'm not sure the ball went in the direction I had intended.

Overleaf: *Ninety-six half hours featuring the animated adventures of Dennis and his friends were produced for the General Mills Corp. in 1988–89 and were distributed to independent television markets throughout the world. The series was targeted to an audience of younger children, ran each weekday, and was remarkably successful.*

Through it all, the stream of imagination continues to trickle and the cranial antenna constantly scans for germs of inspiration. From my experience, *exposure* is the key to fresh ideas, exposure to reading, to travel, to meeting people; exposure to concerts, to the theater, and to sporting events—the whole enchilada—offers exhilarating seasonings for Whimsical Stew. I suppose, for some, all of this should be taken care of during the early years, after which you can then slink away to your garret or curl up in your ivory tower and paint or write to your heart's content about the cold, cruel world you left behind. But for those of us dishing out humor on a daily basis, there is no place to hide; we have to stay on the firing line with our thinking caps squarely in place.

On the other hand, I know guys who come up with fabulous ideas by simply leafing through stacks of old mail-order catalogs.

Talent

When I was a youngster, Mother would show friends some of my sketches and I would hear remarks like, "My, but Henry has a real talent, hasn't he! I wonder who he takes after?"

At that time, one might have better described my ability as a "knack" or a "flair," but I can assure you there was little evidence of "God-given talent." And I don't believe there *is* such an animal.

This attribute is really the result of intense fascination with a particular art or profession. Perhaps a genetic aptitude is present, but this "talent" usually doesn't become visible until after a certain amount of despair and perspiration and the celebration of a few small triumphs.

Persistence, patience, and motivation remain dominant factors in any measure of success. Grandma Ketch would have summed it up in one mouthful: "Stick-to-it-tiveness."

But listening to these tiresome clichés is boring and a pain in the pattoot to a teenager who is not the least bit interested in the revelation that "good things don't come easily"—and all that stuff about study and hard work. I felt the same; I didn't want to stand and watch the parade go by, I wanted to *march* in it!

At times I allow myself to dream that I might have attained a modest success in any number of directions, maybe in the theater or even in some area of music, had I hung in there—but I was otherwise hooked.

If there is a moral to this dissertation, it is probably this: A child must be given the time, the necessary tools, and your full support and encouragement—no matter what his or her interest may be at the moment. In some instances it might take a little seed money, and in all cases it will demand your attention, test your patience, and eat into your time. But, regardless of the outcome, what a precious investment and a proof of your talent for caring.

Humor—What on Earth Is It?

Humor is an ingredient that enters your consciousness acoustically and/or visually and attacks your funnybone, sometimes with a nibble, often with a sharp bite, but occasionally it roars in and rips it to shreds,

I never really get tired of drawing the little upstart. He's become second nature to me, like a member of the family; only sometimes I wish he would grow up and go away to school—but now I'm beginning to sound like Mr. Wilson.

leaving you in tears and happily helpless.

As the comedians Moran and Mack used to ask: "What causes that?"

Obviously, it must relate to the audience. An anecdote about a cricket match might be uproarious in Rangoon but lay an embarrassing egg in Rochester. A play on words is always a favorite. On a visit to the lumberyard with his father, Dennis asked the salesman if he could watch the naughty pine.

In the same category you'd have to list the pun and the double entendre, but it is generally agreed that humor defies analysis. You can't examine it to determine why it is so amusing; once it has been dissected for your inspection it quickly evaporates, like air in a punctured balloon. Like mercury: now you have it, now you don't—it has disappeared. The words have lost all meaning. There is no spontaneous combustion, nothing unexpected, and you are baffled at the reason for your laughter in the first place.

However, if I had to specify *the* common denominator, the element that can be found at the core of most humor, I would list *surprise.* The unexpected catches you off guard; you were anticipating something entirely different and—bam—there you are with a hearty guffaw and a big smile on your face.

It is not what is said but rather who said it.

The basis for some of the richest humor is the personalities involved. When the writer doesn't take time to develop his characters he will resort to stereotypes for instant recognition, a useful ploy to establish age, education, profession, sex, wealth, and ethnic identity—all necessary elements upon which to build comical situations.

But avoid trying to explain a joke to someone. It is no fun.

Cartooning Footnotes

Charles D. Schulz, with his *Peanuts* gang, is an outstanding practitioner of the art of keeping his graphics simple. His features would suffer little damage if some thoughtless editor, eager to free up new advertising space, reduced the reproduction size of the comic section. (Much to his credit, Garry Trudeau, demands that each of his client newspapers run his *Doonesbury* in a specified pica width.)

I look at this work wistfully, wishing somehow that I could produce *Dennis* with such day-to-day simplicity. 'Tis but a dream; I seem to have trapped myself over the years into creating such realistic situations that I must resort to elaborate designs that penetrate space and give the illusion of depth—like peering through a window in the page. It's exciting when it works but, heavenly days, it raises hob with the schedule when I get too detailed and carried away.

From the beginning, *Dennis* was a single-panel feature. My approach to cartoon humor has always been visualized in this manner, obviously influenced by my freelance years when the weekly magazines would liberally sprinkle their back pages with single-panel one-liners. My heroes at the time were the *New Yorker* cartoon giants like Peter Arno, George Price, Whitney Darrow Jr., and Gluyas Williams, all of them producing single drawing gags. This restricts the kind of story you can tell, but the impact can be fantastic.

Consequently, *Dennis* has been presented as an isolated gag-a-day panel, with no particular continuity except for the reg-

"NOW THAT WE'RE **ALONE**, I GOT A LITTLE P.S. TO ADD TO WHAT I SAID BEFORE..."

"WAIT HERE 'TIL I FIND OUT HOW MANY OF US SHE'LL LET IN." "JUST ME."

ular appearance of the featured characters. However, some years ago I decided to experiment with ways of telling more of a story, still only a single drawing with an amusing caption, of course, but dealing with the same subject matter over several successive days. For instance, I had Dennis and Joey spend two weeks on Uncle Charlie's farm, with a supporting Sunday page running in the middle as an intermission. Another time Dennis spent a whole week helping poor old Mr. Wilson clean out his attic.

Sensitive to the probable financial status of the Mitchell household, I have refrained from any sign of opulence or irresponsibility, making sure the family car was always about three years old, that they never traveled by air, and I didn't give them an electric dishwasher or color television until the early seventies. However, once group air fares became available and flying was no

longer such a big deal, I scheduled two weeks of Dennis's first trip on a commercial airliner. That was fun—for everyone but the flight attendants. These were daily gags for sure, but with built-in continuity that offered the same appeal and continuing interest as a trip.

Being aware of these personal issues lends a certain amount of credibility to the feature. Dennis-watchers tend to regard my pen-and-ink people as flesh and blood, friends they see every day and, consequently, feel that they know them intimately. Should I unthinkingly take them out of character and allow them to speak or behave in an unseemly manner, then it's off with my head! I'd face a mountain of protest from the outraged disciples of the half-pint mischief-maker. Lord deliver me from that!

These restrictions narrow my avenue of approach and put a lid on many humorous possibilities but, on the other hand, because of this keen awareness of the special chemistry that flows through the daily presentation, my job actually becomes easier. As I've stressed before, the best humor doesn't come from what is said but rather from *who said it*.

More Questions

I can always count on someone asking, "How long does it usually take you to draw a daily panel?"

"Well," I hedge, "that depends."

In addition to just how alert I feel, there's the question of the number of characters involved and what theatrical elements must be considered. Are there any special costumes or uniforms required? And what are the complexities of the interior design or architecture?

FIRST... THE IDEA!

SNAP

I'VE GOT ONE!

I'LL MAKE A QUICK PENCIL SKETCH..

...AND TEST IT OUT ON MY WIFE.

I DON'T GET IT.

WELL... BACK TO THE OLD DRAWING BOARD.

It sounds as if I'm making a federal case out of this simple inquiry, but there is no pat answer. On the other hand, if the cartoon simply depicts Dennis sitting in the corner, or bugging poor Mr. Wilson from across the garden fence, then it shouldn't take me more than ten or fifteen minutes to develop a pencil layout and another fifteen minutes to produce the pen-and-ink finished piece. But, for the most part, the assignment is more demanding and requires time-consuming research in our scrap file (morgue), various encyclopedias, or at the neighborhood library. During the years in Switzerland, I relied heavily on the Sears Catalog and find, happily, that this portable file cabinet remains an excellent source of alphabetized graphic information.

The Sunday Page is, however, a full-color extravaganza, each one requiring several days of preparation. The page must fit three different layouts, the standard half-page, the one-third page, and the tabloid format, to service the various needs of the client newspapers. This is an awkward way to tell a good story—in fact, almost impossible—so most of the features appear as a watered-down version of a single joke.

For the past few years, more and more bottom-line managers have been telling their editors to reduce the comic space to make room for additional advertising. Most feature editors, aware of loyal readership, choose to shrink the comics rather than cancel some, resulting in postage-stamp proportions and considerable difficulty to read. If this situation continues, tomorrow's newspaper cartoons will feature talking heads telling radio jokes. Talented artists and designers will seek other outlets, as space will be insufficient for exciting graphics or storytelling.

Years ago, the Sunday Comic Section was one of America's most popular forms of entertainment. It was something for the whole family and would be spread out onto the floor for all to enjoy. In those happy days the cartoonist had an entire page to himself and, consequently, lavished on his panels amusing details and some wonderful dialogue.

Can you imagine the frustration of Winsor McCay trying to fit his Rarebit Fiend Dreams onto comic pages of today?—no way!

Strange Point of View

I try to draw so convincingly that the reader won't notice.

I realize that this is an odd statement, but let me explain. Underlying the importance of this idea is this fact: the average newspaper reader will devote just enough of his time to study the drawing, read the caption below, then hopefully smile as he once again scans the art work and moves on to another feature—all in a mere ten seconds.

For example, take everyday objects that are sufficiently complicated and difficult to draw (from memory)—a vacuum cleaner, a bicycle, a meter maid, or a supermarket shopping cart. Items of this nature are often needed to establish the scene, to identify the locale without question. Should the artist's version of this object be inaccurate or odd, or even amusing in itself, the reader's attention will focus on something other than the idea of the cartoon. Thoroughly confused, the reader will move along—and very likely not bother to seek you out the next day. A chilling thought for the creator of a daily newspaper comic.

If, on the other hand, the drawing of the motorcycle or the piece of antique furniture is treated thoughtfully, with a certain de-

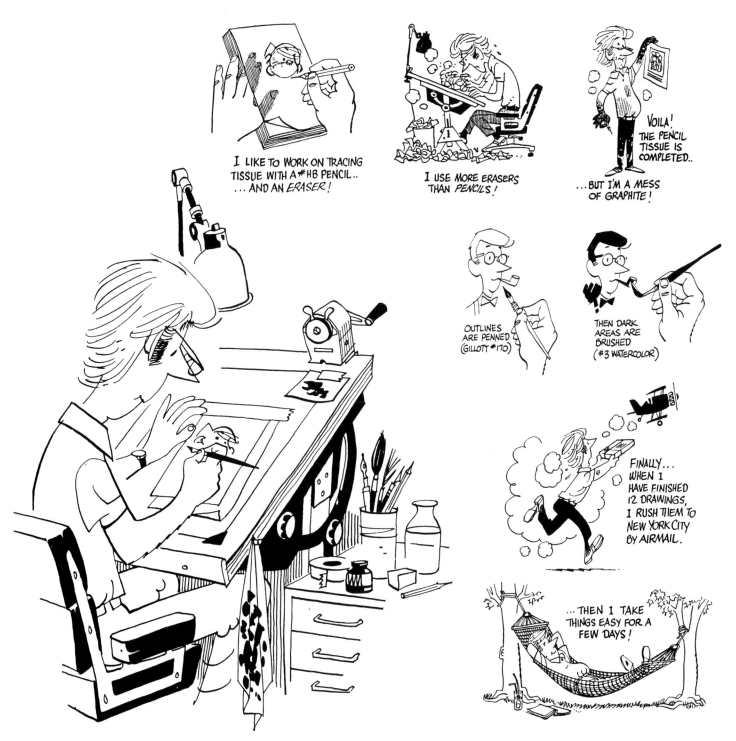

I LIKE TO WORK ON TRACING TISSUE WITH A #HB PENCIL.. ...AND AN *ERASER*!

I USE MORE ERASERS THAN *PENCILS*!

VOILA! THE PENCIL TISSUE IS COMPLETED..

...BUT I'M A MESS OF GRAPHITE!

OUTLINES ARE PENNED (GILLOTT #170)

THEN DARK AREAS ARE BRUSHED (#3 WATERCOLOR)

FINALLY... WHEN I HAVE FINISHED 12 DRAWINGS, I RUSH THEM TO NEW YORK CITY BY AIRMAIL.

...THEN I TAKE THINGS EASY FOR A FEW DAYS!

"IT SOUNDS LIKE DAD....BUT HE
WANTS TO TALK TO THE *PRINCESS!*"

gree of accuracy in the caricature, the reader will automatically accept it at face value and not lose his momentum.

So, research is called for in such instances. Most cartoonists maintain a "morgue," clippings from magazines, catalogs, and brochures, into which they can dip for examples of the articles in question. Sometimes a trip to the library is necessary, or a personal visit to, say, a neighborhood gasoline station if a fuel pump is the object, or to a butcher shop or pet store to obtain details needed to nail down a drawing that is believable, yet handled in such an offhand manner that the reader won't bat an eye.

This must sound strange—to go to so much fuss to be unnoticed. Fred Astaire practiced incessantly so that even his most complicated dancing appeared casual and spontaneous. (Perhaps not an appropriate analogy in this case, but it is interesting—no?)

The same attention to clarity is paid, of course, to the dramatic qualities. In essence, the art of cartooning is a parallel to the theater in that each pen-and-ink persona is an actor, meaning in turn that the artist must "play" each part.

All of this must sound terribly serious and self-conscious, as if I wanted to take all the fun out of the cartoon. Not so.

Technique, the Flair and the Dazzle

This is a subject that is of consuming curiosity to most fledgling cartoonists. The method, the tools, the rendering, and even the nature of one's signature are scrutinized to a fare-thee-well by young students of the art. I was no exception and, like many, failed to fully appreciate the excellence of design, the quality of drawing, the

"WHY SHOULD I WEAR A MASK? I GET LOTS MORE WHEN THEY SEE IT'S *ME* ASKIN'!"

"I'M NEVER GOIN' INTO *THAT* KINDA BUSINESS. I'D GET LONESOME FOR EVERYTHING I SOLD."

"I WONDER WHERE THEY KEEP THIS STUFF IN THE WINTER...
IT ALWAYS COMES BACK LOOKIN' SO NICE AND FRESH IN
THE SPRING."

layout (staging), and the "acting" of the popular cartoonists who were regular contributors to the weekly magazines during my formative years.

I swiped from George Price, borrowed from Whitney Darrow, Jr., and Ralph Barton, took a smidgen from Gluyas Williams, and spent several years floundering from one inspirational hero to another. An experimental phase followed where I vacillated from pen-and-ink to brush only, to pencil only, to inking finishes directly with no preliminary pencil guide whatsoever—and then I worked in tempera and even did some finished art in scratchboard where the solidly inked areas are etched into a line drawing, using a knife or an engraver's tool. I recall doing a drawing for the *Saturday Evening Post* entirely in colored crayons!

I finally returned to the Gillotte #170 and the #3 Winsor & Newton sable brush. I like the way the tiny, flexible penpoint skates across the two-ply plate-finish Strathmore, and if the drawing isn't turning out well, I simply toss it out and reach for a fresh piece of two-ply, tape it back onto my light board, and have another go at it.

Materials are cheap, only your time is precious.

The Same Old Grind

Pulling ink lines across a blank piece of paper every day, dealing with the same cast of characters who year in and year out are still up to their old tricks, still dressed the same, and still living in the same old neighborhood must sound like a treadmill to boredom, but I don't look at it in that light.

Sure, the subject matter has remained the same since 1950, but there are infinite variations on the theme; I can't allow either the reader or myself to be lulled into boredom or a sense of déjà vu. I make a serious effort to keep the daily Dennis-watcher off balance. That is, I don't want him to take me for granted, so I'll toss in a surprise now and then by way of an unusual graphic or by inserting an unexpected detail to attract his attention. Nothing so intrusive that it interferes with the gag, but rather an unobtrusive accent to tickle his risibilities.

Due to the pressure of deadlines and the necessarily heavy concentration, there is a certain amount of stress involved. The same kind of tension is experienced during spells of creative writing when the system can hold up for just so long before it demands a recess, a pit stop, or a change of pace. This gives you time to catch up on your reading, conduct a bit of research,

"THE WAY YOU YELLED, HE PROLLY WON'T *NEVER* COME BACK! HE WAS JUST LICKIN' YOUR FACE TO BE *FRIENDLY!*"

Happiness is a warm peepee.

putter around the house, or just plain goof off. The juices need time to settle down, and regular quiet periods are good for the soul. Weekends are tailor-made for this.

But, by the time Monday morning rolls around, I've built up a pretty good head of steam and usually "hit the deck running," eager once again to joust at windmills.

He Works for Peanuts

Although Mr. Charles D. Schulz (call me Sparky) and I first met in the summer of 1953 in Minneapolis and have since both become California residents and totally committed to the daily reporting of various half-pint outlaws and their pets, our social paths have seldom crossed. So it was a pleasant surprise to find that we were paired in the same foursome during the 1989 AT&T–Pebble Beach Pro-Am golf tournament. I looked forward to getting to know more about this enormously successful man, and our appearance together would also help those in the huge galleries who for years have been waving programs in my direction, begging me to draw them a Snoopy or a Charlie Brown.

Sparky plays to an eleven handicap, thumps the ball with authority, and was able to help his professional partner, Mike Reid, with twenty-three shots, two of them quite spectacular net "eagles." On the other hand, as is to be expected in the game, there was a sprinkling of gronkles and chili-dips. It was a relief to discover that Sparky was not a golf machine but one of us who regularly are subjected to the emotional roller coaster. I waited with interest for his reaction to his errant shots. Would he throw his club in disgust? Would he rend the air with the usual invectives? But, sure enough, true to his code, his

shoulders slumped, his eyes widened in disbelief, and we heard a muffled, "Good grief!"

As we waited for the group ahead to finish the hole, Sparky asked, "Do you ever think of quitting?"

"Quitting?" I was somewhat taken aback. "Hell, no! I've been playing this game since I was a nine-year-old, and I'm going to stay with it until I get it right!"

"No, I mean the cartooning business," he laughed. "Ever think of hanging it up? Of retiring?"

I had to collect my thoughts. Anyone seeing me botch up a hole as bad as I sometimes do might well wonder why I *don't* quit the game. "Retirement has never entered my mind. Training a couple of talented assistants and working fewer hours might be attractive, but I don't plan to join the Rocking chair-Metamucil Club. And another thing: old cartoonists never die— they just slowly erase themselves."

We both finished well out of danger of making the cut and enjoyed a relaxing Sunday watching Mark O'Meara birdie his way to victory. You're a good man, Charlie Schulz.

When to Throw in the Towel?

The retirement community attracts few who have spent their lives in the creative arts. As long as body and soul hang together, the urge to create persists, and I don't feel the slightest compulsion to back off and spend my autumnal days on a beach or a golf course. If, perchance, I should succumb to this temptation, I am positive that after a brief period I would become very busy redesigning the clubhouse and the entire eighteen holes or blocking out elaborate plans for a more effective use of the seaside property. You simply never stop thinking in these terms; the wheels continue to whirl.

During my boring period of convalescence at the Monterey Community Hospital, I compiled a long list of changes I felt were badly needed and called attention to areas of neglect long overlooked. The height of the toilet, the weight of the telephone, menu suggestions, changes in enema procedures—things like that.

Following my second operation a few years later, I continued my dogged pursuit of "excellence-according-to-me" and was gratified to learn that the management had taken note. They further expressed their interest and appreciation by inviting me to serve on the Board of Trustees! That should have taught me a lesson.

When John Gardiner had us down to the opening of Enchantment, his luxurious tennis complex at Sedona, Arizona, just a few miles south of the Grand Canyon, another report card from the friendly lint-picker was a foregone conclusion.

I know it sounds like I'm a first-class pain in the pattoot. But I'm not, really. It just sounds that way. Honest. Go ahead, invite me over.

So, as long as I have bursts of energy and brims of good health, I see no reason to abandon the ol' drawing board. I enjoy doodling with pen and ink, am quick on the draw, and waste little time getting the work out ahead of schedule. The *Dennis* Sunday page, in full color, is produced by my assistants, Ron Ferdinand and Karen Matchette (under my jaundiced-eyed scrutiny), which relieves me of an enormous load. In the process, of course, they are becoming more involved with the preparation of the daily panel and the special designs for Dairy Queen, Hallmark, Western Publishing, and a host of other commercial enterprises. Supersecretary Dottie Roberson keeps the Xerox and the fax machines oiled and tends to a dozen different chores simultaneously. It's a full-time job for all of us.

Come to think of it, though, I would love the time to sink my teeth into some writing and illustration projects, or break out the easel, learn the mysteries of oil painting

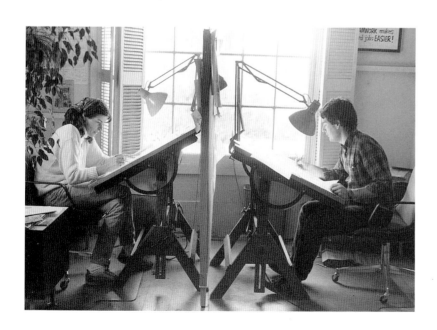

and watercolor, and have a go at some juicy portraits—with days in between to play a few rounds of golf. And, some leisurely motoring around in my own country has always sounded appealing—a casual inspection tour of places I haven't as yet visited.

Some day, perhaps, I'll do all of that. But right now I'm too busy and having too much fun to retire.

"HI, MOM! BOY, I THOUGHT THE SITTER WOULD **NEVER** GO TO SLEEP!"

Best of *Dennis*
—1980s

"IT SOUNDS KINDA LIKE BEIN' ON THE SCHOOL BUS."

"YUP, FIVE YEARS OLD IS A VERY GOOD AGE FOR BOYS."

"WHEN WE'RE FLYIN' OVER CITIES, CAN WE USE THE BATHROOM?"

"WATCH, MOM! ANOTHER HOME RUN!"

"BOY, GOLDFISH DON'T GET MUCH OF A FUNERAL, DO THEY?"

"MY DAD SAYS YOU'RE IN THE CHIPS, MR. CONNER.
WHAT KIND ARE THEY, CHOCOLATE OR POTATO?"

"I WONDER HOW OFTEN THEY HAVE TO CHANGE THE WATER?"

"CAN YOU CHEER ME UP, DAD? I THINK
I GOT THE BLUES IN THE NIGHT."

"I FORGOT. WAS PICASSO IN THE
SECOND OR THIRD GRADE?"

Index